IVORY

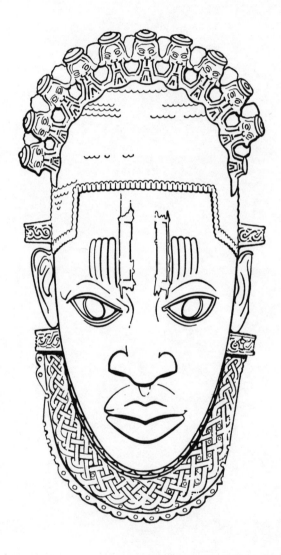

GEOFFREY WILLS

IVORY

SOUTH BRUNSWICK
NEW YORK: A. S. BARNES AND COMPANY

IVORY. © Geoffrey Wills, 1968. First American edition published 1969 by A. S. Barnes and Company, Inc., Cranbury, New Jersey 08512.

Library of Congress Catalogue Card Number: 68–27235

SBN 498–06866–8

Printed in the United States of America

CONTENTS

PLATES

To be found between pages 48 and 49

FIGURES IN THE TEXT

INTRODUCTION

IT HAS been pointed out that the use of ivory extends so far back into the story of civilisation, that a study of it involves the history of manners and customs from prehistoric times to the present day. Ivory is an extraordinarily durable yet tractable substance and this fact, having long been appreciated, has led succeeding generations of craftsmen and artists to treat it in a worthy manner. On its surface has been preserved not only the tentative scratchings of primitive man, but also works of art of the highest importance in both the historic and aesthetic sense. Many of the surviving ivories date from times when objects in other materials have perished without leaving a trace of their existence, and our knowledge of some of the achievements of those days is owed solely to such carvings.

On the aesthetic side, the material itself, with its unctuous surface and pleasing tints, is unequalled for many purposes to which it has been applied. The shape of the complete tusk imposes a strict discipline on the carver, and rising to meet the challenge he has managed to create works seeming to have known no such limitation.

In the following pages are described ivories from early times onwards that were carved in countries of the Old and New Worlds. They range from the prehistoric depiction of the elephant, appropriately on a piece of tusk, to the sophisticated work of German carvers of the baroque school, as well as that of the Bini of Africa and bored American 'scrimshoners'.

Most of the surviving ivories carved for religious use in pre-Renaissance times are of unparalleled beauty, their numbers are limited and the majority of them are now in museums all over the world. Considerable study has been devoted to them during the past hundred years, and in comparison the ivories of the seventeenth and eighteenth

centuries have been neglected. As they are more plentiful (although not to be described as 'commonplace') and therefore more readily available to the collector, I have devoted rather more space to these later works than to the earlier ones.

The illustrations have been selected to provide a cross-section within the limited space available, and to emphasize some of the points raised in the text. Finally, I have included a brief list of books on the subject, for those who want to pursue it further; and a short chapter entitled 'The Care of Ivories' for those who may welcome hints on how to look after the carvings they are so fortunate as to possess.

<div align="right">G.W.</div>

1

TYPES OF IVORY

THE WORD ivory, like jade, has grown to cover an increasing number of substances as the years have passed. To most people it is the material of which the tusks of an elephant are formed, but in fact a number of other substances of a similar appearance have been included under the same heading. It will be as well, therefore, to enumerate them and mention their characteristics so that each may be distinguished from the other. All share a white or creamy-white colour, a hardness that is sufficient to ensure long preservation but not so great as to prevent effective carved decoration and the ability to take a polish that increases with age.

ELEPHANT IVORY. This is the true ivory from the tusk of the elephant; a dense, whitish substance distinguished by being marked, when seen in section, with innumerable criss-crossing lines which produce a pattern similar in appearance to engine-turning. It has been described in other terms as 'that modification of dentine or tooth-substance which, in transverse sections or fractures, shows lines of different colours or striae proceeding in the arc of a circle, and forming by their decussations minute curvilinear lozenge-shaped spaces'. It is this distinctive marking together with the absence of the hard enamel outside coating found on other varieties, that differentiate elephant ivory from similar types, and that so far have defied convincing imitation.

The elephant is divided into two main types: the African and the Indian. The former is the bigger of the two, sometimes reaching a height of sixteen feet or more, and is distinguished readily by the facts that its ears are of great size when compared with those of the Indian species, and that both

male and female have large tusks. The African ivory varies somewhat in both hardness and colour according to the part of the Continent whence it comes.

The value of a complete tusk varies according to the quality of the material and the size and shape of the piece. Also, the size of the internal hollow varies from large to comparatively small, and in the former case leaves less usable ivory. African tusks vary in size from the smaller, weighing 18 lbs. and under and known as scrivelloes, up to enormous specimens weighing over 200 lbs. One in the Natural History Museum at South Kensington measures 10 ft. 2 ins. in length and

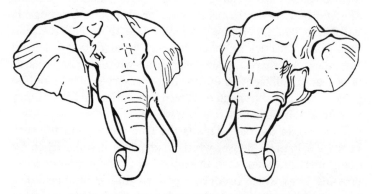

Fig. 2. Heads of (left) African and (right) Indian elephants

weighs 226½ lbs. At the Great Exhibition of 1851 several large tusks were shown, including a pair weighing 325 lbs., each measuring 8 ft. 6 ins. in length and with a circumference of 22 ins. at their bases; three others scaled 139 lbs., 110 lbs. and 103 lbs. apiece. Natives are said to have recollected tusks weighing as much as 280 lbs. each, and an eighteenth-century writer gives the weight of a pair as reaching 330 lbs. In 1898, natives brought to the Zanzibar market a pair of tusks weighing 450 lbs., and on the occasion of his marriage in 1893, the Duke of York (later King George V) was presented with one of 165 lbs., 8 ft. 7½ ins. in length. Owing to the fact that the African elephant feeds on tree boughs and roots and uses

the left tusk in the main for gathering them, this tusk is usually the shorter, and a pair seldom if ever measures exactly the same length.

The Indian elephant has, as has been mentioned, smaller-sized ears than its African relative, but it is also smaller in bulk altogether, and its tusks are not as large. The biggest measure about 9 ft. in length, and weigh between 80 and 90 lbs., and a 6 ft. 8 in. specimen in the Natural History Museum, killed in 1866, weighs 77¾ lbs. The pair to this last one being slightly smaller in size and lighter in weight. Assamese tusks are sometimes of greater length and diameter than those from other parts of the country.

The Indian elephant is found also on the island of Ceylon, whence it was probably imported in the first instance. At one time it was very plentiful there, and it has been reported that 'the late Major Rogers, of sporting notoriety, is known to have killed in that island upwards of 1,000 with his own rifle'. In the five years ending in 1862 it was recorded that 1,600 of the animals were snared and sent across to India, where many of them were tamed and used as beasts of burden. The male Indian elephant provides usable tusks, the female often has none at all, and in Ceylon both sexes are found tuskless. It has been noticed that domestication results in the production of smaller and lighter tusks.

Ivory is surprisingly elastic and flexible, and excellent riding-whips have been cut from the length of a tusk. One of its good points in the eyes of the carver is that once it has been removed from the animal and cleaned it is ready to be worked. A writer has summed up the ideal tusk as follows: 'A fine tooth is known by being of a neat tapering shape, with but a small hollow, free from cracks, with a fine, thin, clear coat, free from flaws; it is also transparent, which may be discovered by holding the point to a candle.'

Much of the structure of ivory consists of a gelatinous matter and it can be used in the form of shavings or dust as a basis for jelly-making. An entry in the household accounts of the Myddleton family at Chirk Castle, in Denbighshire,

North Wales, reads as follows: '1886, July 17. Paid att Chester for halfe pound of Ivory shaveings, to make Gelly, delivered to Mrs Chaplen. . . . 1s. 4d.' A further use for the surplus pieces of a tusk was in making painters' colour, a book of 1701 gave this recipe for making it: 'Ivory Black. It is the deepest black that is; and is thus made. Take pieces of Ivory put it into a furnace till it be thoroughly burned, then take it out, and let it cool; pare off the outside and take the blackest in the middle.' A writer of later date noted: 'Ivory black is the coal of ivory or bone formed by giving them a great heat, all access of air to them being excluded. . . . The goodness of ivory black may be perceived by its full black colour, not inclining too much to blue, and by its fineness as a powder.'

Earlier in the present century, when the game of billiards was more popular than it is now, ivory balls were preferred to all others. Their production involved the use of large numbers of tusks annually, and fifty years ago it consumed more ivory than any other manufacture. The harder types of ivory were preferred, but the balls were made in a number of different qualities and priced accordingly. A further use that has declined in recent years but remains an important one, is for the keys of pianos for which the soft varieties were chosen. Knife-handles, also, were once almost exclusively of ivory, but are now more often made from a substitute. Some of the latter are manufactured with a 'grain' that gives the material a super-ficial resemblance to ivory, but is much less durable.

FOSSIL IVORY. This is included usually under the heading of true elephant ivory, and is only distinguished from it by the circumstances under which it is found. Unlike other fossils, ivory does not become silicified, although some examples acquire a spiral twist, and in both appearance and structure the actual material does not differ from the normal freshly-removed tusk. Great quantities of fossil ivory have been found in Russia, in the neighbourhood of the rivers which flow into the Arctic Ocean, and although much is rotten great quantities have been recovered in good condition. A 12 ft. long tusk was excavated at Dungeness, Kent,

at the beginning of the present century, and others have been found elsewhere in England at various dates.

At one time, fossil ivory formed an article of export from Russia, and much was sent thence to China. In 1246, Giovanni de Plano Caspini, a Franciscan monk, saw in Tartary a throne of carved ivory decorated with gold and precious stones. From his description of the pieces of ivory it seems probable that they were of a size that could have come only from the fossil remains of a mammoth.

Fossilized tusks and teeth are found sometimes to have been stained a brilliant blue in colour from contact with minerals while buried. The material is known as Odontolite, from the Greek meaning literally 'tooth-stone'. It bears a noticeable resemblance to turquoise, but close examination shows it to be of organic and not mineral origin. It has been used convincingly in place of turquoise in jewelry, but it has a higher Specific Gravity, is less hard, and reacts differently to chemical tests.

OTHER VARIETIES OF IVORY. Under this heading are included a number of animal substances usually given the name of ivory. Although they do not come from the elephant and lack the distinctive markings associated with the product from that animal, they are not unlike it in general appearance and can be used in a similar manner.

HIPPOPOTAMUS. The curved canine teeth of the hippopotamus, the 'river-horse', are often used in the same way as elephant ivory. It is harder than the latter, and bears an outside shell of enamel that has to be removed before the material can be worked. It was once used extensively for the making of dentures, for which it was preferred to any other substance. In the eighteenth century it was considered to be the most durable material available for the purpose, and it took something like six weeks to carve into the required form. One commentator spoke of 'the beauty of hippopotamus ivory and the terrible consequences of using gold in the mouth, as it would set up electric currents which would destroy the palate and the throat'.

17

At the end of the eighteenth century a Frenchman intro-duced the making of false teeth from porcelain, but it is reported that as late as 1875 a London firm stocked blocks of ivory for making dentures in the old manner. It may be added that the Romans used ivory, of one type or another, for the same purpose, but then and until recently the fitting of a denture was confined to the wealthier people.

WALRUS. Walrus ivory was used for carving in the eleventh and twelfth centuries and earlier, and the material is known often as morse ivory. This fact causes confusion to the uninitiated, as a morse is also the name given to the clasp of a cope. A walrus tooth can weigh as much as 8 lbs, and vary in length between 18 and 36 inches. It is oval in section, and much less dense than most other types of ivory.

The near-extermination suffered by the animal during the past few centuries has resulted in the ivory getting scarcer. It is a material of good quality, but the inside cavity of the tusk extends rather far and there is consequently much waste.

NARWHAL. The single horn or tusk of the male narwhal, a type of Arctic whale, has been employed in the same manner as ivory. Like the walrus tusk it has a large internal cavity, also it is grooved spirally from end to end, and these factors limit its use. In the past it was highly esteemed as a rarity as well as being endowed with medicinal powers, and a specimen at Windsor Castle in the reign of Queen Elizabeth I was valued at the time at £10,000. A silver pro-cessional cross, now at Lisbon, which bears the cipher of Catherine of Braganza (Queen of Charles II) and the date 1664, is mounted on a narwhal tusk. More recently one has been presented by the Danish Government for use as the staff of a crozier at Coventry Cathedral.

SPERM WHALE. The lower jaw of this whale has between forty and fifty strong teeth, which can be used as ivory. They are comparatively small in size, and the articles into which they can be made are consequently limited.

In addition to the above, the teeth and tusks of a number

of animals, such as boars and hogs, when of a suitable size
for the purpose have been employed in the same manner as
elephant ivory.

BONE. The bones of human-beings and of both wild and
domestic animals have been used for the same purposes as
ivory. Sometimes bone has been mistaken for the real thing,
but it lacks the distinction of ivory. It has neither the tell-
tale markings of the latter nor does it take a comparable
polish, and the mellow creamy colour is absent. The outside
of a bone is of so-called 'compact' form, dense and hard,
whereas the interior is 'cancellated' with a spongy appear-
ance. The larger the bone the greater the outer surface and
the depth of compact material. The cancellated part is of no
use for artistic purposes, and bone cannot be cut into pieces
of a size to compare with slabs of ivory.

Bone was used by the ancients, when it was often more
readily available and more manageable than tusks would
have been, and objects made from it dating back many
thousands of years have been preserved. Many are strictly
utilitarian and plain, such as hair-pins, but others are
ornamented with carving.

More recently bone was popular in the fourteenth century
in northern Italy, where Baldassare degli Embriachi founded
a school of carvers who specialized in its use. It was employed
widely in Europe from the sixteenth century onwards for
decorating furniture; a fashion that originated in Italy and
reached its peak of popularity in the early 1700s.

The craftsmen of most of the countries of Europe vied with
one another in their use of such veneered ornament, which
was glued on to the surface of a piece of furniture and known
as marquetry. The best-known exponent of the art was the
French cabinet-maker, André-Charles Boulle (1642–1732),
whose work was confined principally to the employment of
ebony, tortoiseshell and brass, but who occasionally incor-
porated other materials with them.

For this purpose, bone and sometimes ivory was often
stained a bright green, usually to represent foliage, and made

a pleasing contrast with different woods against a background of walnut, tulipwood or kingwood. In most instances the green has faded with age, and only occasionally, for instance on the inside doors of a cabinet, can a piece of old marquetry be seen in its original rich hues. As an alternative to staining, the inlays were enhanced sometimes with engraving. In that case, the incised patterns were filled with a black composition to make them more conspicuous.

In England, bone came into prominence at the end of the eighteenth century through the activities of the many French prisoners captured in the war against Napoleon Bonaparte. The men were confined in camps and hulks in various parts of the country, and one of their pastimes was the making of articles from waste bones from the kitchens. Many of the prisoners were highly skilled, and their most successful and popular productions were models of sailing-ships. While some were poor attempts at realism, others were carefully built and more or less to scale, complete in detail and rigged with human hair. It is a tribute to their patient workmanship that so many of these models have survived a century and a half of wear-and-tear, and this in spite of the conditions under which they were constructed. Less pleasing are the models of the guillotines made at the same time. They are usually contrived to work in a realistic manner, and incorporate a model victim ready for decapitation on the platform.

HORNBILL IVORY. This substance is the casque or *epithema* of the Helmeted Hornbill, a native of the East Indies. The bird has some unusual habits that are outside the scope of this volume, but it is distinguished from others of its family (*Bucerotidae*) 'by having the front of its nearly vertical and slightly convex *epithema* composed of a solid mass of horn.' It is a closely-textured and hard material valued highly by the Chinese and used by them for making small objects, such as buckles and brooches, which are decorated with carving. When cut across, the section shows a bright yellow interior with a scarlet rim.

Non-animal, vegetable and artificial, products which simu-

late the genuine material are also numerous, and the principal
ones are the following:

VEGETABLE IVORY. The inner lining of a coconut-like
seed, grown on a type of dwarf palm called *Phytelephas
macrocarpa*, is known as Vegetable Ivory. In localities where
it grows it was named the 'niggers' head tree', because of
the colour, shape and size of the large fruits containing the
seeds. Other names given to it are *tagua* by the Indians on
the banks of the Magdalena river in Colombia, *anta* on the
coast of Darien, and the *pulli punta* and *homero* in Peru. It
has been imported into England under the name of Corozo
nut.

The tree produces six or seven fruits, each weighing about
25 lbs. and containing from six to nine seeds. If the coverings
of the seed cases are removed, the inner white lining or
albumen is revealed. When the seed-head is young, this
albumen is a clear liquid, but in time it turns milky and
eventually hardens.

Phytelephas macrocarpa was first noticed growing in the
valleys of the Andes along the west coast of South America,
and its use by the natives was commented on by Baron
Alexander von Humboldt (1769–1859), the German natural-
ist and traveller. He was in the area in the first years of the
nineteenth century, and following his suggestion increasing
quantities of Corozo nuts were imported into Europe.

Their use in the west has been confined in the main to
utilitarian purposes, and many millions of buttons have been
formed from them. On occasions attempts have been made to
create works of art from vegetable ivory, and specimens were
shown at the Great Exhibition of 1851. Benjamin Taylor of
Clerkenwell displayed 'An Oriental tower, with minarets
composed of upwards of 1,000 pieces', but the cold whiteness
of the material does not compare favourably with the
mellowness of true elephant ivory.

The Japanese have used the material, or a variety resem-
bling it closely, for the carving of their netsukes: the small
ornaments which were worn to prevent the *inro* on the waist

belt from slipping out. It is known as *binroji* and with the aid of stains to simulate age and disguise its vegetable origin, it has been given a very deceptive appearance.

SYNTHETIC IVORIES. The invention of celluloid was due to the investigations of an Englishman, but two Americans who were seeking a substitute material for making billiard balls discovered it at about the same time. The material has been marketed since about 1880, and its uses have been numerous but limited by the fact that it is highly inflammable. Suitably tinted, it has been employed frequently as a substitute for ivory in the form of knife handles, piano keys, combs and hair-brush backs, and so forth. A similar use is made of plastics based on casein (a constituent of milk) which are easily charred but do not burst into flame readily. Other, more modern plastics are also made to resemble ivory.

While both plastics and celluloid have been used to imitate carved ivories cheaply, they should hoodwink only those who are completely off their guard. Provided such forgeries are sold at the price of copies no one should complain, but if marketed unscrupulously as the genuine material a purchase can be a costly and humiliating matter.

Of all substitutes, plaster of Paris is the least likely to trap the collector. In the mid-nineteenth century there were several bodies formed to instruct the public in the principles of art and design. Among them was the Arundel Society, which published in 1856 a list of plaster reproductions of ivories for sale to its members and to the public in general. At the time, Mr Edmund Oldfield, of the British Museum, wrote of the collection: 'it may safely be affirmed that from this assemblage of mere plaster copies more knowledge is to be obtained in the history of the art they are intended to illustrate, than from any single cabinet of originals in Europe.' He explained that 'casts were obtained in a superior species of plaster, which, when saturated with a preparation employed for this purpose, acquired a hard and smooth surface, approaching in appearance to ivory'. Although such

treatment might produce a superficial resemblance to the original, the feel of the piece, and probably also a lack of sharpness in the finish, should immediately reveal the imposition. Copies of this type are usually referred to as Fictile Ivories, and some museums hold large collections of them for educational purposes.

2

ANCIENT ASSYRIA, EGYPT,
GREECE AND ROME

ASSYRIA. From about 3,000 B.C. until 500 B.C. Egypt and
Mesopotamia were twin centres of culture and civilization in
the near East. Each had its great cities, its religion and its
different modes of artistic expression, and much has been
done in the past few decades to clarify the picture of what
life was like in those remote ages. The first important dis-
coveries relating to Assyrian civilization were made more
than a century ago by Sir Henry Layard, author and diplo-
matist, who gave up his work in an English solicitor's office
to travel by way of Asia to seek employment in the Ceylon
civil service. He did not reach his destination, but through
the encouragement of Sir Stratford Canning, British Ambas-
sador at Constantinople, he excavated the remains of
Nineveh, Nimrud and Babylon. He worked on the sites
during the years 1845 to 1851, and sent back to the British
Museum large quantities of material of all kinds which
constitute the greatest collection of its type in the world.

Many ivories found by Layard were in such a state of
decomposition that it was dangerous to handle them for fear
they crumbled away. He found, fortunately, that by immers-
ing them in a solution containing gelatine he was able to
restore some of the substance lost during burial, and the
majority of the specimens was saved by this means.

Most of them were no more than fragments, and had
formed part of the ornamentation of furniture in Royal
ownership. This was a type of furniture decoration wide-
spread at the time (and later), and has resulted in the
recovery of more than one copy of the same plaque that had

been made for forming a frieze with a repetitive theme. The woodwork to which they had been affixed has powdered to dust long ago, but the durability of ivory preserved it more or less intact for over five thousand years.

Because most of the recovered ivories have a strong resemblance in their decoration to known Phoenician work it has been suggested that most or all were imported from the Damascus area. Other pieces bear figures and ornament with noticeable Egyptian affinities, but these also are ascribed to Phoenicia. Another group, also showing the prevailing Egyptian influence, is perhaps of Syrian origin.

The Assyrians preferred to have their ivory decorated. Many found by Layard and others bear traces of gold leaf

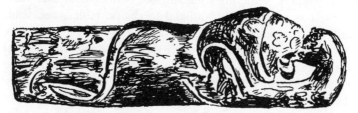

Fig. 3. Knife handle showing a lion devouring a gazelle. Assyrian, seventh century B.C. Length: 4⅜ in.

and coloured pigments, and were inlaid in addition with lapis lazuli and other suitable brightly-coloured stones.

EGYPT. The earliest ancient Egyptian ivories are some small figures, believed to be about 6,000 years old, now in the Walters Art Gallery, Baltimore. Each figure is some two inches in height, carved in a very simple style with the head somewhat out of proportion to the body in most instances, but showing a curious realism that is even more striking when their great age is considered. Perhaps they were carved especially as an offering to a deity, but their foetus-like appearance suggests the possibility that they may have been buried with a dead person in accordance with reincarnation belief.

The fourth dynasty King Cheops is portrayed in a statuette

in the Cairo Museum, and there is a comparable, but un-identified, Royal personage in the British Museum. Both of these pieces date from about 2,900 B.C.

From the Amarna period, which lasted from 1372 to 1350 B.C., have been preserved pieces that show considerable sophistication in their design. They include the figure of a grasshopper with movable wings to conceal places in the body of the insect in which its original owner kept her kohl, and a realistic duck equipped similarly for use at the dressing-table.

Less rare than any of the foregoing pieces are carved plaques used for the embellishment of furniture, a form of decoration that was common throughout the Near East. The plaques, sometimes embellished with colour and inlay as well as carving, were affixed to chairs, tables, bedsteads and other articles made for royal and wealthy inhabitants, but time has dealt heavily with the woodwork and in most instances only the ivories remain. Some of the rare surviving intact pieces of furniture were found in the tomb of King Tutankhamen.

Amongst other ancient Egyptian ivories may be included the handles of hand-mirrors. Many are carved with repre-sentations of the god Bes, a ferocious-looking dwarf, who had a number of functions including that of presiding over the toilet-table.

GREECE. Ancient Greek ivories are more familiar from descriptions given by observers than they are from actual surviving specimens. Those few that have been found are of interest, but usually in such poor condition that they can scarcely be recognized as being made from ivory. Several such pieces, in fact, have been thought to be of wood and were so labelled in museums until their true nature was discovered.

The celebrated Greek sculptor Phidias, who lived from about 500 to 432 B.C., is known to have made two very celebrated statues that were greatly admired while they existed. They were a seated figure of the god Zeus which

was 58 ft. in height, at Olympus, and a standing figure of Athena, also of colossal size, in the Parthenon at Athens. Both were made of gold and ivory, a type of work referred to sometimes as *chryselephantine* sculpture, and took the form of plates of either material rivetted to a wood or metal foundation. The plates or sheets of gold and ivory would be made sufficiently thin to bend to any shape, and the joins between them would not be noticeable at a reasonable distance from the statue.

Pausanias wrote his *Periegesis*, or Itinerary of Greece, in the second century A.D. and noted a number of chryselephantine statues that had been, or were still, standing. They included the two noted above, and others at Corinth, Mycenae, and Aegina.

ROME. Phoenician ivories were as familiar to the Romans as they were to the inhabitants of many other lands in the Mediterranean area and beyond. In addition to imported work the home market was supplied by several successful groups of native carvers, but surviving examples of their art are not plentiful. As in Egypt and elsewhere, the Romans decorated much of their best furniture with carved ivory plaques of which some have been preserved, and those in the Villa Giulia, Rome, formerly in the Barberini collection are noteworthy.

Among the outstanding relics of Roman civilization are the so-called 'Consular Diptychs': folding and hinged pairs of plaques sent by a newly-elected consul to important personages and friends on his accession to the office. Some fifty examples have been preserved, and they range in date from A.D. 410 to 541; the latter year being when the consulship was abolished. As they often bear the name of the consul himself on them, they can usually be dated accurately and are rare in this respect, but the exact country of origin of many of them is not so easily determined. A few of the finer ones are thought to have been carved in Rome, but the majority probably came from Constantinople or Egypt.

The Consular diptych usually shows a full-length figure

of the consul seated in his chair of office, the curule, and some show lion and other fights in the arena in which games were played to celebrate the election. One such diptych, of which only a single leaf has survived, is in the Liverpool Public Museum, and shows scenes in a stag fight with three officials watching.

Other Roman diptychs celebrate family occasions, and one of the finest of them (and of all surviving secular examples) is now separated; one leaf is in the Victoria and Albert Museum, London, and the other in the musée de Cluny, Paris. Each leaf is carved with the figure of a woman, perhaps a priestess, and one is engraved with the name *Symmachorum* and the other *Nichomachorum*. It is probable that the diptych was made to celebrate a marriage between two members of these families in about the year 400. (Plate 1).

3

PREHISTORIC EUROPE

Ivory is a natural substance of which supplies have always been limited: not only was the elephant or the mammoth confined to certain regions, but even where these beasts were plentiful their tusks might not be obtained easily. It is a material that is well suited to be carved yet is very durable, and it has been known and treasured by man for thousands of years. Excavations on the sites of many ancient civilizations have yielded specimens of ivory, and remote trading-stations for the bartering of raw and finished materials usually included it among the goods for which merchants journeyed half across the world.

There is no doubt that many other materials were treated artistically in the remote past, but apart from gold and stone it is ivory that has proved the most lasting and from which it has been possible to gain an insight into life in early times. Wood has mostly rotted long ago into dust, metals other than gold were sometimes unknown or scarce and not easy to manage, and glass and pottery were less tractable and fragile. Ivory remains as clear evidence of a surprising range of skill and inventiveness.

Prehistoric carvings are, of course, very rare, but a quantity have been brought to light during the past hundred years. The principal finds were made in the regions of the lake-dwellings, and in the celebrated caves of the Vézère valley in the Dordogne in south-western France. These were explored in 1858 and later by an Englishman, Henry Christy the son of a hatter, and his French friend Edouard Lartet. Their discoveries led the way to many later ones in the same district, and elsewhere; especially the caves of Aurignac and

Mas d'Azil, south of Toulouse, and the group including Altimira near Santander.

From one of the Dordogne caves comes a well-known drawing of a mammoth presumably sketched from life, scratched on a piece of the tusk of one of these animals, and now in a Paris museum. In the British Museum and elsewhere are preserved small carvings that show not only how well the primitive people of the time observed the animal life around them, but that they were able to translate it into the round.

Fig. 4. Prehistoric fragment of mammoth ivory with engraved decoration. Length: 9 in.

This they were able to do in spite of a lack of any but the most elementary tools. In some exceptional instances there are carvings in the form of human beings, torsos as well as heads have been found, and it is possible that some of these were made as children's playthings: prehistoric dolls. While the carvers who made them have paid attention to some details, a head found at Brassempouy wears a headdress of recognizably Egyptian style, little attempt was made to render facial features at all distinctly. Eyes, nose and mouth are only indicated and there would seem to have been no attempt to portray a likeness.

PREHISTORIC EUROPE

IVORY is a natural substance of which supplies have always been limited: not only was the elephant or the mammoth confined to certain regions, but even where these beasts were plentiful their tusks might not be obtained easily. It is a material that is well suited to be carved yet is very durable, and it has been known and treasured by man for thousands of years. Excavations on the sites of many ancient civilizations have yielded specimens of ivory, and remote trading-stations for the bartering of raw and finished materials usually included it among the goods for which merchants journeyed half across the world.

There is no doubt that many other materials were treated artistically in the remote past, but apart from gold and stone it is ivory that has proved the most lasting and from which it has been possible to gain an insight into life in early times. Wood has mostly rotted long ago into dust, metals other than gold were sometimes unknown or scarce and not easy to manage, and glass and pottery were less tractable and fragile. Ivory remains as clear evidence of a surprising range of skill and inventiveness.

Prehistoric carvings are, of course, very rare, but a quantity have been brought to light during the past hundred years. The principal finds were made in the regions of the lake-dwellings, and in the celebrated caves of the Vézère valley in the Dordogne in south-western France. These were explored in 1858 and later by an Englishman, Henry Christy the son of a hatter, and his French friend Edouard Lartet. Their discoveries led the way to many later ones in the same district, and elsewhere; especially the caves of Aurignac and

Mas d'Azil, south of Toulouse, and the group including Altimira near Santander.

From one of the Dordogne caves comes a well-known drawing of a mammoth presumably sketched from life, scratched on a piece of the tusk of one of these animals, and now in a Paris museum. In the British Museum and elsewhere are preserved small carvings that show not only how well the primitive people of the time observed the animal life around them, but that they were able to translate it into the round.

Fig. 4. Prehistoric fragment of mammoth ivory with engraved decoration. Length: 9 in.

This they were able to do in spite of a lack of any but the most elementary tools. In some exceptional instances there are carvings in the form of human beings, torsos as well as heads have been found, and it is possible that some of these were made as children's playthings: prehistoric dolls. While the carvers who made them have paid attention to some details, a head found at Brassempouy wears a headdress of recognizably Egyptian style, little attempt was made to render facial features at all distinctly. Eyes, nose and mouth are only indicated and there would seem to have been no attempt to portray a likeness.

4

CHRISTIAN EUROPE

EUROPEAN ivories dating from the fourth century A.D. onward have survived, and apart from their intrinsic beauty they are important for the light they throw on many aspects of life and thought in the past. Together with illuminations in manuscripts, with which many ivories have much in common, they often constitute the only remaining evidence of artistic effort in the early days of Christianity.

All the more wealthy and settled areas of Europe and the near-East in the fourth to sixth centuries had their groups of ivory-carvers, and Rome, Milan, Antioch, Constantinople, and Alexandria were among the more important centres. Craftsmen in these and other places each had their distinctive mannerisms, but the exact city or country where a piece was made, as well as the date when it was done, is often debated hotly and inconclusively. With the spread of the near-Eastern Byzantine style through Europe, brought there by merchants and pilgrims on their travels, each country adopted more or less of its features and the many monasteries near the banks of the river Rhine were foremost in their use of it on ivory.

The famous ivory chair or throne made for Maximilian, Archbishop of Ravenna and still in that city, is inscribed with the name of the man for whom it was made in the middle of the sixth century. It is built-up from a number of finely carved panels, one group of which illustrates the history of Joseph and his brethren, but not the least important feature of this piece is the fine condition in which it remains after a period of fourteen centuries. The chair has much of Byzantine character about it, and after many ascriptions to different centres of carving is now credited by many to Constantinople.

As the countries of the near-East became pre-occupied with internal problems the northern European area grew in artistic importance, and by the twelfth century there were signs of the development of a new style—the Gothic, which slowly spread in popularity and since then has had many revivals. Its characteristics are not difficult to recognize: the stiffly-posed figures within arched recesses; the lack of proportion between the principal figure or figures and any others depicted; the toga-like clothing with its deep and carefully-arranged folds; and the cleverly contrived patterns that make the maximum use of every centimetre of ivory.

The subtle and barely-noticeable differences between pieces carved in France and those executed a mere twenty miles or so across the Channel in England and perhaps by French carvers, often defeat many authorities on the subject. It must suffice, under the present circumstances, to state boldly that almost all of these early European pieces are beautiful, all are rare and, just to complicate the matter further, most have been given close attention by forgers during the past hundred years.

The ivories can be divided for convenience into two types: those made probably for religious purposes, and those for secular use, but the division cannot be watertight. Many objects were made in the first place for everyday employment in a wealthy home and were adapted in time for ecclesiastical use, and it is not always clear now for which need an article was intended when it was made. Many of the carvings of all kinds were decorated originally with painting and gilding, but few retain more than slight traces of either. While the lovely tones of the natural material itself nowadays appeal to most people, our ancestors thought differently and treated ivory in the same way as they treated sculpture in marble. They coated it with bright colours.

Most of the surviving early European ivories are those used in the Church. Not only may this be because the presence on many of them of religious subjects stayed the hand of the wanton destroyer, but those of secular origin were adapted

for Church purposes as Christianity overcame paganism. The principal ivories made between the fourth and fifteenth centuries and of which examples have been preserved, are the following:

DIPTYCH. This is the name for a two-leaved, centrally-hinged, folding and book-like article, the word coming from the Greek and meaning 'two-fold'. The outsides of the earlier ivory ones were decorated with carving, the inner surfaces being left plain or coated with wax and on them were written or scratched the names of persons, living or dead, commemorated at Communion. The carving depicts scenes from the Passion or the life of a Saint, and the fact that many of these follow closely in style the illuminations of manuscripts is often a clue to their date. Later diptychs were plain outside and carved within. They passed slowly out of use, and many had their leaves separated; the corners being drilled with holes so that they could be used to decorate the covers of books.

Not all diptychs were carved with religious subjects or were connected with Christian worship, and the Consular examples have been mentioned in an earlier chapter (see page 27).

TRIPTYCH. Similar to the foregoing but with three leaves, they were used as miniature altar-pieces. It is rare to find a diptych or triptych complete with its original fastenings more or less untouched (Plate 3). A single leaf, the form in which most have survived, may have belonged to one or other of the folding types, or may have been made purposely for a book cover. In the latter case, one would not expect to find traces of hinges.

CASKETS. While boxes of many shapes and sizes for holding valuables were made from the earliest times, those for ecclesiastical use were designed principally to enshrine the relics of a Saint. Some of these Reliquaries were made of wood with applied carved plaques of ivory or bone, others were more sumptuous in appearance and were of gilt metal, again on a wooden body. One of the most renowned of this latter type is the Eltenburg Reliquary, in the Victoria and Albert Museum, made of gilded copper and ornamented with

coloured enamels. It is in the form of a domed church, and the spaces below the dome and around the body are filled with carvings in walrus ivory. It was made perhaps at Cologne in the last half of the twelfth century, and has had a chequered career during some of its existence. At the time of the French Revolution it was in a nunnery at Eltenburg (known now as Hoch-Elton) near Emmerich, on the Rhine and just inside the border of East Germany. The nunnery was ransacked and the Reliquary saved by one of the nuns, who gave it to a canon of a nearby church. On the death of the canon in 1841 it was sold to a dealer in the district who started to dispose of the ivory carvings separately. Fortunately, before he had had time to part with many of them it was bought by a collector, sold again to a Russian, Prince Soltykoff, and acquired by the museum at the sale of the latter's famous collection in 1861.

While Reliquaries were carved with appropriate religious scenes, caskets for secular use were decorated with subjects taken from the Romance tales popular at the time. Tristan and Iseult, Launcelot and Guinevre, and others are found, and a popular subject was the storming of the Castle of Love, with the beleagured ladies depicted showering flower-petals on the beseiging knights who are sometimes encouraged further by the God of Love.

A group of caskets, some rectangular and others circular in shape, is known to have been made at the once-important Spanish town of Cordoba; ten centuries ago one of the great cities of the world and a centre of Islamic power. The caskets are carved with figures, birds and beasts amid intertwined foliage, and most of them bear inscriptions naming the original owner and the date when they were made. This was principally in the second half of the tenth century A.D. (Plate 17. See also page 71).

Caskets inset with panels of carved bone within mouldings of inlaid wood were made in north Italy from the late fourteenth century by followers of Baldassare degli Embriachi. (Plate 12. See also page 52). The inlay or marquetry (known

in Italy as *intarsia*) was often the work of Carthusian monks and is described commonly as *alla Certosina*.

PYXES. These are boxes in which is kept the consecrated bread for the Sacrament. Usually the ivory examples are circular in shape and carved on the outside with Biblical scenes, but there is often little to distinguish them from a small-sized casket.

PASTORAL STAVES. The tall pastoral staff of a bishop bears at its head either a curved ornament or a cross. The latter, a Tau-cross, was often of ivory, and fine examples dating from the eleventh and twelfth centuries are to be seen in the British and Victoria and Albert Museums. The name

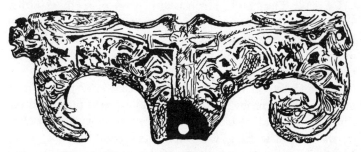

Fig. 5. Tau cross. English, eleventh century

comes from that of the letter 'T', a cross lacking the upper limb as in our own alphabet, in the Greek and Hebrew alphabets. The style of decoration of those crosses is comparable to that of contemporary illuminations in manuscripts, and the facts that one of them was excavated in the City of London and many are carved from Walrus ivory which was more common in England than elephant ivory, point to the probability that some of these, and related crosses, are of English origin. They were also made in other countries.

The curved staff-heads (Crooks, or Croziers) are of later date than the Tau-cross type, and are among the most beautiful of ivory carvings (Plate 4). In almost every instance the carver has made the utmost use of his material; ornamenting the curled head with running foliage

and incorporating a group of figures in the central space.

STATUETTES. These date from the thirteenth century, and are very rare when they can be ascribed with certainty to any time prior to about 1600. The most famous is a group of the Virgin and Child carved by Giovanni Pisano in 1299, now at Pisa. There are others, of which the makers remain unknown, in the Louvre, at the British Museum, and elsewhere (Plate 5). A group in the Louvre shows the crowning of the Virgin with two attendant angels, and a fifteenth-century South German *Pietà* in the British Museum conveys the poignancy of the scene in an admirable manner aided through retaining its original colouring.

COMBS. The comb, always with rows of teeth at either side of a central carving, was as necessary in the past as it is today. High ecclesiastics used them before the celebration of Mass, and they were provided at the service of consecration of a bishop. As late as 1625 in the Order of the Coronation Service of Charles I it was noted that after prayers and prior to the Anointing with oil a small cap was placed on the King's head, and 'if his Majesties hair be not smooth after it; then there is King Edward's ivory comb for that end'. Most surviving specimens are of the sixteenth century, but a few are earlier in date. (Plate 6).

MIRRORS. Few mirrors were made of glass before the late sixteenth century, and most were made from a metal named Steel or Speculum; an alloy of copper and tin, which took a high polish and did not tarnish readily. Whatever their composition they were of small size, circular, and sometimes set in cases of carved ivory. The backs of the cases were carved, often finely, with scenes from the Romances, or with other subjects having a feminine appeal. Several are known which depict a knight and a lady seated in a tent playing chess, others show groups of lovers, and some feature the Attack on the Castle of Love. (Plate 7).

CHESS AND DRAUGHTS MEN. The game of Chess reached Europe from the near-East by about the eleventh century, at which date it was known in Italy. Thence, it

spread westwards rapidly. Probably the most renowned men comprise the hoard of nearly a hundred found in a cavity in a sandbank on the island of Lewis, in the Hebrides, in 1831. The finder, a labourer, is said to have thought at first that he had discovered an abode of elves or fairies and to have run away frightened, but returned later to examine and remove the objects. Parts of seven sets are among the majority of the Lewis chessmen now in the British Museum.

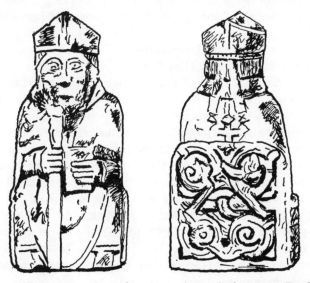

Fig. 6. Two views of a walrus ivory (morse) chessman. English, twelfth century.

They are well carved in the form of figures of men in the costume of the time when they were made, the twelfth century, and are ornamented with interlaced scrolling on the backs of the thrones or chairs on which some of the figures are seated.

Draughts is of more modern origin than chess, and is stated by a recent authority to have been invented in the south of France in the twelfth century, but was perhaps not known very widely for two or three hundred years afterwards.

In the early sixteenth century a revised version of the game was introduced, and in this it was compulsory to capture an opponent's piece or pay the penalty of a *huff*.

Circular game-pieces, presumed to have been used for playing draughts or perhaps for some similar game, have been dated to as early as the sixth century A.D. Twelfth century discs, usually in walrus ivory ornamented with animal and other subjects, include a specimen in the Victoria and Albert Museum carved with a group of people watching a man and woman playing a board game. It has a border of raised dots, each of which is drilled and once held a small glittering paste.

HORNS. These are known often as Oliphants, a corruption of the word elephant. They fall into two types: those made for ceremonial purposes, i.e. for drinking and for exchanging for the tenure of land or office, and those made for emitting a noise, discordant or otherwise. They were made in many countries over a period of many centuries, and examples of the varieties can be seen in the larger museums of the world.

For the making of noise, the elephant tusk or the horn of any other animal was very suitable, and all it required was the removal of the tip and for the interior to be hollowed out. In this form they were used as *mote horns* to summon the burgesses of English boroughs, to give the alarm in case of fire or attack and when hunting. It may not be surprising to learn there is no evidence that they ever had a place as musical instruments.

For drinking, the horn is again suitable, but in this case the tip would not be removed and the elephant tusk might be considered to be too great in capacity for that of a potential drinker. As tenure horns there are examples dating back at least to the twelfth century which have been preserved in England. For this purpose the horn was given in exchange for an area of land or for some specified office, which could be held for as long as the horn remained with the recipient or his successors. Oliphants were often left quite plain, or fitted with silver mounts so that they could be hung from the shoulder or stood on a table. Some surviving examples are carved.

5

EUROPEAN WORK OF THE SEVENTEENTH AND EIGHTEENTH CENTURIES

THE ART OF ivory-carving flourished throughout the period when the baroque style was in vogue, and continued to be popular after this had been superseded by the rococo. From the Church, to which its use had been confined in the main for so long, ivory began to be employed for the making of utilitarian articles and for decorative purposes of many kinds. Germany and Austria initiated techniques which spread to France, Flanders, England and elsewhere, and there were finally few countries in Europe that could not boast groups of carvers in the material; either creating original work, or else imitating the most versatile specialists of other lands.

The seventeenth century saw the making of large numbers of crucifixes in ivory. They usually showed the figure of Christ on a cross of wood with the materials contrasting dramatically, but small-sized examples were made wholly from ivory. There followed a wider introduction of this style of carving, with the flesh of a human figure in ivory, and the clothing, background, etc., rendered in wood. It was used with arresting success by a German, Simon Troger, who carved religious and mythological groups in this manner and on a much larger scale than would have been possible using ivory alone. Modern imitations of the technique, akin to that of the ancient Greeks and using ivory in combination with bronze, have been made mainly in Central Europe with a range of subjects to suit twentieth-century taste.

Some types of work have become associated with certain countries. For instance, the large tankards, obviously more

for display than for serious use, allocated invariably to Germany but which, in spite of the hallmarks on their silver mounts, may in some instances have been carved in nearby Flanders. To many English collectors and students of ivory-carving these tankards are the best-known of German productions, but while they may be numbered among the most elaborate achievements of the art the renown of the vessels rests mainly on the numerous copies of seventeenth-century originals made no more than a hundred years ago.

The tankards measure from about nine inches to a foot or more in height, and have a diameter varying from four to six inches. Their skilfully carved ornament usually depicts subjects from classical mythology with a preponderence of Bacchanalian scenes. Genuinely old examples are rare. Their great popularity a century ago is attested by the fact that several were shown at the Great Exhibition of 1851. A typical example, carved by C. W. Heyl of Darmstadt, was described as follows: '. . . a colossal goblet, composed of three principal portions, stand, body and cover. The principal part, or body, represents in alto relief the battle fought by Hermann (after a drawing by Lindenschmidtt, in the possession of H.R.H. the Grand Duke of Baden). The body is supported by the figures of eight German emperors (taken from the portraits of the emperors in the Roemer at Frankfort). The cover, in the shape of a cupola, is surmounted by the figure of Germania, resting her right hand upon a shield, and her left upon a sword. The whole of the minor ornaments are in the old German style.' Unfortunately, in spite of this careful description the cataloguer omitted to record the size of the piece.

A number of carvers specialized in carving portraits in low relief on circular medallions which bear a close resemblance to large coins. Others carved portrait busts and statuettes, but such work 'in the round' grew less and less as the competition of porcelain increased. Probably the principal use for ivory in the eighteenth century was, however, for the painting of miniatures. It was introduced for

this purpose about 1690, when it was found that the surface texture, colour of the substance and its durability made it ideal. Shortly, it had ousted completely vellum, chicken-skin, card and copper; all of which had been used hitherto.

The preparation of the thin sheet of ivory for painting was done usually by the artist, and the following instructions which were printed in about 1820 make the method clear: 'The process of whitening must be done by placing it in a moderately-heated oven, or in the sun, which will warp one side; turn it then on the other, and when it has the degree of whiteness you require, take it out, that it may not become too dry; for in that case it loses its transparency, and is apt to split when cut. This operation finished, you must proceed to one of more consequence and difficulty, and which requires practice: it is the polishing. Some painters use a large scratcher; others, an instrument with a blade three or four inches long, and of triangular shape. To either of these I prefer the use of a razor: to benefit completely by it, you must be sure to have not the smallest notch in it, or that it be not too sharp. Open it so that the back part of the blade touches the handle; in that way you will use it easily to scrape your ivory from angle to angle. When you have thus polished the whole, begin again from the contrary angles, to be quite assured there remains no trace of the saw upon the side you wish to paint.'

The size of a miniature was limited by the size of the tusk obtainable, and the area of flawless material that could be cut from it. This was increased greatly about 1850 by the introduction of a process of 'cutting the tooth round by means of a saw'; in a manner similar to that by which veneers of wood are produced at the present day. For the latter a saw cuts longitudinally along the bark to 'peel' an endless length of veneer until the centre is reached, and in the case of ivory the length is limited by the size of the central cavity of the tusk. According to one authority, 'some time ago a sheet (of ivory) 17 inches by 38 was shown, and a French manufacturer has produced them so large as 30 by 150 inches'. At

about the same date, an American firm, in Meriden, Connecticut, invented a machine which produced a sheet of ivory measuring 12 ins. in width and 40 ft. in length.

Among the many articles made from ivory for daily or occasional use during the seventeenth and eighteenth centuries may be numbered the following: snuff-boxes, tobacco-rasps (known also as Rapps; fitted with a metal grater and used for powdering tobacco to snuff), fans, counters for card games, bodkin and needle cases, handles for daggers, swords and canes, and gunpowder flasks; some of which received so much decoration that their intended purpose was obscured.

A considerable use was made of ivory for the manufacture of scientific instruments; the precision to which it could be worked and its durability being points in its favour for the purpose. Not only were pocket-dials, drawing-instruments and parts of the microscope made from it, but pocket calculators (known as 'Napier's Bones') were sometimes of ivory. Rarely, terrestial and celestial globes, rather heavy and in spite of their size hardly to be described as 'pocket', were turned from tusks. Most of the folding or 'Diptych' dials, which preceded the watch for telling the hour and were also often essential to check the accuracy of the latter, were beautifully engraved with information set amidst cherubs and scrollwork. Most will be found inscribed with the names of makers in Nuremburg or Dieppe, and some bear views of those places.

The tea-caddy, which was the subject of much decorative ingenuity in the hundred years following its introduction in about the year 1730, was sometimes veneered with ivory. The tusk was cut into thin sheets and glued on to a wooden box, the edges being masked neatly by strips of tortoiseshell or ebony. In some instances the ivory was fluted, and the escutcheon and handle made of silver. Also popular during the eighteenth century were green-stained ivory handles for knives and forks. According to Robert Dossie, who published the recipe in 1758, the colour was obtained by boiling the material in a solution of verdigris in vinegar or of copper in

aqua fortis, '(a vessel of glass or earthen ware being employed for this purpose) till they be of the colour desired'.

Ivory was used also at various dates for the making of jewelry: necklaces, bracelets and brooches. A pleasing type of the latter took the form of imitation cameos, which were made by carving a small plaque of the material in low relief, and with the background cut away the whole was stuck to a coloured backing and mounted under a convex glass. Some of these small and exquisite pieces were used to decorate the tops of snuff-boxes, and their workmanship is usually of such delicacy as to raise doubts that it was not done by mechanical means.

It is known that early in the nineteenth century an attempt was made in Birmingham to simulate Chinese carving on fan-sticks by machinery, but it failed and the import of the hand-made articles continued until fans became unfashionable. Later, in about 1830, a sculptor named Benjamin Cheverton devised a machine for reproducing marble statuettes and busts on a small scale, and this was used successfully with ivory. Although quite a number of Cheverton's copies have survived, the cost of ivory was too great to justify production in any quantity.

The mid-nineteenth century revival of interest in early forms of art led to a large output of copies of ivories of all kinds, especially those of Gothic design. Many of them have acquired subsequently a deceptive appearance of age to the unsuspecting, and any example lacking adequate documentation must be treated with caution. A large proportion of the forged pieces are direct copies of famous originals, less well-known a hundred years ago than they are now, and one particular carver made so many imitations of ivories in the Trivulzio collection in Milan that he has earned himself a modest fame from being given the name of the 'Trivulzio Carver'. It is perhaps fortunate that this man and his colleagues in other countries made such slavish copies that their recognition by experts is therefore both possible and positive.

In other instances, Victorian carvers designed their own

pieces in the Gothic style, but it is found that period manner-
isms inevitably make their appearance. The typically-shaped
faces of the time, and details of dress and background
accessories, can be detected in most examples, and a careful
study and comparison of new and old will prove beneficial to
the collector.

The port of Dieppe, in northern France, was a centre of
· ivory-carving from about the fourteenth century, and John
Evelyn noted in his diary in 1644: 'It abounds with workmen
who make and sell curiosities of ivory . . .' Following the
bombardment of the town by the British and Dutch navies
in 1694 ivory-working, and much else, suffered a severe
setback and there was little activity until the nineteenth
century. All types of carving was done there, and a reputa-
tion was acquired for making small pieces of extreme
delicacy; tiny groups of figures and landscapes for framing
as wall-decoration or mounting in rings and brooches. At a
later date there was an outburst of activity in copying old
designs, and the market was flooded with reproductions of
early pieces of which most were of indifferent quality.

From Dieppe, also in the first half of the nineteenth cen-
tury, probably came over-praised figures of ladies wearing
voluminous skirts, the latter hinged at either side and open-
ing to reveal minutely-carved religious scenes. One of them,
a statuette of the Virgin, was purchased many years ago by
the Louvre and ascribed to a fourteenth-century craftsman.
Doubt was thrown on its genuineness, and it became the
subject of lengthy, scholarly and acrimonious dispute. More
mundane in appeal are similarly constructed figures which
disclose small-scale erotic spectacles.

Ivory-carving was practised in Spain from an early date
(see page 34), and then seems largely to have lapsed until
the sixteenth century. From that date onwards there was an
output of religious figures which cannot always be differen-
tiated from those made elsewhere. In neighbouring Portugal,
from the same time, there were made somewhat similar
figures to the Spanish. While many of them are neither well

modelled nor well finished, this does not excuse the present-day habit of labelling any poor-quality ivory 'Portuguese'. (Plate 8).

Turning, instead of carving, was a form of decoration found principally on cups or other objects suitable for lathe-work. Many came from the Nuremburg area where a speciality was made of such treatment, but in spite of their sophisticated appearance surviving examples are not always of professional workmanship. It was not unfashionable in the eighteenth and nineteenth centuries for a gentleman to have a lathe of his own, and books were published for his guidance with engraved plates of suitable 'engine-turning' and instructions on how to accomplish it. Eminent amateurs devoted to the hobby included Augustus, Elector of Saxony (1526–86) known as The Pious but described also as 'covetous, cruel and superstitious'; George William, Elector of Brandenburg (died 1640) and Maximilian, Elector of Bavaria (1573–1651), who employed Christof Angermair and gave him the position of Court Turner.

Bone was employed, especially in the eighteenth century, for making many simple domestic articles which fall into the category of 'bygones'. The bead-hung bobbins used for pillow lace, stay-busks, and apple-corers are among the many things for which it was used. Some were decorated but others were left quite plain, and have usually mellowed with age and use to a pleasing colour. Occasionally specimens were made of ivory.

Sometime during the course of the seventeenth century the etiquette requiring an artist to preserve a strict anonymity ceased to be enforced. From the same period it is found that there is less and less by which to distinguish the productions of one country from those of another; the growing ease of travel made it possible for many more artists to wander far from their native lands in search of inspiration and employment. Further, the widespread use of printing and the employment of the copperplate for illustration led to a general exchange of ideas and patterns. What was new,

say, in Rome on one day was to be seen imitated, and perhaps improved, in most other capitals before much time had passed.

Ivory-carvers are therefore not easily allocated to 'schools' or to particular countries, and are best treated as individuals; they were fewer in number than artists in most other media and many created recognizably personal styles. While most of the known names date from the seventeenth and eighteenth centuries, some carvers of earlier and later times have been recorded and together are listed alphabetically in the following chapter. It contains the names of most of the important men, a note of the years in which they flourished, the types of work in which they specialized, and other relevant details of their lives and artistic outputs.

6

SOME EUROPEAN CARVERS

ALESSANDRO ALGARDI, 1602–54, was born in Bologna but worked principally in Rome. Although known primarily as a sculptor in marble and as a rival to Bernini in that medium, he worked also in silver, bronze and ivory, and was architect of the Villa Doria Panfili for the nephew of Pope Innocent X. Algardi's ivories are said to have been carved in his younger days, and authentic specimens are very scarce. A Pietà by him was in the Palazzo Rospigliosi, and a crucifix from his hand is in a Munich church.

CHRISTOF ANGERMAIR was active during the first part of the seventeenth century, it is presumed that he died about 1633 but the date of his birth remains unknown. He was born at Weilheim (West Germany), and from 1618 to 1631 was Court Turner to the Emperor Maximilian I of Bavaria, at Munich. He carved a number of ivories for the princess Elizabeth of Lorraine, wife of the Emperor, and much of his most important work is to be seen in the Bayerisches Nationalmuseum. Included is a magnificent coin cabinet, of which almost every square inch is covered in plaques of carved ivory and the whole topped by an equestrian figure of the Emperor in Roman armour. A plaque, signed and dated 1616, of the Temptation is in the British Museum.

Angermair's work is characterized by his careful carving of the most minute detail without a loss of overall decorative effect. A plaque of the Judgment of Paris, attributed to him, in the Victoria and Albert Museum, is typically pleasing, both with regard to the grouping of its figures and the finish given to them and to the background.

MICHEL ANGUIER, 1612–86, who was born at Eu, to the

47

north of Dieppe and died in Paris, spent ten years of his life studying at Rome where he was under the direction of Alessandro Algardi. Although he worked in marble, he is recorded as having carved a figure of Christ in ivory in the year 1668.

JAKOB AUER, was an Austrian sculptor of whom little is known except that he worked in Vienna for most of his life, and that between the years 1697 and 1704 he carved a series of statues decorating the façade of the abbey of St Florian in Upper Austria. In the Victoria and Albert Museum there is a pair of groups by Auer representing the Immaculate Conception and the Assumption of the Virgin. They are composed of numerous tiny figures in full relief, designed and executed in a most distinctive manner.

JOHANN LEONHARD BAUR, 1681–1760, is said to have been born and died at Augsburg, but another account states that he came from Worms whence he proceeded to Augsburg. He made carvings in ivory, wood and mother-of-pearl, and is supposed to have worked for some time in Berlin. Two of his works are in the Victoria and Albert Museum, London. One, a group of a man and a woman, is signed *Leon Baur* 1716. It depicts the couple with a serpent at their feet, and perhaps represents Orpheus and Eurydice with the latter showing her husband the fatal serpent-bite on her foot (Plate 9). The other is of a boy, signed and dated 1710.

MAGNUS BERG, 1666(or 68)–1739, was born at Hedemarken in Norway and died at Copenhagen (Denmark). He came to Copenhagen at an early age and began by studying painting, but he turned to ivory-carving at which he became very successful. While he carved principally biblical and mythological subjects, he also made relief portraits of the Danish kings, and his large plaque of *The allegorical glorification of king Frederick IV* occupied three years before it was completely finished. While much of his work is in Rosenborg Castle, Copenhagen, specimens are to be seen in museums in other countries.

SILVANUS BEVAN, 1691–1765, was an apothecary, a

1. Leaf of a diptych probably made to celebrate a marriage which took place in Rome in about the year A.D. 400. The companion leaf is in the Musée de Cluny, Paris, and both were possibly carved in Rome at the time of the wedding. Height: 11⅝ in. *Victoria and Albert Museum.*

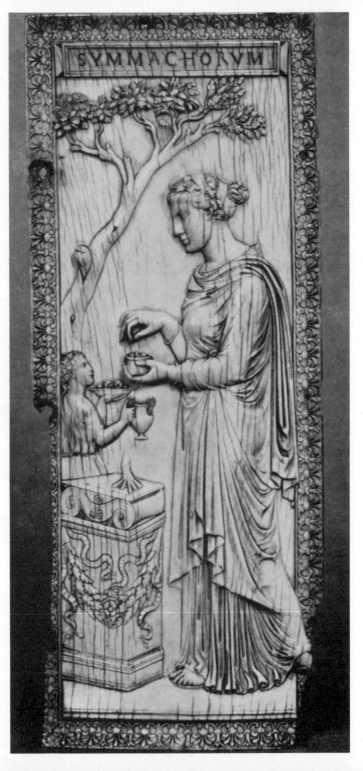

2. Panel carved with The Vision of
Ezekial. Byzantine, 9th or 10th century
A.D. Height: 5¾ in. *British Museum*.

3 (above). Triptych
bearing the coat of
arms of John Grandison,
Bishop of Exeter 1327–
69: the centre panels
depict The Virgin in
Glory and The
Crucifixion. English, 14th
century. Height: $9\frac{1}{2}$ in.
British Museum.

4 (left). Head of a
Pastoral Staff carved
with scenes from The
Nativity and The
Passion. English, 11th
century. Height: $4\frac{3}{4}$ in.
*Victoria and Albert
Museum.*

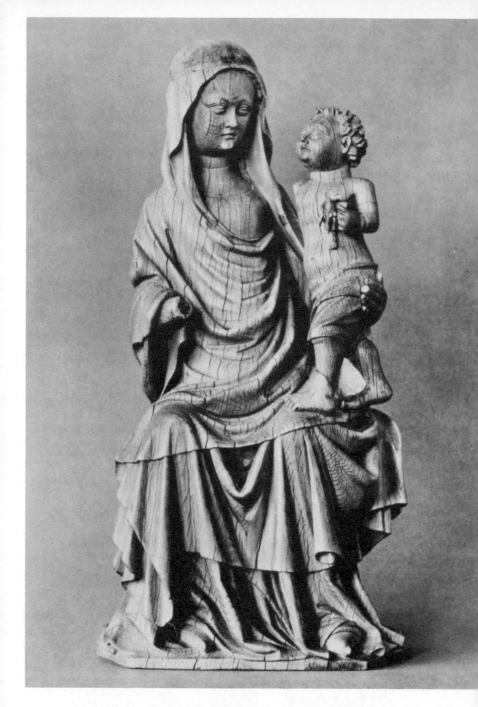

5. Group of the Virgin and Child. French, late 14th century. Height: 8 in. *Victoria and Albert Museum.*

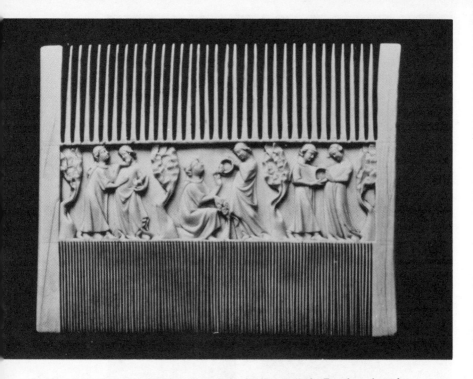

6 (above). Comb carved with lovers in a garden holding garlands. French, early 14th century. Height: 4 in. *Victoria and Albert Museum.* 7 (below). Mirror-case carved with lovers on horseback carrying falcons. French, early 14th century. Height: 4 in. *British Museum.*

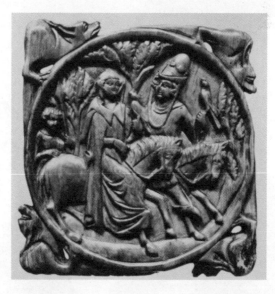

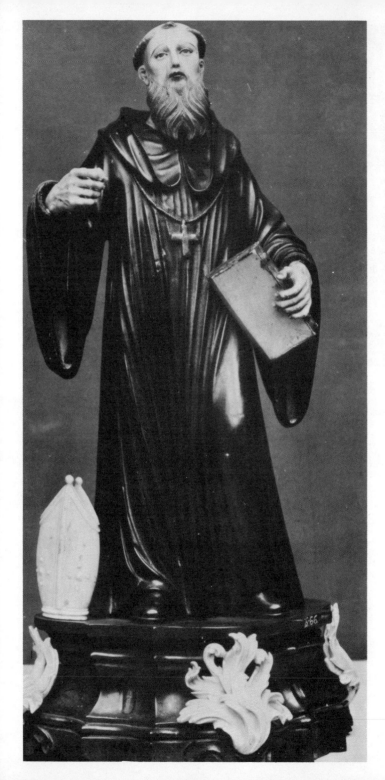

8. Ivory and ebony statuette probably representing Saint Anthony of Lisbon. Spanish or Portuguese, early 18th century. Height: 13½ in. *Victoria and Albert Museum.*

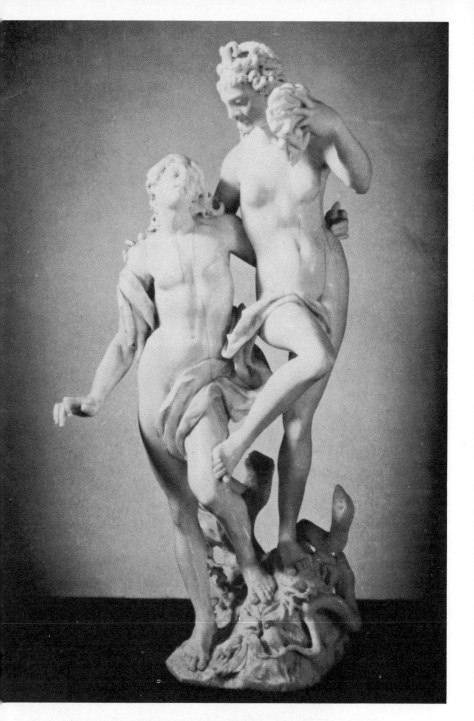

9. Group, probably representing Orpheus and Eurydice, signed by Johann Leonhard Baur and dated 1716. Height: 9½ in. *Victoria and Albert Museum.*

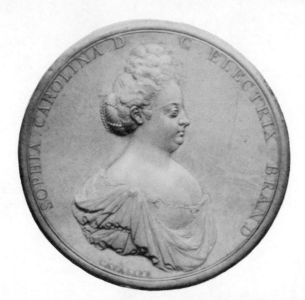

10. Portrait of Sophia Caroline, Electress of Brandenburg (1668–1705), signed by Jean Cavalier, late 17th century. Diameter: 3½ in. *British Museum.*

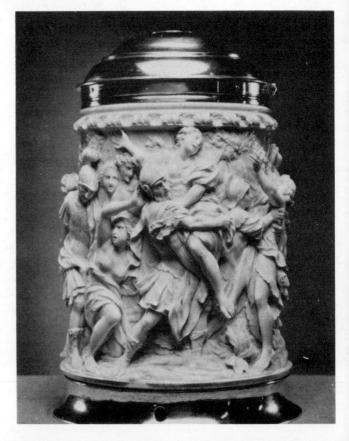

11. Silver-mounted tankard carved with the Rape of the Sabines, by Ignaz Elhafen. *C.* 1700. Overall height: 8¼ in. *Victoria and Albert Museum.*

12. Casket of wood inlaid *alla certosina* and inset with carved plaques of bone in the manner of Baldassare degli Embriachi. North Italian, 15th century. Height: 12½ in. *Victoria and Albert Museum*.

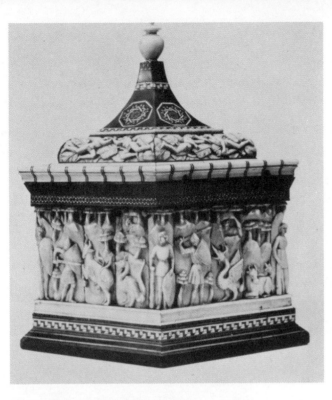

13. Sir Isaac Newton (1642–1727), carved by David le Marchand. Signed and dated 1718. Height: 9¾ in. *British Museum*.

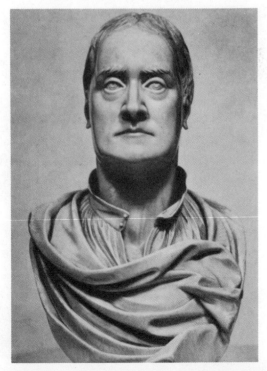

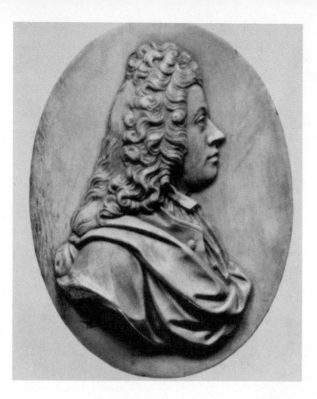

14. Portrait relief of an unknown gentleman, signed D. L. M. By David le Marchand (1674–1726). Height: 5 in. *British Museum*.

15. Armchair of wood veneered with ivory. Mysore, India, late 18th century, in the English style of the time. Height: 36¾ in. *Victoria and Albert Museum*.

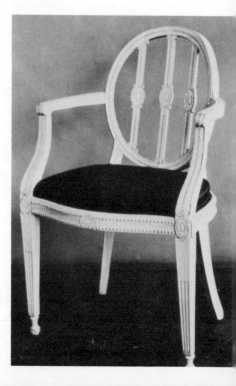

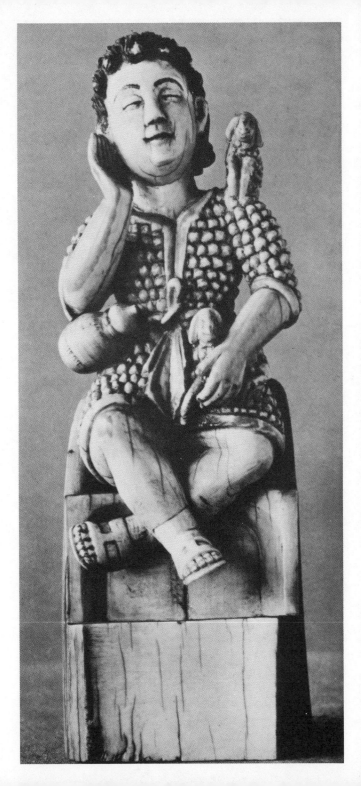

16. Figure of the Good Shepherd. Goa, India, 17th century. Height: 6½ in. *Victoria and Albert Museum.*

17 (above). Casket made for Caliph al-Hakam II (961–976). Hispano-Moresque, made by Arab craftsmen working in Cordoba, Spain, *c.* A.D. 970 Diameter: 4 in. *Victoria and Albert Museum.*

18 (left). The astrologer, Liu Po-Wen. Chinese, early 19th century. Height: 17¼ in. *Graves Art Gallery, Sheffield Corporation.*

Quaker, and an amateur carver of portraits. His religious beliefs brought him in contact with a number of eminent persons, and of some of them he carved likenesses that are important. He is known to have made at least thirty portraits, some in honestone and some in ivory, but the majority of them have been lost. His portrait of William Penn, the founder of Pennsylvania, was 'said to be a good likeness', and is the only reliable representation of the man. Bevan's portrait of Dr Richard Mead (1673–1754), the most eminent physician of his time, is in the British Museum. This, the portrait of Penn, and some others, were used by Josiah Wedgwood as models for his jasperware plaques of the sitters.

GIUSEPPE MARIA BONZANIGO, 1744–1820, was born at Asti, worked for all his life in Turin and died in that city. He used both wood and ivory on a small scale, and is known for his renderings of foliage, and 'for portraits framed with allegorical and emblematic designs of minute execution'.

FRANÇOIS BOSSUIT (or Bossiot) 1635–92, was born at Brussels and died at Amsterdam, but spent most of his life in Italy and Holland. Some of his work was engraved in a book published by Matthys Pool in Amsterdam in 1727, entitled: *Cabinet de l'Art de Sculpture par le fameux Francis van Bossiot, executé en yvoire ou ébauché en terre*; which illustrates pieces of many types. One shown there, a panel carved in relief with the 'Toilet of Bathsheba', is in the Wallace Collection in London, and in the Musée de Cinquentenaire at Brussels is a Crucifixion. At the Amsterdam Museum are two reliefs of 'Music' and 'The Death of Adonis', and there are two further reliefs, 'Apollo and Daphne' and 'Mercury and Psyche' in the Brunswick Museum. The rare surviving examples of Bossuit's work show him to have been an artist of importance, and he must have had a considerable reputation in his lifetime to have merited a publication devoted to his work thirty-five years after his death. The fact that the title-page refers to him as 'the famous Francis van Bossiot' would seem to confirm this.

JEAN CAVALIER (or Chevalier, or Cavailer) is an ivory-carver of whom perplexingly little is known beyond the facts that he flourished during the second half of the seventeenth century, and that he worked in Germany, England, Sweden and Denmark. It may be assumed from his name that he was a Frenchman, but there seems to be no record that he did any work in that country. He is supposed to have died while on a voyage to Persia in 1698 or 1699. A finely-carved medallion signed *I.C.* and dated 1693 is in the Victoria and Albert Museum, London. It depicts Ulrich Friedrich Guldenlöwe, a Norwegian Count. (Plate 10).

BENJAMIN CHEVERTON 1794–?1876, invented in 1828 a machine for making copies, of the same size or on a small scale, of carvings in marble and other materials. For small-scale copies sometimes, but not invariably, he used ivory and his work is usually inscribed *Cheverton Sc.* together with the name of the sculptor of the original. The machine with which he made his copies is in the Science Museum, South Kensington.

He displayed some of his work at the Great Exhibition of 1851. The entry in the Official Catalogue reads: 'Statuettes, busts, and bas reliefs, in ivory, alabaster, marble and metal; carved by a machine from originals of a larger size. Those in ivory and marble not finished by hand'. The final sentence is interesting in view of the fact that this has been doubted, and one modern writer asserted: 'the busts were apparently worked over by hand by Cheverton as they show little, if any, trace of mechanical aid'.

JOSEF DEUTSCHMANN, 1717–82, was born at Imst, in the Tyrol, and died in the German town of Passau. Examples of his well-executed work are to be seen in churches in the vicinity of Passau.

FRANÇOIS DUQUESNOY, known as 'Il Fiammingo'— the Fleming, 1593–1643. He was born in Brussels and died in Leghorn, but worked principally in Rome whence he came in 1618. He made not only ivory-carvings, but modelled in wax, bronze and terra cotta, and executed the giant statue

of St Andrew under the dome of St Peter's. He was a prolific worker and was famous in his day, and for long afterwards, for his small reliefs and statuettes in many materials; a fact recalled more than a century after his death by a passage in the biography of the English sculptor, Joseph Nollekens, R.A. It relates a conversation that took place between him and Panton Betew, a silversmith and dealer in works of art, when they met in an auction room. 'Nollekens. "What do you want for that model of a boy? I suppose you have got it still?" Betew. "Why now, why can't you say Fiammingo's boy? You know it to be one of his, and you also know that no man ever modelled boys better than he did:—it is said that he was employed to model children for Rubens to put into his pictures". Nollekens. "Well, what must I give you for it?" ' Betew asked fifteen shillings, but after some slight argument took Nolleken's offer of ten.

Earlier, when he was in Rome in 1644, John Evelyn visited the Villa Borghese where he saw the statue of the so-called *Fighting Gladiator* (in fact a *Warrior* and now in the Louvre), he noted that it was the original of which he had bought in Italy a small version in ivory, 'copied by that signal artist, Hans Fiammingo, esteemed one of the best statuaries in the world'.

Fiammingo did not sign his work and identification can be only tentative. Six ivory plaques in the Victoria and Albert Museum have long been known as the *Fiammingo Boys*, are sometimes assumed to have been carved by him, and have in their favour the fact that they have been taken from his designs. They show typical groups of cupids and child centaurs in Bacchanalian scenes: binding the sleeping Silenus, playing with a donkey and with a goat, making wine, being suckled by a she-goat, and fighting and drinking. In view of the quality of the design and workmanship of his known marbles, it is disappointing that so little positive information is available about his ivory carvings.

FRANÇOIS DUSART, or de Waal or Walloni, was born early in the seventeenth century and is assumed to have died

about 1661. He worked in Rome, and then went to London where he was employed in restoring ancient marbles for Charles I. After 1646 he was in Holland and working for the Prince of Orange. Two ivory statuettes by Dusart are in the Victoria and Albert Museum, they represent Henri IV of France and Frederick-William, Elector of Brandenburg.

IGNAZ ELHAFEN (or Oelhafen) is said to have been a native of Bavaria and to have lived from about 1650 to about 1700. He worked in Rome and Dusseldorf, and in Vienna whence he was summoned by the Elector. Much of his work, distinguished by excellent modelling and a liking for nymphs and satyrs, is to be seen in the Bayerisches Nationalmuseum, Munich, and at Karlsruhe is his 'Augsburg Clock' dated 1697. This is in the form of a tall cup carved with satyrs and surmounted by a cupid.

A plaque by Elhafen in the Wallace Collection, London, is carved in high relief with Pan teaching a nymph to play the pipes, and is based on a composition by the Italian painter and engraver, Giovanni Castiglione. Also in London, at the Victoria and Albert Museum, is a fine tankard, carved with a spirited rendering of the Rape of the Sabines, and two plaques depicting the Nursing of Jupiter by Amalthea and the Death of Cleopatra. All three bear Elhafen's signature. (Plate 11).

BALDASSARE DEGLI EMBRIACHI founded a school of carvers working in North Italy and Venice at the end of the fourteenth century and during the first half of the fifteenth century. They used ivory on occasions, but more typical work was executed by them in narrow lengths of bone set together to form large panels. An altarpiece made in this distinctive manner, measuring three feet in height and no less than six feet in width, is in the Victoria and Albert Museum. There are comparable examples in Paris and New York, and others remain in the Italian churches for which they were made originally.

The work of the Embriachi was probably once coloured and gilded, mounted in wood frames inlaid with stained

woods and ivory, and their effect must have been both striking and decorative. Today only faint traces, if any, of the colours remain, and we can only imagine how they appeared when they were made. (Plate 12).

ANDREAS FAISTENBERGER, 1647–1736, was a member of a large family of Tyrolese artists, many of whom were born at Kitzbüel. His father was also named Andreas, but he and most of the other Faistenbergers were painters. Andreas II, the carver, worked in stone, wood and ivory, and much of his work is to be seen in churches in Munich. A fine crucifix exhibited at Lille in 1874 belonged to the archbishop of Tours, and bore the initials *A.F.* and date 1681.

LUCAS FAYDHERBE (or Fayd'herbe) 1617–97, was born and died at Malines, in Belgium. He was a pupil of Sir Peter Paul Rubens, and a surviving document written by the painter refers to the fact that Faydherbe had carved an ivory statuette of the Virgin, 'in my studio, alone and no one aiding him, for the church of the Béquinage at Malines', and added that it was a 'morceau d'une beauté ravissante.' Although Rubens died when his pupil was only twenty-four, the influence of his master is said to have persisted so that any ivory carving incorporating Rubens-like women and children in its design is assigned automatically to Faydherbe. The fact that no signed examples are known has made identification of his work debatable.

AMBROSE GALLE worked in Antwerp, where he died in 1755. The date of his birth is not recorded. Signed examples of his ivory carving are known.

CHRISTOF HARRICH worked at Nuremburg in the second half of the sixteenth century, but very little is known about his life. He specialized in making pieces that are considered morbid at the present time, but were once very fashionable. They are accurate representations of a human skull usually contrasted with one or more of the frivolities of life; a reminder of the shortness of our stay on earth. Of this fact we seem to be more aware than our ancestors, and have little need of symbolic reminders. A *memento mori*

(translated as 'Remember you must die') by Harrich is in the British Museum, and takes the form of an ivory skull with a human head placed at the back of it. It is mounted in gold decorated with enamel.

LEONHARD KERN, 1588–1662, was born at Forchtenberg and died at Hall, near Stuttgart. He lived in Italy for five years, and worked in a number of places in Germany before settling finally at Hall (Schwäbisch-Hall) about 1620. He worked in marble and wood as well as in ivory and used a monogram for his signature, but his work is rare. He was one of the more important German sculptors of his time.

WILHELM KRÜGER of Danzig worked during the eighteenth century, and is known to have been in Dresden in 1715. He used the technique, perfected by Simon Troger, of combining wood and ivory, and made a speciality of figures of peasants and beggars. One of his beggars, shown with a wooden leg and a crutch, was copied in porcelain at the Fürstenburg factory.

ADAM LENCKHARDT, 1610–61, was born at Würzburg and died at Vienna. For some years he is said to have been occupied in making objects for the Lichtenstein Museum of Curiosities, and an inventory of the collection describes eleven ivory statuettes by Lenckhardt. They include one of Sebastian, of which there is another example in the Museum für Kunst and Gewerbe, Hamburg, attributed to the same carver. A small plaque carved with The Lamentation and signed by Lenckhardt, is in the Victoria and Albert Museum, and there are other signed works by him in the Metropolitan Museum of Art, New York.

RICHARD COCKLE LUCAS, 1800–83, was born at Salisbury and died at Chilworth, near Winchester. He was a most versatile artist; engravings, watercolours, waxes, sculptures and carvings flowed from his studio during his long life. Two scale models of the Parthenon, one showing it in its original state and the other after the explosion of 1687, were made by Lucas and are in the British Museum. At the Great Exhibition of 1851 he showed eighteen ivories,

which included biblical and mythological subjects and 'the seal of Richard, Bishop of Durham'. A collection of his works in ivory may be seen in the Bethnal Green Museum, London, to which the artist presented them.

Richard Cockle Lucas is remembered also in connection with the purchase in England by Dr Wilhelm von Bode, Director of the Kaiser Friedrich Museum in Berlin, of a wax figure of *Flora* for which, it was alleged, he paid the sum of £8,000 in the belief that it was by Leonardo da Vinci or one of his school. It was found that it had once been in the possession of Lucas, and a theory was put forward in the press that he had actually made it, using as a model a painting of *Flora* attributed to da Vinci. Although the sculptor's son concurred in this suggestion, it is not accepted generally as having been fully proved.

JOHANN CHRISTOF LUDWIG LÜCK (or Lücke) was a member of a family from the Dresden area of which several were ivory carvers. Johann Christof, who died in 1780, probably had the most interesting and varied career of any of them. Although he was a sculptor he worked chiefly in ivory, and a portrait of George II which he exhibited in London in 1760 is now in the Victoria and Albert Museum. He spent much of his lifetime working in porcelain factories, which included those at Dresden (Meissen) and Vienna. At the former he held the post of chief modeller from April 1728, but was dismissed after only six months. Almost equally short-lived was his stay in Vienna, where he described himself as 'principal director of the whole factory'. This exalted position he was able to enjoy for no more than a year from 1750, after which he continued his journeyings.

DAVID LE MARCHAND, 1674–1726, was born at Dieppe, and spent most of his life in England. He carved mythological groups, but is better known for his excellent plaques and busts. His likeness of George I, in the British Museum, bears the signature *Le Marchand, carved from life*, but some of his other pieces are marked with the initials DLMF for David Le Marchand Fecit. A group of Venus and Cupid in

the Victoria and Albert Museum is signed at the back of
the base *D. Le Marchand Scul.*

Le Marchand carved a fine bust of Sir Isaac Newton,
dated 1718, in the British Museum, and one of John Flam-
stead, first Astronomer Royal, dated the following year and
now at the Royal Observatory, Greenwich, but it is excep-
tional to find dates on his work. (Plates 13 and 14).

CHRISTOF MAUCHER, 1642–?1705, was born at
Schwäbisch-Gmünd and died probably at Danzig, but there
would seem to be few recorded details of his life and career.
A group by him in the Vienna Museum has been described
by one writer, who says: 'one feels that the degradation of
art could scarcely descend lower than in this curious mixture
of bewigged princes, holy figures, stars and masks, conglo-
merates of cherubs, trumpet-blowing angels, scrolls and
garlands.' Although it is pointed out that such juxtapositions
were not unusual in other works of art of the period, it would
seem clear that the writer lacked sympathy for it.

JOHANN MICHAEL MAUCHER, 1645–?1700, was born
at Schwäbisch-Gmünd and died at Würzburg in Southern
Germany. Probably he was a relative of the preceding.
According to one authority he made, amongst other things,
large ewers and dishes which were intended for decoration
rather than use, and were composed of many separate pieces
of ivory built up until the size of the article was reached.
Maucher then proceeded to cover every square inch of the
surface with carving, 'with the fixed idea, apparently', a
critic has remarked, 'of leaving no space unoccupied'. A fine
ewer attributed to him, in the Victoria and Albert Museum,
is boldly carved round the body with figures in high relief
and has the handle in the form of a winged caryatid.

BALTHASAR PERMOSER, 1651–1732, worked at a num-
ber of places including Florence, Berlin and Dresden, and
at the latter he died. He was an important sculptor, and
occasionally used ivory. A crucifix by him is in the Brunswick
Museum, and a pair of small figures of Spring and Winter
is in the Germansiches Museum, Nuremburg. Much of

Permoser's sculpture in marble is to be seen on buildings and in gardens at Dresden.

GEORG PETEL, ?1590–?1634, was born at Weilheim and died at Augsburg, where he carried out most of his work. After travelling to Flanders and becoming acquainted with Rubens, he settled in Augsburg and carved in wood as well as in ivory. There is an important ivory crucifix and a statuette of St Sebastian by him at Munich, and a salt-cellar incorporating a figure of Venus rising from the Sea at the National Museum, Stockholm. An exhibition of Petel's work was held in 1964 at the Bayerisches Nationalmuseum, Munich.

PIETRO PIFFETTI, 1700–77, was not an ivory-carver, but is included here because he made a considerable use of ivory in the furniture for which he is famous. He is the best-known of Italian cabinet-makers and worked for the King of Sardinia, Charles-Emmanuel III, at Turin, where many of his best pieces are to be seen. His use of panels of engraved ivory and other materials increases the exuberance of his designs, which have been criticized as 'undisciplined' but are certainly individual. Much of his furniture is signed with his name, often found on the edge of a drawer. Piffetti was buried in the crypt of Turin Cathedral.

GIOVANNI PISANO, ?1250–?1330, was an architect and sculptor who worked in many Italian cities after studying under his father, also an architect, Niccola Pisano. His name is connected with the building of the Campo Santa at Pisa, the Cathedral at Siena, and the church of St Domenico at Perugia. Although it is much restored, his ivory Madonna and Child in the Cathedral at Pisa is an important thirteenth-century carving.

MATTHIAS RAUCHMILLER (or Rauchmuller), 1645–1686, was a versatile Austrian who worked as a sculptor, engraver, painter and architect. His ivory carvings of the Rape of the Sabines and Proserpine and the Centaur are to be seen at Munich. He died in Vienna, where there is his version in ivory of Bernini's group of Apollo and Daphne.

REEVES. In April 1652 John Evelyn noted in his diary

that he paid a visit to a man of this name, who was 'famous for Perspectives, & turning curiosities in Ivorie'.

ROSSET. Three members of the family in south-east France were prominent as ivory-carvers: Joseph (known also as Du Pont) ?1703–86 was assisted by his sons and pupils, Jacques 1741–1826 and Antoine 1749–1818. The father is known for some fine crucifixes and religious statuettes, and either he or his sons carved likenesses of Voltaire, Rousseau, Montesquieu, Buffon, d'Alembert and other famous men of their time.

They made also snuff-boxes and other articles bearing medallions of celebrities. Examples of their work may be seen in several French museums—an ivory figure of St Teresa is in the Louvre—and a marble bust of Voltaire is in the Victoria and Albert Museum, London.

FILIPPO SENGER. A worker in ivory about whom little appears to have been recorded. He was certainly active towards the end of the seventeenth century, and a cup and cover by him in the Victoria and Albert Museum is the source of some information concerning its maker. It is inscribed under the base: FIL . SENGER . TORN . DEL . S . G . D . DI . TOSCANA . INVENT, and inside the cup: *anche la figura fatta al torna*. The first gives the name of the maker and adds that he was Turner to the Grand Duke of Tuscany, and the second refers to the fact that not only were the bowl, base and cover turned on the lathe, but the figure supporting the former was made in the same manner.

Turned work in ivory and other materials was popular in the seventeenth century and later, and a number of workers in southern Germany specialized in the art. Judging from his surname, it is not improbable that Senger was a German.

STEPHANY and DRESCH, who called themselves 'Sculptors in miniature in ivory to Their Majesties', and give their address as 107 Jermyn Street, London, specialized in fine work at the end of the eighteenth century. A signed example, giving the above information, is in the Bullock Collection, at Bristol City Museum.

BALTHASAR STOCKAMER. A late seventeenth century ivory-carver who died at Nuremburg. As is the case with so many others who followed the same calling, few details of his life have been preserved, but it is known that he was patronized by members of the Medici family. Stockamer carved a striking crucifixion scene in the Palazzo Pitti, Florence, where there is also a group by him of Hercules killing the Hydra.

BERNHARD STRAUS was a mid-seventeenth century Augsburg craftsman, by whom there is a large silver-mounted tankard in the Victoria and Albert Museum. It is carved round the body with mythological figures and the hinged lid bears a group of Hercules killing the Centaur. The drum is signed *Bernard Straus goldschmid fec.*, and the group is dated 1651 followed by an inscription reading: *Bernard Straus Godschmidgesel, Von Marckhdorf am Bodensee, Fecit, A, Vinde.* He is said to have worked in ivory, wood and silver, and there are other signed ivories by him in the Rijksmuseum in Amsterdam and in the Kunsthistorisches Museum, Vienna.

MARTIN TEUBER (J. M. von der Teuber) was a skilful exponent of the art of ivory-turning. He wrote a book on the subject, *Vollstandiger Unterricht Drehkunst,* published in 1730.

JOSEPH TEUTSCHMANN, 1717–87. A German ivory-carver by whom there is the head of a pastoral staff in the Victoria and Albert Museum, and another in the Bayerisches Nationalmuseum, Munich. The London example is finely carved with cherubs, one of which wears a mitre, and bears the coat-of-arms of Theobold Ritlinger, Abbot of the Cistercians of Aldersbach, in Lower Bavaria. It was purchased in 1855 by the Museum of Ornamental Art at Marlborough House, forerunner of the Victoria and Albert Museum, at the dispersal of the large collection of works of art formed by Ralph Bernal, M.P. The auction sale lasted for thirty-two days, and realized a total sum of about £70,000; a big figure for such an event more than a century ago.

SIMON TROGER, ?1693–1769, was born at Abfaltersbach in Austria and died at Haidhausen near Munich. Between 1723 and 1725 he studied at Innsbruck under Nikolaus Moll,

the sculptor who, in turn had probably been a pupil of Balthasar Permoser. Troger then worked in Munich with Andreas Faistenberger.

Simon Troger made groups in which wood was used together with ivory, and as a result he was able to work on a much larger scale than would have been possible if he had used ivory alone. He employed the latter for rendering heads, flesh and parts of costume, which contrasted with darker woods in other parts of his work. Eyes were of coloured glass. He achieved a remarkable realism by this juxtaposition of light and dark materials, which he contrived with brilliance.

A group of The Judgment of Solomon at the Victoria and Albert Museum is described as 'quite the finest and most sumptuous example of his work known'. It is carried out in ivory and walnut, and the figures are placed on a base of rosewood and satinwood. Other examples of his work are to be seen in Munich and at the Residenz, Würzburg.

GASPAR VAN DER HAGEN (or Vanderhagen). Some of the little known information about this carver, who worked in both marble and ivory, was recorded by George Vertue, the eighteenth century antiquary. Vertue stated that Van der Hagen worked for Michael Rysbrack and 'has done several head portraits in ivory very well, but not meeting with proper encouragement, did not continue'. He exhibited an ivory bust of the Duke of Cumberland at the Free Society of Artists in 1767, which is now in the Victoria and Albert Museum. The latter is derived from Rysbrack's marble bust at Windsor Castle, and it seems feasible that it should have been used as a model by a pupil of the sculptor.

In his will, Rysbrack left the sum of £50 to 'Gasper Vanderhagen, Statuary, who did live with me', but the master outlived the student and a codicil directed the money elsewhere. It is assumed that Van der Hagen died in 1775, in which year a pension he received from the Royal Academy ceased to be paid.

GERARD VAN OPSTAL, ?1597–1668, was born at Antwerp, and his work was influenced strongly by his fellow-

citizen, Peter Paul Rubens. Van Opstal went to Paris in 1643, and after a few years became sculptor to the king, Louis XIII. He carried out much work in French palaces, and some reliefs in marble and in ivory made by him for the Louvre are still in that building. Two of the ivory examples bear his signature, and from these a number of comparable pieces have been attributed to him. All depict fat, Rubens-like children, usually playing with one or more goats, some of the former with wind-swept hair which is said to be a typical feature of his work.

In the Wallace Collection, London, is a pair of reliefs attributed to Van Opstal, each composed of two standing boys or cupids. Other works perhaps carved by him are in a number of Continental museums.

JAKOB FRANS VERSKOVIS (or Verscovers). George Vertue, the eighteenth century antiquary recorded the following details about the life of Verskovis: 'An excellent carver in ivory, born in Flanders, but settled at Rome, where he was so much employed by English travellers, that he concluded he should make a fortune in England: he came over—and starved. He executed whole figures in small, and vases with perfect taste and judgment, and carved also in wood. He had a son who to the same arts added painting, but died young in 1749, before his father. The latter did not survive above a year.' Confusingly, Horace Walpole added a note to his edition of Vertue's *Catalogue* stating that Verskovis senior was reported as having died in 1744.

On July 11th, 1743, Walpole wrote from his town house in Arlington Street to Sir Horace Mann, his friend and the British envoy in Florence: 'I have a new cabinet for my enamels and minatures just come home, which I am sure you would like: it is of rosewood; the doors inlaid with carvings in ivory.' Almost one hundred years later, in 1842 and long after he had died, the contents of Walpole's country seat, Strawberry Hill, near Twickenham just outside London, were dispersed by auction. Lot 66 on the fifteenth day was described as 'A splendid cabinet of rosewood, designed by

Horace Walpole', and after lengthy particulars concluded by stating in italics: '*It is perfectly unique and as a work of art may be pronounced matchless.*'

The cabinet was sold for £126, and after an interval of about eighty years it found a permanent home in the Victoria and Albert Museum. It may be mentioned that both Walpole and the auctioneer were at fault in describing it as being made from rosewood, as it is actually of kingwood. The mistake is pardonable, because the two timbers often closely resemble one another in appearance.

The ivories ornamenting the cabinet comprise eighteen Italian plaques carved in relief inset in the doors, at the base a small plaque and two heads of eagles which hold festoons of carved wood flowers and at the top a carving of a cupid and a lion with the Walpole coat of arms. The pediment above the whole bears three well-executed ivory figures of bearded men, described by their original owner as being of Andrea Palladio and Inigo Jones, the architects, and Fiammingo, the sculptor (see François Duquesnoy, page 50), all of them the work of Verskovis after statues by Michael Rysbrack.

A further error of description by Walpole, this time regarding the three statues, has been indicated in her book on Rysbrack by Mrs M. I. Webb. She points out that one of the figures is not that of Palladio, who was clean-shaven, but almost certainly depicts Peter Paul Rubens. The men therefore represent Architecture, Sculpture and Painting: an appropriate trio to surmount a cabinet designed to contain works of art.

7

AFRICA

BECAUSE the elephant has always been indigenous to the country, its tusks must have been treated as comparatively commonplace in Africa. On the other hand, there was mystery inherent in the awe-inspiring bulk of the animal itself, and in the ignorance of its habits. Tusks might be found accidentally wherever one of the creatures had lain down to die, and this often made the acquisition of ivory simpler than that of wood.

The huts of many leading tribesmen had door-openings formed of large tusks, and some of those brought back to England were said to be 'covered with congealed blood and have probably figured in many a dreadful Ju-ju ceremony'. Although numerous other Africans carved ivory into forms suitable for display or for use, the Bini centred on Benin City, now in Nigeria, were foremost in their use of the material. Their fine craftsmanship and sense of design were virtually unknown in Europe until 1897, when a British punitive expedition captured and plundered the city in retaliation for the massacre of an official party journeying to meet the King of the country. Much of the loot taken on that occasion, bronzes as well as ivories, is now to be seen in the British Museum.

Benin carved ivory masks, the most striking and scarce of the work in this material, vary in length from nine to ten inches, and combine a realism of features that contrasts with the surrounding ornament; based on patterns of plaited straw and strangely Celtic in feeling. Some have additional decoration of copper wire, and all were inlaid at one time with pieces of iron to represent forehead tattoo-marks,

Fig. 7. Benin armband carved with Europeanized
figures. Height: 5 in.

eyelids and the pupils of the eyes, but this latter has rusted
away long ago. They were made for wearing on the breast
on ceremonial occasions, and the known examples were all
found in a box in the bedroom of King Ovonramwe. A fine
example is in the British Museum, another is in the Museum
of Primitive Art, New York, and the last one to be sold by
auction in London realized more than £6,000 (See Frontis-
piece).

Other Benin carvings take the form of armlets, staff

handles, head rests and long tusks, most of which exhibit noticeable signs of the influence of the Portuguese traders who had had contact with West Africa since the fifteenth century. Almost all these pieces show European as well as African figures; the former, Portuguese with bows or muskets and wearing appropriate European clothing.

At one time confused with the Benin examples were a number of covered bowls (perhaps salt-cellars), horns and other pieces. Finely carved with African figures and European motives, some bear the coat-of-arms of Portugal and all have features indicating a common source. Probably they were made to the order of Portuguese traders in one of the many African ports at which they did business; equally, however, it has been suggested that they were carved in Portugal by natives, but this is perhaps hair-splitting. Whatever the source, it remains obstinately unidentified at present, and an important group of the pieces may be seen at the British Museum where it is labelled 'Afro-Asian'.

The Benin ivories date back to the seventeenth and eighteenth centuries, if not earlier, but the widespread interest evinced in them during the past sixty years has brought forth innumerable copies. Few exhibit qualities comparable with those to be found in the genuine pieces, but the latter are now so rare that any undocumented specimen should be viewed with caution.

8

INDIA AND GOA

IVORY was used from the earliest times, as might be expected in a country where the elephant was indigenous in some parts. Very few pieces older than the seventeenth–eighteenth centuries are to be seen outside India; the art of the country has never had for Europeans the wide appeal of that of China. Indian carvers used similar styles to those employed in sculpture, and among their work may be mentioned typical pierced panels of interlaced design used for the making of caskets, and the sandalwood boxes with ivory inlay from Bombay.

Some plaques dating from A.D. 240 used for decorating wooden cosmetic boxes and other articles, were made in Begram, Afghanistan, and are remarkable for their superb carving of female figures. It has been suggested that these may be counted among the most beautiful ivories in the world, but few are to be seen in the West. There are some examples in the musée Guimet, Paris.

Travellers from India have for long returned with neatly-carved figures of natives at work, bullock-carts, and similar miniatures made expressly for the tourists. Of better execution are figures of elephants carved from a single piece of ivory and sometimes mounted in silver or gold. The latter, in the form of trappings and a howdah, sometimes set with rubies, sapphires, pearls and other stones to form a sumptuous *objet d'art* rivalling the work of Fabergé.

In the same way as Europeans sent or took specimens of china and silver to the Far East and had them copied by craftsmen in China and elsewhere, they took furniture with like intent and some of this was imitated in India in ivory.

Some surviving examples of this rare Anglo-Indian form of artistic co-operation are well documented and their stories are interesting.

A fine and extensive set of ivory furniture at Buckingham Palace, the property of Her Majesty Queen Elizabeth II, comprises settees, chairs and two cabinets, copied from mid-eighteenth century English mahogany originals with typical interlaced and pierced backs and with ball and claw feet. They are made of Indian sandalwood veneered with engraved ivory, and were ordered in Madras in about 1770 by the Governor of Fort St George. The Governor brought them with him when he returned to England, and when he died in 1781 the contents of his house were put up for auction by James Christie. Prior to the sale, King George III and Queen Charlotte happened to pass the house and were shown the furniture. As a result, it was bought for the Queen, and on her death in 1818 re-sold by the same auctioneer. This time the purchaser was the Prince Regent who had the suite placed in the Chinese Gallery of his Pavilion at Brighton, whence later, it was brought to London.

Some ivory armchairs and a table are in the Victoria and Albert Museum, but these were made in Mysore, the adjoining state to Madras. They belonged originally to the Sultan, Tippoo Sahib, and were taken at the fall of Seringpatam in 1799 by the elder brother of the Duke of Wellington, Lord Wellesley. He gave them to Queen Charlotte, on whose death they were sold with the foregoing set. The armchairs and table were bought by John Jones, the former for £600 and the latter for £350, who gave them with his fine collection of furniture and works of art to the museum. (Plate 15.)

A table and four ivory chairs, also from Seringpatam, may be seen in Sir John Soane's Museum, Lincoln's Inn Fields, London. It is probable that these also belonged in turn to Queen Charlotte.

Anglo-Indian ivory furniture copies most of the furniture styles of the later eighteenth century. Examples in

recognizable imitations of the designs of Chippendale, Adam and Sheraton have been noticed, often with the carved ornament of the originals simulated by engraving or gilding. The tradition of making ivory seat-furniture in India continued into the nineteenth century. At the Great Exhibition of 1851, Queen Victoria 'graciously permitted the presents of the Nawab Nizam of Moorshebad, and of the Rajah of Travancore, to be exhibited in the Indian department'. These included an ivory howdah with gold and silver elephant trappings from the former, and from the latter 'a splendid ivory chair of state, with footstool, beautifully carved and jewelled'. The latter is illustrated by a woodcut in the *Official Catalogue*, and would seem to merit a share of the comments of a modern writer who referred to a suite of ivory armchairs and a chess table, also shown in 1851, in these ringing words: 'If an attempt were purposely made to show to what depths of vulgarity and bad taste art could be made to descend, together with a waste of a valuable and beautiful material, it would be difficult to succeed better than has been done with these astounding specimens.'

The former Portuguese settlement of Goa on the west coast of India was captured by Albuquerque in 1510, and soon became the most important of Portugal's oversea possessions. It was an ecclesiastical headquarters for missionaries who travelled to all parts of Asia, and in 1557 it was made a bishopric with jurisdiction over the seas of Malacca and Cochin, to which were added in time Macao, Japan, Pekin and Nankin, and the entire coast of East Africa including Mozambique. It was stated in 1774 that earlier in that century the number of ecclesiastics in Goa had reached the astounding total of 30,000; possibly the remark of a spiteful imagination.

The archbishop received the title of Primate of the East, the king of Portugal was named Patron of the Catholic Missions of the East, and Goa was described as 'Rome in

India'. Thus, it is hardly surprising that it was the seat of a considerable industry in carving ivory statuettes of religious figures. Most of them have a cast of feature that draws attention to the fact that in spite of their subjects they are not the work of Europeans. (Plate 16.) Many that were made in the eighteenth century and later proclaim that quantity rather than quality was considered important by the makers; many are so poorly finished and could only have been carved so crudely in a land where ivory was a comparatively cheap material.

While many of the Goanese ivories must have been sent to all parts of Asia where Portuguese missionaries had made converts, others doubtless went to Europe. While good early examples are rare, the later figures are all too commonly found and only rarely described correctly as to their country of origin. Furniture made from ebony and inlaid with ivory was also made in Goa.

9

ISLAM

VERY FINE ivory carvings were executed by groups of craftsmen in the Islamic countries, and these were responsible for some of the decorative motifs to be found on early Christian work. Much use was made by Islamic artists of inlaying in wood, either with plain or carved pieces of ivory, and much of this type of decoration is to be seen in mosques where pulpits, reading-desks and niches for the Koran are ornamented with such incrustation.

Work produced in each of the different countries under the sway of Mohammedanism has its recognizable characteristics. Whereas Persian carvings often feature stiffly-posed figures flanked by bushes or pots of flowers, the area of Turkey confined its attention to intricate arabesques and geometrical forms, and the Egyptian Fatimid craftsmen linked the two styles by posing human beings and winged lions realistically against elaborately designed backgrounds.

Probably the most admired Islamic ivories in the West are the caskets or boxes, sometimes referred to as covered cups, made at Cordoba, in Spain. They are carved in the Hispano-Moresque style with birds, beasts and humans, or with the ubiquitous arabesque. Most of them bear inscriptions in Arabic that record the name of the original owner, and sometimes additionally that of the artist and the date of the work.

A typical circular example in the Victoria and Albert Museum measures four inches in diameter and three in height. It is inscribed round the body: 'The favour of Allah to the servant of Allah, al-Hakam al-Mustansir billah, Commander of the Faithful! This is what he ordered to be

made under the direction of Durri as-Saghir' (Plate 17). Of about the same date is a taller casket with a domed hinged cover in the Louvre, Paris. This one is carved with a lively design of birds, animals and humans, and has on the front a panel showing a pair of lions biting the rumps of two oxen. It bears a typical flowery inscription, which reads: 'The blessing of Allah, favour, joy and prosperity for al-Mughira, son of the Commander of the Faithful—may Allah have mercy upon him! This is what is made in the year 357 (A.D. 968).' It was made for the Prince al-Mughira who was brother of al-Hakam mentioned above, and both were sons of the Caliph Abd ar-Rahman III.

It should be added that these Cordoban caskets have been copied skilfully, especially in a workshop in Valencia owned by D. Francisco Pallàs y Puig, who died in 1926.

10

CHINA

IN CHINESE art there has always been a strong tendency for an artist to copy in his chosen medium something that has been attempted with success in another. Thus, a bronze vase was imitated in jade or porcelain; the worker laboriously overcoming the difficulty of making it in a material that was often quite unsuitable either for the form or for the decoration. While a bronze piece was modelled first in wax, then cast in metal and chiselled to its finished state, a jade copy would have to be realized from a solid boulder of the comparatively intractable stone; a porcelain version of the same piece would be built up carefully before being exposed to the searing heat of the kiln, which would quickly reveal any deficiencies in workmanship. Similar articles are to be found made from ivory as exist in bronze, jade and porcelain; size was limited by that of the tusk, but could be overcome with careful joins. Where these were made, the pieces are held together by neat ivory dowels.

Not only was copying from medium to medium practised down the ages, but the same patterns, whether modelled or painted, persisted in successive dynasties. The archaic ornaments of the earliest times were reproduced continually and, in fact, are still current today as they were in the centuries before the birth of Christ. It can be understood that the dating of Chinese ivories relies on far more than the style of the piece in question, and only prolonged study reveals the subtle changes that take place over a period of hundreds of years.

From an early date the Chinese not only carved their ivory, but ornamented it additionally with lacquer, paint or inlays

of stone. Unlike Europeans, they seemed not to admire the material for its own qualities, but could not resist embellishing, and even concealing, its surface. Many old pieces retain some of their original decoration in the form of traces of gold lacquer, or show clearly where they were encrusted with turquoise.

The Chinese have known the elephant from prehistoric times, and the animals were native to parts of the country probably until the second century B.C. Early specimens of worked ivory are very scarce, but bone is less uncommon; undocumented specimens of either are the cause of much argument, both as regards their substance and their age. A few pieces catalogued as dating from the Shang Yin dynasty (?1766–1122 B.C.) were displayed at the Chinese Exhibition held at Burlington House, London, in 1935. They included a broken figure of a dragon some $3\frac{3}{4}$ inches in length, part of the head of an owl, and a number of small objects carved in bone.

Following the extinction of the elephant in China, tusks began to be imported from India and elsewhere. Again, there is a lack of surviving work, but from the year A.D. 752 there date a number of authentic examples. The collection of the Japanese Emperor Shomu, who died in 752, was dedicated to Buddha by his widow, and has remained intact from that day to this in the Shosoin, at Nara.

It was during the Ming dynasty (1368–1644) that ivories became more plentiful, but surviving specimens are far from commonplace. The exhibition of 'The Arts of the Ming Dynasty' organized in London in 1958 by the Oriental Ceramic Society included a few pieces. They were catalogued with a note stating that 'Criteria for the attribution of carvings in these materials (Jade, Ivory, Rhinoceros Horn and Bamboo) are especially meagre. Objects are included mainly on account of analogies between their style and that of Ming Porcelains, Painting, etc., or on the evidence of inscriptions. Some may well be shown to be of earlier or later date when more knowledge is available'. This very

cautious approach to the subject may be necessary for many years to come, and most authorities are tentative in their attributions to any period prior to the eighteenth century.

In 1680, the *Kung Pu*, or Chinese Imperial Board of Works, established a number of artistic manufactures in Pekin. The Emperor Kang H'si sent for accomplished carvers and other craftsmen from all over China, and they were set to work in factories built within the grounds of the Summer Palace. The various workshops continued in production for about a century, and the buildings themselves stood until the year 1869 when they were destroyed by fire. Of the twenty-seven or so departments, one was concerned with ivory-carving.

The ivory carvers under the *Kung Pu* worked in a more restrained style than was usual at other centres. Their work was to the Imperial taste and in the true Chinese manner, with no sign of the foreign influences or of ingenuity for ingenuity's sake that is apparent in most of the work from elsewhere.

The principal centre of carving for traders and visitors was Canton, where William Hickey recorded in 1768 how he was taken to see 'some of their most celebrated painters upon glass, to the fan makers, workers in ivory, japanners, jewellers and all the various artificers of Canton'. This coastal city was the headquarters of the European trading nations, and the Chinese catered there not only for wholesale orders but for the requirements of individual visitors.

The most celebrated of all the Chinese ivory productions are the concentric balls, described as follows by a writer a century and a half ago: 'Out of a solid ball of ivory, with a hole in it not more than an inch in diameter, they will cut from nine to fifteen distinct hollow globes, one within another, all loose and capable of being turned round in every direction and each of them carved full of the same kind of openwork that appears on the fans. A very small sum of money is the price of these trifles." An example was displayed

at the Great Exhibition, and the illustration in the catalogue shows it to have been complete with a length of chain carved from a piece of ivory. It is recorded as containing fifteen smaller balls within the outer one, but another example displayed at the same time contained twenty balls.

The compilers of the catalogue of the Exhibition anticipated queries by printing a note referring to this specimen. It ran as follows: 'These puzzles to ordinary observers display in a very peculiar manner the patience, ingenuity, and skill of the Chinese in the art of working in ivory. The question as to how the interior balls got in, is best answered by saying that they never got out, but were separated from the solid sphere of ivory, of which they were made, by a series of hooked or bent tools, the same being introduced while the ivory is running in a lathe; at the several perforations or large holes, which is observed on the outer surface, and which it will be found correspond to others in the concentric balls in the interior.'

The concentric balls were made not only as ornaments and curiosities in themselves, but are found incorporated often in the bases of chess sets made for export to Europe. They are then usually only small in size, and contain no more than two or three interior balls. These sets are most frequently carved to represent Chinese and Mongol soldiers, with the Castles represented attractively by elephants bearing flags. Each side is of a different colour, one being left unstained and the other dyed red, green or black.

Berthold Laufer wrote in 1925 that the balls were known as 'Devil's Work Balls' (the term 'Devil's Work' being applied to almost anything that appeared to be beyond the accomplishment of humans), and that they were manufactured as early as the fourteenth century'. However, there would seem to be no other record of the latter part of his statement, and he gave no authority for making it. It is accepted that most surviving examples are little more than one hundred years old, and often less than that.

Fans with their sticks carved intricately in ivory are not

uncommon, and some will be found to have been made to European order in China with the coat-of-arms or monogram of their first owner incorporated in the design. Many remain intact with their original box of lacquered wood, but most were carved so finely that their very delicacy has been their undoing. John Barrow, who wrote in 1804, noted: 'In this trade they stand unparalleled even at Birmingham, that great nursery of the art of manufacture where I understand it has been attempted by means of a machine to cut ivory fans and other articles, in imitation of the Chinese, but this experiment, although ingenious, has not hitherto succeeded to that degree so as to produce articles fit to vie with those of the latter.'

Other articles made from ivory by the Chinese include chop-sticks, back-scratchers, seals for use with ink in the Orient and with wax in the west, snuff-bottles, boxes, and models of boats and houses. There are some of the latter in the Victoria and Albert Museum, London, which bear labels showing them to have been sent as gifts from the Emperor of China to Josephine, wife of Napoleon Bonaparte. They were part of the cargo of a French ship captured and brought to England, and although offered to the French after the Treaty of Amiens in 1802 the offer was declined and they remained British property.

The model houses and boats were constructed of innumerable delicately carved and pierced pieces fitted together carefully in the manner of a toy, but their elaborate detail and their fragility proved that they were made for adult contemplation rather than childish play. Unless they have been kept carefully under glass shades and in a steady temperature they tend to gather dust and fall apart, and the majority of these monuments of misplaced patience have perished. Certainly, they are now much less common than they were in the years prior to 1939, and the upheavals of the last few decades must have taken a heavy toll of them.

A further Chinese speciality is the carving of minutely exact representations of flowers and fruit. Enamelled copper

bowls, filled realistically with flowering bulbs of tinted ivory date from the eighteenth century onwards. More common are modern carvings of a partly-peeled banana; the skin folded back and a curl of pith shown detached from the fruit. With the outer skin stained a tone of yellow and the rest of the piece in natural ivory, each is a veritable *tour-de-force* and it is perhaps regrettable that such a high degree of skill is not better employed.

Tall figures of Chinese ladies have been in demand during recent years, but it is doubtful whether many of them are very old. Some stand as much as 36 ins. in height, and skilfully utilize the shape of the tusk to portray their willowy grace. The subject is often Kwan Yin, the goddess of Mercy and much else, and when carved with a child in her arms she is not dissimilar in appearance to the Virgin Mary. Kwan Yin is found modelled in many materials including bronze and porcelain, and carved in jade and other stones, lacquered wood, and amber as well as ivory. It may be mentioned that not every portrayal of a graceful Chinese female represents this particular deity. She and others are distinguished by the attributes held or grouped about them, and correct identification is made with their aid.

11

JAPAN

ALTHOUGH ivory was known and worked in early times by the Japanese, only a small number of specimens, which date from the eighth century, have been preserved. The art of carving the material seems then to have been forgotten, and very little work older than the first quarter of the eighteenth century has survived. The revival that took place about then may perhaps have been due to Hideyoshi's unsuccessful invasion of Korea and China, when those of his men who returned to their native-land would have been well loaded with loot, including ivory-carvings, or was caused more probably by the fact that Dutch traders were bringing regular supplies of tusks among the other goods with which their ships were laden. A great incentive to modellers and sculptors was an edict that every home must contain a Buddhist image, and ivory carvers willingly helped to meet the demand.

An initial attempt by the Spaniards to introduce Christianity to Japan, and the Portuguese to convert and trade at the same time, was followed by the total expulsion of both. In the meantime, the Dutch had successfully introduced themselves, and after many vicissitudes were allowed to occupy the tiny island of Deshima in Nagasaki harbour. They retained their precarious footing from 1641 until 1853 in which year the Americans, under Commodore Perry, forced the Japanese to take notice of the outside world and permit free trading with one and all. Thus ended a period of some two centuries in which the country enjoyed peace and prosperity and, in spite of (or perhaps because of) only the

most tenuous intercourse with the West, raised its artistic standards to a very high level.

Japanese ivory-carvings may be divided into two types: *netsuke* and *okimono*. The netsuke is a carving of small size, made either with two holes drilled in the base or with a place incorporated in the design so that it can be attached to a cord. The other end of the cord held an article, usually an *inro* (medicine-box) which was hung over the sash (*obi*) of the native costume, which was thus prevented from slipping out. At first, no more than a simple functional object, the Japanese soon began to lavish thought and skill on the netsuke, and finally it held a place in their daily life equivalent to that of the snuff-box in Europe.

Fig. 8. Netsuke in the form of a seated
goat. Length: 2⅞ in.

During the eighteenth century and the first half of the nineteenth century the netsuke was a part of the costume of the Japanese, and some of the finest and rarest were made. It was recorded in 1781 that there were then fifty-seven carvers of these objects, and many of them created markedly individual styles to which their names have been given. A revolution in 1868 was followed by a new spirit of Westernization which spread through the country, and the national dress, the loose robe or *kimono*, lost favour and began to be replaced by clothing of European style. The netsuke-carvers, lacking a demand in their native-land, turned to the export market which welcomed their miniature works of art with eagerness.

At first many of the old netsukes left the country, but before long the supply of new specimens was sufficient to meet the demand, and the Japanese became eager to retain any available pre-1868 examples. Fine specimens of eighteenth century date have been known to change hands in Japan for sums up to £600 apiece; a temptation to fakers. Tens of thousands of netsukes have been brought to Europe and the United States, but on the whole their workmanship has declined in quality with each succeeding decade, and the finer examples have become very hard to obtain.

Netsukes have been made of elephant and vegetable ivory, whalebone, wood and much else, the resource of the carver extending as much to the material as to the story it was made to tell. Some of the more unusual specimens are of Dutchmen and other foreigners in European dress with cocked hats, perhaps carved as momentoes for them to take home across the seas. Others have another use in addition to being netsukes, and in this category are included: telescopes, compasses, hour-glasses, whistles, and miniature flint and steel fire and pipe-lighters.

The okimono is a carving, of larger size than the netsuke, made as an ornament either for the altar or in the home and usually of elephant ivory. It received equally careful treatment from innumerable carvers, but has not received the attention from scholars given to the netsuke. Okimono have been made in very large numbers, and few people have not seen and probably admired them. The skill displayed so often in their carving is frequently a cause of amazement; the stooping native fisherman with his net, every wrinkle on his old face clearly defined and the net depicted 'hanging' loosely and with every little detail carved painstakingly is invariably a subject of comment. In the eyes of some Westerners such extreme realism is not an endearing quality.

The netsuke and the okimono often bears the signature of a carver; not necessarily that of the craftsman who did the work but of someone more eminent who has been copied.

The signature will be found engraved neatly on the surface of the piece or else on a small red seal inset in the base. Both types of carvings vary greatly in quality, and all the best examples have been imitated continually by those less skilled in workmanship and in poorer materials than was used for the originals. The ultimate in this type of reproduction has been achieved by making netsuke from celluloid which is given a core of plaster and a coat of dark stain. In an ill-lit room an unwary beginner might be deceived by such an object.

A by-path of Japanese work in ivory is the technique named after the Shibayama family, who perfected it and specialized in its use at the end of the eighteenth century. Shibayama work consists of inlaying a panel of ivory (or sometimes lacquer) with pieces of coloured stone, mother-of-pearl and other suitable substances, to form a design. The effect is very rich and it was used occasionally to ornament figures, but more often is found as plaques for use as table-screens or set in vases of silver which are sometimes of extremely fine workmanship.

12

UNITED STATES OF AMERICA

THE ROUGH conditions of life in the early days of American settling would not have called for much in the way of luxuries; which, while welcome, would have proved an expensive burden in most cases. By the mid-1700s, however, there was a continual flow of skilled craftsmen from Europe to New York and the other rapidly-growing cities, where the new country held promise for the future. Among the many newspaper advertisements that appeared were very few relating to workers in ivory, but one is outstanding as giving a list of things for which there was a demand; all, it will be seen, are useful rather than ornamental. The notice appeared in the *New York Journal* in August, 1767, and read as follows:

'CHARLES SHIPMAN, Ivory and Hardwood Turner, lately from England: Takes this method to acquaint all gentlemen, &c., that having served a regular apprenticeship to a very considerable Turning Manufactory in Birmingham; he purposes carrying on that business here, in all the various undermentioned articles; Therefore all those who please to favour him with their employ, may depend on being served with the strictest assiduity, and on the most reasonable terms. Mahogany dice boxes, pack thread boxes, pepper boxes, soap boxes, washball boxes, patch boxes, raisin boxes, glove sticks, drum sticks and walking stick heads, paste rollers, round rulers and sugar hammers, tobacco sieves, sand dishes, ivory totums, tooth-pick-cases and eggs, nutmeg graters, pounce boxes and ivory thimbles, ivory netting and knotting

needles; tobacco stoppers, and cases for smelling boxes, counting-house seal handles, and steel seals cut with cyphers, ivory counters engraved with alphabets and figures, (very popular for children) back gammons and chess men; Cruet frames repair'd and German flutes tip'd in the neatest manner, oval picture frames, and sundry articles too tedious to mention.'

One particular contribution to the art of ivory-working has been claimed for the United States: the unsophisticated one known variously as Scrimshaw, Scrimshonter, Scrimshander or Scrimshon. It is the art of carving and decorating whalebone, whale's teeth and walrus tusks, and the work was done by men forming the crews of whalers. Sailing to the Arctic regions and away from their home ports for anything up to three years at a time, they would have ample periods of dreary leisure between the excitements of actual fishing. The work was not always entirely voluntary, as is shown by the entry in the log of a whaler in 1836: 'An idle head is the workshop of the devil. Employed scrimshon.'

The most familiar form of scrimshaw is the plain whale's tooth decorated with an engraved design into which black and red pigments have been rubbed to make the work show up against the whitish background. The tooth itself had to be prepared by smoothing the surface, and Herman Melville, who sailed before the mast and later wrote *Moby Dick* and other books, noted that some of the men 'have boxes of dentistical looking implements especially for the Skrimshandering business, . . . but in general they toil with jacknives alone'.

More ambitious articles made on board ship included stay-busks for mothers, sisters, wives or sweethearts, pie-crimping wheels for the same recipients, and things that could be used by the maker such as chess and draughts sets, cribbage boards, and items for sail-making including seam-rubbers and needle cases. All or most were embellished with engraving.

The decoration that is the most sought after is that showing the boat herself, preferably when flying the Stars and Stripes and giving the name of the vessel. Most commonly seen are full-lengths of men and women, while rarest of all and most interesting are dated pieces. Many of the men who did the work would have lacked the skill to make recognizable drawings of these subjects, and it is probable that they pasted book illustrations on to the tooth and then pricked through the pattern in outline or engraved direct through the paper. The latter could then be removed and the picture completed with the aid of inks, tar or any other suitable substance that was available.

While most scrimshaw is claimed to have been done on boats belonging to the United States, there is little doubt that on board whalers and other ships of many nationalities time hung equally heavily and was passed in the same manner. Most folk-art has a lack of self-consciousness that gives very few clues to its country of origin, and only the presence of a flag or some other obvious distinction can be relied on to make attribution certain.

Unfortunately, the demand for pieces that can be allocated to the United States has outstripped the supply of genuine examples, and the land-based faker is encouraged to embellish every whale's tooth on which he can lay his hands with the Stars and Stripes and much else. The very simplicity of old scrimshaws has proved fatal, for nothing is easier to imitate with enough success to deceive most people.

13

THE CARE OF IVORY

As has been mentioned earlier in this book, many of the ivories excavated in Assyria by Sir Henry Layard were in an advanced stage of decomposition. In the words of Alfred Maskell:

'When the workmen came across these fragments they were deeply embedded in the soil, to which they adhered so closely that it was only with extreme care, and in many cases with the aid of a penknife, or some other small instrument, that they could be detached and cleaned without falling to pieces. Not only so, but the action of the earth, and in some cases the effect of fire from a conflagration at the time of the destruction of the palaces had so decomposed them, that many separated into flakes or fell into powder. The action of the external air would no doubt before long have completed their destruction, when it occurred to their discoverer to restore to them the gelatinous matter which had dried up in the course of centuries. This was done with a very gratifying measure of success by boiling them in a solution of gelatine disolved in alcohol, so that some of them have almost completely regained their pristine beauty.'

Few men have the good fortune of Layard in discovering such treasures, whether decomposed or not. For the great majority of readers the description of his restoration of the finds is not without interest, but is unlikely to prove of use. Anyone finding or possessing ivories in bad condition, either from age or accident, or both, can do little to them himself unless he is highly experienced. Information on the type of

work involved is given in the relevant chapter (on pages 144 to 156) in Dr H. J. Plenderleith's *Conservation of Antiquities and Works of Art*, published in 1956. The complex processes there described should have the effect of imbuing a would-be-restorer with the greatest of caution. It may cause him to stay his eager hand from ruining further a work of art that might otherwise be saved.

Exposure to heat, excessive cold or dampness will damage ivory by inducing it to crack and discolour. Carvings are best kept away from central-heating radiators, fireplaces and open windows. It has been said that sunlight has the effect of bleaching it, but equally it has been found that examples kept in ill-lit museums have not darkened with the years.

Although prolonged exposure to water or damp will harm an ivory, the best method of cleaning a specimen is to brush it carefully and quickly with a little soap and water (or a little detergent and water). Dry it as soon as possible with a soft towel, and nothing else should be necessary in caring for a carving that is in normal condition.

BOOKS ON THE SUBJECT

GENERAL works on ivory include the under-mentioned, but not all of them remain in print and can be bought new. Those falling into the latter category, however, can usually be obtained second-hand or can be consulted in a good reference library.

> *Ivories*, by Alfred Maskell (1905, but re-issued recently in the United States).
> *Elfenbein*, by O. Pelka (1923).
> *History of English Ivories*, by M. H. Longhurst (1926).
> *The Book of Ivory*, by G. C. Williamson (1938).
> *Ivory*, by O. Beibeder.

The catalogues of the important collections in the British Museum and the Victoria and Albert Museum, London, the Bayerisches Nationalmuseum, Munich and the Staatliche Museen, Berlin, are important and highly instructive. So many books and articles on special categories of ivories have been written and printed during the past 150 years that to give a full list of them is quite beyond the scope of the present volume: it would fill many pages. Two illustrated monographs by John Beckwith, *The Andrews Diptych* and *Caskets from Cordoba*, issued recently by the Victoria and Albert Museum, are most informative on their particular subjects. Articles on ivories appear from time to time in such publications as *The Burlington Magazine*, *Apollo* and *The Connoisseur* in England, and in *Antiques* in the United States.

INDEX

BEAUTY AND THE BEAST

When lo ! at her resistless call,
Gay crouds came thronging through the hall,
The blissful hour to celebrate
When Persia's Prince resum'd his state :
At once the dome with music rang,
And virgins danc'd, and minstrels sang ;
It was the JUBILEE OF YOUTH,
Led on by Virtue and by Truth ;
The pride of Persia fill'd the scene,
To hail ORASMYN and his QUEEN !

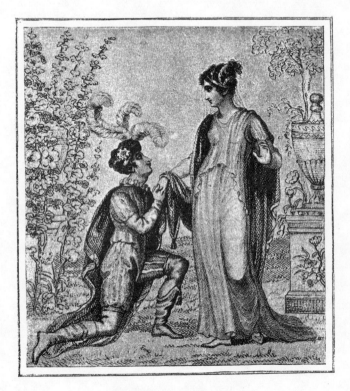

The Enchantment Dissolved.

BEAUTY AND THE BEAST

" Till this re-humanizing hour,
" The victim of a Fairy's pow'r ;—
" Till a deliverer could be found,
" Who, while the accursed spell still bound,
" Could first *endure*, tho' with alarm,
" And break at last by *love* the charm ! "

BEAUTY delighted gave her hand,
And bade the PRINCE her fate command ;
The PRINCE now led through rooms of state,
Where BEAUTY's family await,
In bridal vestments all array'd,
By some superior power convey'd.

" BEAUTY," pronounc'd a heavenly voice,
" Now take from me your princely choice.
" VIRTUE, to every good beside
" While wit and beauty were denied,
" Fix'd your pure heart ! for which, unseen,
" I led your steps ; and now a QUEEN,
" Seated on Persia's glittering throne,
" 'Tis mine and Virtue's task to crown !

" But as for you, ye Sisters vain,
" Still first and last in Envy's train,
" Before fair Beauty's Palace-gate,
" Such Justice has decreed your fate,
" Transform'd to statues you must dwell,
" Curs'd with the single power, to feel—
" Unless by penitence and prayer—
" But this will ask long years of care,
" Of promise and performance too,
" A change of mind from false to true—
" A change I scarce can hope from you."
Instant the Power stretch'd forth her wand,
Her sceptre of supreme command,

BEAUTY AND THE BEAST

But when had past the wonted hour,
And no wish'd footstep pass'd the door ;—
When yet another hour lagg'd on,—
Then to the wide canal she ran :
"For there in vision," said the fair,
"Was stretch'd the object of my care !"
And there, alas ! he now was found,
Extended on the flowery ground.
"Ah ! fond and faithful BEAST," she cried,
"Hast thou for me perfidious died ?
"O ! could'st thou hear my fervid prayer,
"'Twould ease the anguish of despair."

BEAST open'd now his long clos'd eyes,
And saw the fair with glad surprise.
"In my last moments you are sent ;
"You pity, and I die content."
"Thou shalt not die," rejoin'd the Maid ;
"O rather live to hate, upbraid—
"But no ! my grievous fault forgive !
"I feel I can't without thee live."

BEAUTY had scarce pronounc'd the word,
When magic sounds of sweet accord,
The music of celestial spheres
As if from seraph harps she hears !
Amaz'd she stood,—new wonders grew ;
For BEAST now vanish'd from her view ;
And, lo ! a PRINCE, with every grace
Of figure, fashion, feature, face,
In whom all charms of Nature meet,
Was kneeling at fair BEAUTY's feet.
"But where is BEAST ?" still BEAUTY cried :
"Behold him here !" the PRINCE replied.
"Orasmyn, lady, is my name,
"In Persia not unknown to fame ;

The Absence of Beauty Lamented.

BEAUTY AND THE BEAST

"No more with MONSTER shall she sup,
"Who, in his rage, shall eat her up."

And now such art they both employ'd,
While BEAUTY wept, yet was o'erjoy'd;
And when the stated hour was come,
"Ah! can you quit so soon your home?"
Eager they question'd—tore their hair—
And look'd the Pictures of Despair.
BEAUTY, tho' blushing at delay,
Promis'd another week to stay.

Meantime, altho' she err'd from love,
Her conscious heart could ill approve—
"Thy vow was giv'n, thy vow was broke!"
Thus Conscience to her bosom spoke.

Thoughts such as these assail'd her breast,
And a sad vision broke her rest!
The palace-garden was the place,
Which her imaginations trace:
There, on a lawn, as if to die,
She saw poor BEAST extended lie,
Reproaching with his latest breath
BEAUTY's ingratitude in death.

Rous'd from her sleep, the contrite Maid
The RING upon her toilette laid,
And *Conscience* gave a sound repose:
Balmy her rest; and when she rose,
The palace of poor BEAST she found,
Groves, gardens, arbours, blooming round:
The morning shone in summer's pride,
BEAUTY for fairer evening sigh'd—
Sigh'd for the object once so fear'd,
By worth, by kindness now endear'd.

BEAUTY AND THE BEAST

But oftner bent the raptur'd ear
Or ravish'd eye, to see or hear.
And if th' appointed hour past by,
'Twas mark'd by BEAUTY with a sigh.
"Swear not to leave me," sigh'd the BEAST:
"I swear"—for now her fears were ceas'd,
"And willing swear,—so now and then
"I might my Father see again—
"One little WEEK—he's now alone."
"Granted!" quoth BEAST: "your will be done!
"Your RING upon the table lay
"At night,—you're there at peep of day:
"But, oh,—remember, or I die!"
He gaz'd, and went without reply.

At early morn, she rang to rise;
The Maid beholds with glad surprise:
Summons her Father to her side,
Who, kneeling and embracing, cried,
With rapture and devotion wild,
"O bless'd be Heaven, and blest my Child!"

BEAUTY the Father now address'd,
And strait to see her Sisters press'd.
They both were married, and both prov'd
Neither was happy or belov'd.
And when she told them she was blest
With days of ease, and nights of rest;
To hide the malice of the soul,
Into the garden sly they stole,
And there in floods of tears they vent
Their hate, and feel its punishment.
"If," said the eldest, "you agree
"We'll make that wench more curs'd than we!
"I have a plot, my sister dear:
"More than her WEEK let's keep her here.

Beauty entertained with Invisible Music.

But when the evening board was spread,⎫
The voice of BEAST recall'd her dread : ⎬
" May I observe you sup ? " he said ; ⎭
" Ah, tremble not; your will is law;
" One question answer'd, I withdraw.—
" Am I not hideous to your eyes ? "
" Your temper's sweet," she mild replies.
" Yes, but I'm ugly, have no sense : "—
" That's better far, than vain pretence."—
" Try to be happy, and at ease,"
Sigh'd BEAST, "as I will try to please."—
" Your outward form is scarcely seen
" Since I arriv'd, so kind you've been."

One quarter of the rolling year,
No other living creature near,
BEAUTY with BEAST had past serene,
Save some sad hours that stole between.
That she her Father's life had sav'd,
Upon her heart of hearts was grav'd :
While yet she view'd the BEAST with dread,
This was the balm that conscience shed.
But now a second solace grew,
Whose cause e'en conscience scarcely knew.
Here on a Monster's mercy cast,—
Yet, when her first dire fears were past,
She found that Monster, timid, mild,
Led like the lion by the child.
Custom and kindness banish'd fear ;
BEAUTY oft wish'd that BEAST were near.

Nine was the chosen hour that BEAST
Constant attended BEAUTY's feast,
Yet ne'er presum'd to touch the food,
Sat humble, or submissive stood,
Or, audience crav'd, respectful spoke,
Nor aim'd at wit, or ribbald joke,

BEAUTY AND THE BEAST

When she in GOLDEN LETTERS trac'd,
High o'er an arch of emeralds plac'd,
"BEAUTY'S APARTMENT! Enter blest!
"This, but an earnest of the rest!"

The fair one was rejoic'd to find,
BEAST studied less her eye, than mind.
But, wishing still a nearer view,
Forth from the shelves a book she drew,
In whose first page, in lines of gold,
She might heart-easing words behold:
 "Welcome BEAUTY, banish fear!
 "You are Queen, and Mistress here:
 "Speak your wishes, speak your will,
 "Swift obedience meets them still."
"Alas!" said she, with heartfelt sighs,
The daughter rushing to her eyes,
"There's nothing I so much desire,
"As to behold my tender sire."

BEAUTY had scarce her wish express'd,
When it was granted by the BEAST:
A wond'rous mirror to her eye,
Brought all her cottage family.
Here her good Brothers at their toil,
For still they dress'd the grateful soil;
And there with pity she perceiv'd,
How much for her the Merchant griev'd;
How much her Sisters felt delight
To know her banish'd from their sight,
Altho' with voice and looks of guile,
Their bosoms full of joy the while,
They labour'd hard to force a tear,
And imitate a grief sincere.

At noon's repast, she heard a sound
Breathing unseen sweet music round;

Beauty Visits her Library.

BEAUTY AND THE BEAST

Scarce could she conquer her alarms,
Tho' folded in a father's arms.
Grim BEAST first question'd fierce, if she
Had hither journied WILLINGLY ?
" Yes," BEAUTY cried—in trembling tone :
" That's kind," said BEAST, and thus went on,
" Good Merchant, at to-morrow's dawn,
" I charge and warn you to BE GONE !
" And further, on life's penalty,
" Dare not again to visit me.
" BEAUTY, farewell ! " he now withdrew,
As she return'd the dread adieu.

Each then their separate pillow prest,
And slumber clos'd their eyes in rest.

As zephyr light, from magic sleep,
Soon as the sun began to peep,
Sprang BEAUTY ; and now took her way
To where her anguish'd father lay.—
But envious time stole swiftly on ;
" Begone ! lov'd Father ! ah ! begone !
" The early dew now gems the thorn,
" The sun-beams gain upon the morn.
" Haste, Father, haste ! Heaven guards the
 good ! "
In wonder rapt the Merchant stood ;
And while dread fears his thoughts employ,
A child so generous still was joy.
" My father's safe ! " she cried, " blest heaven !
" The rest is light, this bounty given."

She now survey'd th' enchanting scene,
Sweet gardens of eternal green ;
Mirrors, and chandeliers of glass,
And diamonds bright which those surpass ;
All these her admiration gain'd ;
But how was her attention chain'd,

BEAUTY AND THE BEAST

" And O, a thousand deaths I'd prove
" To shew my Father how I love ! "
The Brothers cried, " Let *us* away,
" We'll perish, or the Monster slay."

" Vain hope, my gen'rous Sons, his power
" Can troops of men and horse devour :
" Your offer, BEAUTY, moves my soul ;
" Mine was the fault ; you, Love, are free ;
And mine the punishment shall be."
BEAUTY was firm ! the Sire caress'd
Again his Darling to his breast ;
With blended love and awe survey'd,
And each good Brother blest the Maid !

Three months elaps'd, her Father's heart
Heav'd high, as she prepar'd to part ;
The Sisters try'd a tear to force,
While BEAUTY smil'd as she took horse ;
Yet smil'd thro' many a generous tear,
To find the parting moment near !
And just as evening's shades came on,
The splendid Palace court they won.
BEAUTY, now lost in wonder all,
Gain'd with her sire the spacious hall ;
Where, of the costliest viands made,
Behold, a sumptuous table laid !
The Merchant, sickening at the sight,
Sat down with looks of dire affright,
But nothing touch'd ; tho' Beauty prest,
And strove to lull his fears to rest.

Just as she spoke a hideous noise
Announc'd the growling monster's voice.
And now BEAST suddenly stalk'd forth,
While BEAUTY well nigh sank to earth :

227

Beauty in the Enchanted Palace.

"My Lord, I swear upon my knees,
"I did not mean to harm your trees;
"But a lov'd Daughter, fair as spring,
"Intreated me a ROSE to bring;
"O didst thou know, my Lord, the Maid!"—

"I am no Lord," BEAST angry said,
"And so no flattery!—but know,
"If, on your oath before you go,
"Within three wasted Moons you here
"Cause that lov'd Daughter to appear,
"And visit BEAST a volunteer
"To suffer for thee, thou mayest live:—
"Speak not!—do this!—and I forgive."
Mute and deprest the Merchant fled,
Unhappy traveller, evil sped!
BEAUTY was first her sire to meet,
Springing impatient from her seat;
Her Brothers next assembled round;
Her straying Sisters soon were found.
While yet the Father fondly press'd
The Child of Duty to his Breast,—
"Accept these Roses, ill-starr'd Maid!
"For thee thy Father's life is paid."

The Merchant told the tale of BEAST;
And loud lamentings, when he ceas'd,
From both the jealous Sisters broke,
As thus with taunting rage they spoke:
"And so thou kill'st thy Father, Miss,
"Proud, sinful creature, heardst thou this?
"We only wish'd a few new clothes;
"BEAUTY, forsooth, must have her ROSE!
"Yet, harden'd Wretch, her eyes are dry,
"Tho' for her Pride our Sire must die!"

"Die! Not for worlds!" exclaim'd the Maid;
"BEAST kindly will take me instead:

But had it been a rushy bed,
Tuck'd in the corner of a shed,
With no less joy had it been press'd :
The good man pray'd, and sank to rest.

Nor woke he till the noon of day ;
And as he thus enchanted lay,
" Now for my storm-sopp'd clothes," he cries :
When lo ! a suit complete he spies ;
" Yes, 'tis all fairy-work, no doubt,
" By gentle Pity brought about ! "
Tenfold, when risen, amazement grew ;
For bursting on his gazing view,
Instead of snow, he saw fair bowers
In all the pride of summer flowers.
Entering again the hall, behold,
Serv'd up in silver, pearl and gold,
A breakfast, form'd of all things rare,
As if Queen Mab herself were there.

As now he past, with spirits gay,
A shower of ROSES strew'd the way,
E'en to his hand the branches bent :
" One of these boughs—I go content !
" BEAUTY, dear BEAUTY— thy request
" If I may bear away, I'm blest."
The Merchant pull'd,—the branches broke !—
A hideous growling while he spoke,
Assail'd his startled ears ; and then
A frightful BEAST, as from a den,
Rushing to view, exclaim'd, " Ingrate !
" That stolen branch has seal'd thy fate.
" All that my castle own'd was thine,
" My food, my fire, my bed, my wine :
" Thou robb'st my Rose-trees in return,
" For this, base Plunderer, thou shalt mourn ! "

The Rose Gather'd.

And guess our Merchant's glad surprize,
When a rich palace seemed to rise
As on he mov'd ! The knee he bent,
Thankful to Heaven ; then nearer went.
But, O ! how much his wonder grew,
When nothing living met his view !—
Entering a splendid hall, he found,
With every luxury around,
A blazing fire, a plenteous board,
A costly cellaret, well stor'd,
All open'd wide, as if to say,
"Stranger, refresh thee on thy way ! "

The Merchant to the fire drew near,
Deeming the owner would appear,
And pardon one who, drench'd in rain,
Unask'd, had ventur'd to remain.
The court-yard clock had number'd seven,
When first he came ; but when eleven
Struck on his ear as mute he sate,
It sounded like the knoll of Fate.
And yet so hungry was he grown,
He pick'd a capon to the bone ;
And as choice wines before him stood,
He needs must taste if they were good :
So much he felt his spirits cheer'd—
The more he drank, the less he fear'd.

Now bolder grown, he pac'd along,
(Still hoping he might do no wrong),
When, entering at a gilded door,
High-rais'd upon a sumptuous floor,
A sofa shew'd all Persia's pride,
And each magnificence beside :
So down at once the Merchant lay,
Tir'd with the wonders of the day.

BEAUTY AND THE BEAST

The envious sisters, all confusion,
Commissions gave in wild profusion ;
Caps, hats, and bonnets, bracelets, broaches,
To cram the pockets of the coaches,
With laces, linens, to complete
The order, and to fill the seat.

Such wants and wishes now appear'd,
To make them larger BEAUTY fear'd ;
Yet lest her silence might produce
From jealous Sisters more abuse,
Considerately good, she chose,
The emblem of herself,—a ROSE.

The good Man on his journey went,
His thoughts on generous BEAUTY bent.
" If Heav'n," he said, and breath'd a prayer,
" If Heav'n that tender child should spare,
" Whate'er my lot, I must be bless'd,
" I must be rich : "—he wept the rest.
Timely such feelings !—Fortune still,
Unkind and niggard, crost his will.
Of all his hopes, alas, the gains
Were far o'erbalanc'd by the pains ;
For after a long tedious round,
He had to measure back his ground.
A short day's travel from his Cot,
New misadventures were his lot ;
Dark grew the air, the wind blew high,
And spoke the gathering tempest nigh ;
Hail, snow, and night-fog join'd their force,
Bewildering rider and his horse.
Dismay'd, perplext, the road they crost,
And in the dubious maze were lost.

When, glimmering through the vapours drear,
A taper shew'd a dwelling near.

Beauty in a State of Adversity.

BEAUTY AND THE BEAST

Our Merchant, late of boundless store,
Saw Famine hasting to his door.

With willing hand and ready grace,
Mild BEAUTY takes the Servant's place;
Rose with the sun to household cares,
And morn's repast with zeal prepares,
The wholesome meal, the cheerful fire:
What cannot filial love inspire?
And when the task of day was done,
Suspended till the rising sun,
Music and song the hours employ'd,
As more deserv'd, the more enjoy'd;
Till Industry, with Pastime join'd,
Refresh'd the body and the mind;
And when the groupe retir'd to rest,
Father and Brothers BEAUTY blest.

Not so the Sisters; as before
'Twas *rich* and idle, now 'twas *poor*.
In shabby finery array'd,
They still affected a parade:
While both insulted gentle BEAUTY,
Unwearied in the housewife's duty;
They mock'd her robe of modest brown,
And view'd her with a taunting frown;
Yet scarce could hold their rage to see
The blithe effects of Industry.

In this retreat a year had past,
When happier tidings came at last,
And in the Merchant's smile appear'd
Prospects that all the Cotters cheer'd:
A letter came; its purport good;
Part of his ventures brav'd the flood:
"With speed," said he, "I must to town,
And what, my girls, must I bring down?"

BEAUTY AND THE BEAST

A MERCHANT, who by generous pains
Prospered in honourable gains,
Could boast, his wealth and fame to share,
Three manly SONS, three DAUGHTERS fair ;
With these he felt supremely blest.—
His latest born surpass'd the rest :
She was so gentle, good and kind,
So fair in feature, form and mind,
So constant too in filial duty,
The neighbours called her LITTLE BEAUTY !
And when fair childhood's days were run,
That title still she wore and won ;
Lovelier as older still she grew,
Improv'd in grace and goodness too.—
Her elder Sisters, gay and vain,
View'd her with envy and disdain,
Toss'd up their heads with haughty air ;
Dress, Fashion, Pleasure, all their care.

'Twas thus, improving and improv'd;
Loving, and worthy to be lov'd,
Sprightly, yet grave, each circling day
Saw BEAUTY innocently gay.
Thus smooth the May-like moments past;
Blest times ! but soon by clouds o'ercast !

Sudden as winds that madd'ning sweep
The foaming surface of the deep,
Vast treasures, trusted to the wave,
Were buried in the billowy grave !

Beauty in her Prosperous State.

BEAUTY

AND

THE BEAST.

OR

A ROUGH OUTSIDE WITH GENTLE HEART.

A POETICAL VERSION OF AN ANCIENT TALE

ILLUSTRATED WITH A
SERIES OF ELEGANT ENGRAVINGS
AND BEAUTY'S SONG AT HER SPINNING-WHEEL
SET TO MUSIC BY MR. WHITAKER.

LONDON

PRINTED FOR M. J. GODWIN.

AT THE JUVENILE LIBRARY, 41 SKINNER STREET

AND TO BE HAD OF ALL BOOKSELLERS AND TOYMEN
THROUGHOUT THE UNITED KINGDOM.

PRICE 5s. 6d. COLOURED, OR 3s. 6d. PLAIN.

PRINCE DORUS

Self-knowledge obtains its reward.

The aged Fairy in their presence stands,
Confirms their mutual vows, and joins their hands.
The Prince with rapture hails the happy hour,
That rescued him from self-delusion's power ;
And trains of blessings crown the future life
Of Dorus, and of Claribel, his wife.

For, till he view'd that feature with remorse,
The Enchanter's direful spell must be in force.
Midway the road by which the Prince must pass,
She rais'd by magic art a House of Glass ;
No mason's hand appear'd, nor work of wood ;
Compact of glass the wondrous fabric stood.
Its stately pillars, glittering in the sun,
Conspicuous from afar, like silver, shone.
Here, snatch'd and rescued from th' Enchanter's
 might,
She placed the beauteous Claribel in sight.

The admiring Prince the chrystal dome survey'd,
And sought access unto his lovely Maid :
But, strange to tell, in all that mansion's bound,
Nor door, nor casement, was there to be found.
Enrag'd he took up massy stones, and flung
With such a force, that all the palace rung ;
But made no more impression on the glass,
Than if the solid structure had been brass.
To comfort his despair, the lovely maid
Her snowy hand against her window laid ;
But when with eager haste he thought to kiss,
His Nose stood out, and robb'd him of the bliss.
Thrice he essay'd th' impracticable feat ;
The window and his lips can never meet.

The painful Truth, which Flattery long conceal'd,
Rush'd on his mind, and " O ! " he cried, " I yield ;
Wisest of Fairies, thou wert right, I wrong—
I own, I own, I have a Nose too long."

The frank confession was no sooner spoke,
But into shivers all the palace broke.
His Nose of monstrous length, to his surprise,
Shrunk to the limits of a common size ;
And Claribel with joy her Lover view'd,
Now grown as beautiful as he was good.

Truth brought Home.

He finds her raillery now increase so fast,
That making hasty end of his repast,
Glad to escape her tongue, he bids farewell
To the old Fairy, and her friendly cell.

But his kind Hostess, who had vainly tried
The force of ridicule to cure his pride,
Fertile in plans, a surer method chose,
To make him see the error of his Nose ;

215

'Twas I that, when his hopes began to fail,
Shew'd him the spell that lurk'd in Minon's tail—
Perhaps you have heard—but come, Sir, you don't
 eat—
That Nose of yours requires both wine and meat—
Fall to, and welcome, without more ado—
You see your fare—what shall I help you to?
This dish the tongues of nightingales contains;
This, eyes of peacocks; and that, linnets' brains;
That next you is a Bird of Paradise—
We Fairies in our food are somewhat nice.—
And pray, Sir, while your hunger is supplied,
Do lean your Nose a little on one side;
The shadow, which it casts upon the meat,
Darkens my plate, I see not what I eat—"

The Prince on dainty after dainty feeding,
Felt inly shock'd at the old Fairy's breeding;
But held it want of manners in the Dame,
And did her country education blame.
One thing he only wonder'd at,—what she
So very comic in his Nose could see.
Hers, it must be confest, was somewhat short,
And time and shrinking age accounted for 't;
But for his own, thank heaven, he could not tell
That it was ever thought remarkable;
A decent Nose, of reasonable size,
And handsome thought, rather than otherwise.
But that which most of all his wonder paid,
Was to observe the Fairy's waiting-Maid;
How at each word the aged Dame let fall;
She courtsied low, and smil'd assent to all;
But chiefly when the rev'rend Grannam told
Of conquests, which her beauty made of old.—
He smiled to see how Flattery sway'd the Dame,
Nor knew himself was open to the same!

PRINCE DORUS

With difficulty she could find a place
To hang them on in her unshapely face ;
For, if the Princess's was somewhat small,
This Fairy scarce had any nose at all.
But when by help of spectacles the Crone
Discern'd a Nose so different from her own,
What peals of laughter shook her aged sides !
While with sharp jests the Prince she thus derides.

FAIRY.

" Welcome great Prince of Noses, to my cell ;
'Tis a poor place,—but thus we Fairies dwell.
Pray, let me ask you, if from far you come—
And don't you sometimes find it cumbersome ? "

PRINCE.

" Find what ? "

FAIRY.

" Your nose—"

PRINCE.

" My Nose, Ma'am ! "

FAIRY.

" No offence—
The King your Father was a man of sense,
A handsome man (but lived not to be old)
And had a Nose cast in the common mould.
Ev'n I myself, that now with age am grey,
Was thought to have some beauty in my day,
And am the Daughter of a King.—Your sire
In this poor face saw something to admire—
And I to shew my gratitude made shift—
Have stood his friend—and help'd him at a lift—

Prince Dorus offended.

The Prince, with toil and hunger sore opprest,
Gladly accepts, and deigns to be her guest.
But when the first civilities were paid,
The dishes rang'd and Grace in order said ;
The Fairy, who had leisure now to view
Her guest more closely, from her pocket drew
Her spectacles, and wip'd them from the dust,
Then on her nose endeavour'd to adjust ;

Visit to the Beneficent Fairy.

At length he to a shady forest came,
Where in a cavern lived an aged dame ;
A reverend Fairy, on whose silver head
A hundred years their downy snows had shed.
Here ent'ring in, the Mistress of the place
Bespoke him welcome with a cheerful grace ;
Fetch'd forth her dainties, spread her social board
With all the store her dwelling could afford.

Claribel carried off.

Mounting his horse, he gives the beast the reins,
And wanders lonely through the desert plains ;
With fearless heart the savage heath explores,
Where the wolf prowls, and where the tiger roars,
Nor wolf, nor tiger, dare his way oppose ;
The wildest creatures see, and shun, his Nose.
Ev'n lions fear ! the elephant alone
Surveys with pride a trunk so like his own.

PRINCE DORUS

And subtle Courtiers, who their Prince's mind
Still watch'd, and turn'd about with every wind,
Assur'd the Prince, that though man's beauty owes
Its charms to a majestic length of nose,
The excellence of Woman (softer creature)
Consisted in the shortness of that feature.
Few arguments were wanted to convince
The already more than half persuaded Prince ;
Truths, which we hate, with slowness we receive,
But what we wish to credit, soon believe.

The Princess's affections being gain'd,
What but her Sire's approval now remain'd ?
Ambassadors with solemn pomp are sent
To win the aged Monarch to consent
(Seeing their States already were allied)
That Dorus might have Claribel to bride.
Her Royal Sire, who wisely understood
The match propos'd was for both kingdoms' good,
Gave his consent ; and gentle Claribel
With weeping bids her Father's court farewell.

With gallant pomp, and numerous array,
Dorus went forth to meet her on her way ;
But when the Princely pair of lovers met,
Their hearts on mutual gratulations set,
Sudden the Enchanter from the ground arose,
(The same who prophesied the Prince's Nose)
And with rude grasp, unconscious of her charms,
Snatch'd up the lovely Princess in his arms,
Then bore her out of reach of human eyes,
Up in the pathless regions of the skies.

Bereft of her that was his only care,
Dorus resign'd his soul to wild despair ;
Resolv'd to leave the land that gave him birth,
And seek fair Claribel throughout the earth.

PRINCE DORUS

While doctrines such as these his guides instill'd,
His Palace was with long-nosed people fill'd;
At Court whoever ventured to appear
With a short nose, was treated with a sneer.
Each courtier's wife, that with a babe is blest,
Moulds its young nose betimes; and does her best,
By pulls, and hauls, and twists, and lugs, and
 pinches,
To stretch it to the standard of the Prince's.

Dup'd by these arts, Dorus to manhood rose,
Nor dream'd of aught more comely than his nose;
Till Love, whose power ev'n Princes have confest,
Claim'd the soft empire o'er his youthful breast.
Fair Claribel was she who caus'd his care;
A neighb'ring monarch's daughter, and sole heir.
For beauteous Claribel his bosom burn'd;
The beauteous Claribel his flame return'd;
Deign'd with kind words his passion to approve,
Met his soft vows, and yielded love for love.
If in her mind some female pangs arose
At sight (and who can blame her?) of his Nose,
Affection made her willing to be blind;
She loved him for the beauties of his mind;
And in his lustre, and his royal race,
Contented sunk—one feature of his face.

Blooming to sight, and lovely to behold,
Herself was cast in Beauty's richest mould;
Sweet female majesty her person deck'd—
Her face an angel's—save for one defect—
Wise Nature, who to Dorus over kind,
A length of nose too liberal had assign'd,
As if with us poor mortals to make sport,
Had giv'n to Claribel a nose too short:
But turn'd up with a sort of modest grace;
It took not much of beauty from her face;

PRINCE DORUS

That length of nose portended length of days,
And was a great advantage many ways—
To mourn the gifts of Providence was wrong—
Besides, *the Nose was not so very long.*—

These arguments in part her grief redrest,
A mother's partial fondness did the rest ;
And Time, that all things reconciles by use,
Did in her notions such a change produce,
That, as she views her babe, with favour blind,
She thinks him handsomest of human kind.

Meantime in spite of his disfigured face,
Dorus (for so he's call'd) grew up apace ;
In fair proportion all his features rose,
Save that most prominent of all—his Nose.
That Nose, which in the infant could annoy,
Was grown a perfect nuisance in the boy.
Whene'er he walk'd, his Handle went before,
Long as the snout of Ferret, or Wild Boar ;
Or like the Staff, with which on holy day
The solemn Parish Beadle clears the way.

But from their cradle to their latest year,
How seldom Truth can reach a Prince's ear !
To keep th' unwelcome knowledge out of view,
His lesson well each flattering Courtier knew ;
The hoary Tutor, and the wily Page,
Unmeet confederates ! dupe his tender age.
They taught him that whate'er vain mortals boast—
Strength, Courage, Wisdom—all they value most—
Whate'er on human life distinction throws—
Was all comprised—in what ?—a length of nose !
Ev'n Virtue's self (by some suppos'd chief merit)
In short-nosed folks was only want of spirit.

207

Prince Dorus and his Maids.

Her maids, as each one takes him in her arms,
Expatiate freely o'er his world of charms—
His eyes, lips, mouth—his forehead was divine—
And for the nose—they call'd it Aquiline—
Declared that Cæsar, who the world subdued,
Had such a one—just of that longitude—
That Kings like him compell'd folks to adore
 them,
And drove the short-nos'd sons of men before
 them—

PRINCE DORUS

From your unhappy nuptials shall be born
A Prince, whose Nose shall be thy subjects' scorn.
Bless'd in his love thy son shall never be,
Till he his foul deformity shall see,
Till he with tears his blemish shall confess,
Discern its odious length, and wish it less ! "

This said, he vanish'd ; and the King awhile
Mused at his words, then answer'd with a smile,
" Give me a child in happy wedlock born,
And let his Nose be made like a French horn ;
His knowledge of the fact I ne'er can doubt,—
If he have eyes, or hands, he'll find it out."

So spake the King, self-flatter'd in his thought,
Then with impatient step the Princess sought ;
His urgent suit no longer she withstands,
But links with him in Hymen's knot her hands.
Almost as soon a widow as a bride,
Within a year the King her husband died ;
And shortly after he was dead and gone,
She was deliver'd of a little son,
The prettiest babe, with lips as red as rose,
And eyes like little stars—but such a nose—
The tender Mother fondly took the boy
Into her arms, and would have kiss'd her joy ;
His luckless nose forbade the fond embrace—
He thrust the hideous feature in her face.

Then all her Maids of Honour tried in turn,
And for a Prince's kiss in envy burn ;
By sad experience taught, their hopes they miss'd,
And mourn'd a Prince that never could be kiss'd.

In silent tears the Queen confess'd her grief,
Till kindest Flattery came to her relief.

The Transformation.

No more a cat, but chang'd into a man
Of giant size, who frown'd, and thus began:

" Rash King, that dared with impious design
To violate that tail, that once was mine ;
What though the spell be broke, and burst the
 charms,
That kept the Princess from thy longing arms,—
Not unrevenged shalt thou my fury dare,
For by that violated tail I swear,

PRINCE DORUS

Minon Asleep.

A desperate suit 'twas useless to prefer,
Or hope to catch a tail of quicksilver.—
When on a day, beyond his hopes, he found
Minon, his foe, asleep upon the ground ;
Her ample tail behind her lay outspread,
Full to the eye, and tempting to the tread.
The King with rapture the occasion bless'd,
And with quick foot the fatal part he press'd.
Loud squalls were heard, like howlings of a storm,
And sad he gazed on Minon's altered form,—

The Enchanted Cat.

With wary step the cautious King draws near,
And slyly means to attack her in her rear ;
But when he thinks upon her tail to pounce,
Whisk—off she skips—three yards upon a bounce—
Again he tries, again his efforts fail—
Minon's a witch—the deuce is in her tail—

The anxious chase for weeks the Monarch tried,
Till courage fail'd, and hope within him died.

PRINCE DORUS

In days of yore, as Ancient Stories tell,
A King in love with a great Princess fell.
Long at her feet submiss the Monarch sigh'd,
While she with stern repulse his suit denied.
Yet was he form'd by birth to please the fair,
Dress'd, danc'd, and courted with a Monarch's air ;
But Magic Spells her frozen breast had steel'd
With stubborn pride, that knew not how to yield.

This to the King a courteous Fairy told,
And bade the Monarch in his suit be bold ;
For he that would the charming Princess wed,
Had only on her cat's black tail to tread,
When straight the Spell would vanish into air,
And he enjoy for life the yielding fair.

He thank'd the Fairy for her kind advice.—
Thought he, " If this be all, I'll not be nice ;
Rather than in my courtship I will fail,
I will to mince-meat tread Minon's black tail."
To the Princess's court repairing strait,
He sought the cat that must decide his fate ;
But when he found her, how the creature stared !
How her back bristled, and her great eyes glared !
That tail, which he so fondly hop'd his prize,
Was swell'd by wrath to twice its usual size ;
And all her cattish gestures plainly spoke,
She thought the affair he came upon, no joke.

PRINCE DORUS;

OR,

FLATTERY PUT OUT OF COUNTENANCE,

A POETICAL VERSION OF AN ANCIENT TALE.

1811.

Their Majesties so well have fed,
The tarts have got up in their head;
"Or may be 'twas the wine!" hush gipsey
Great Kings & Queens indeed get tipsey!
Now, Pambo, is the time for you:
Beat little Tell-Tale black & blue

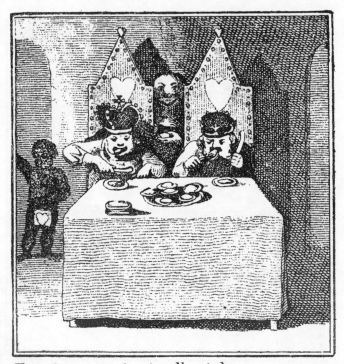

How say you Sir? tis all a joke
Great Kings love tarts like other folk."
If for a truth you'll not receive it,
Pray view the picture and believe it.
Sly Pambo too has got a share
And eats it snug behind the chair

197

And vow'd he'd steal no more

Lo! Pambo prostrate on the floor
Vows he will be a thief no more.
O King your heart no longer harden,
You've got the tarts, give him his pardon.
The best time to forgive a sinner
Is always after a good dinner

THE KING AND QUEEN OF HEARTS

Brought back those Tarts

The Knave brings back the tarts he ftole,
The Queen fwears, that is not the whole.
What fhould poor Pambo do? hard preft.
Owns he has eaten up the reft.
The King takes back as lawful debt.
Not all but all that he can get.

The Knave of Hearts

How like he looks to a dog that begs
In abject sort upon two legs!
Good M.r Knave, give me my due.
I like a tart as well as you,
But I would starve on good roast Beef,
Ere I would look so like a thief.

And beat the Knave full sore

Behold the due reward of sin;
See what a plight rogue Pambos in
The King lays on his blows so stout,
The Tarts for fear come tumbling out
O King! be merciful as just,
You'll beat poor Pambo into dust

193

Call'd for those Tarts

The meat removed, and dinner done.
The knives are wip'd and cheese put on
The King aloud for Tarts does bawl,
Tarts, tarts, resound through all the Hall
Pambo with tears denies the Fact.
But Mungo saw him in the act.

192

THE KING AND QUEEN OF HEARTS

The King of Hearts

Behold the King of Hearts how gruff
The monarch stands how square how bluff
When our eighth Harry ruld this land.
Just like this King did Harry stand;
And just so amorous sweet and willing.
As this Queen stands stood Anna Bullen.

And took them quite away

How like a thievish Jack he looks!
I wish for my part all the cooks
Would come and baste him with a ladle
As long as ever they were able
To keep his fingers ends from itching
After sweet things in the Queen's kitchen

He stole those Tarts

Thieves! Thieves! holla, you knavish Jack
Cannot the good Queen turn her back
But you must be so nimble hasty
To come and steal away her pastry
You think you're safe there's one sees all,
And understands, though he's but small

The Knave of Hearts

When Kings and Queens a riding go,
Great Lords ride with them for a fhow
With grooms & courtiers, a great ftore,
Some ride behind & fome before.
Pambo the firft of thefe does pafs,
And for more ftate rides on an Afs

THE KING AND QUEEN OF HEARTS

All on a Summers day

Now firſt of May does ſummer bring
How bright and fine is every thing!
After their dam the chickens run,
The green leaves glitter in the sun,
While youths and maids in merry dance
Round ruſtic may poles do advance.

187

She made some Tarts

The Queen here by the King's commands,
Who does not like Cook's dirty hands,
Makes the court pastry all herself
Pambo the knave that roguish elf
Watches each sugary sweet ingredient
And shly thinks of an expedient

The Queen of Hearts

High on a Throne of state is seen
She whom all Hearts own for their Queen.
Three Pages are in waiting by
He with the umbrella is her Spy.
To spy out rogueries in the dark
And smell a rat as you shall mark

1

The Queen of Hearts

She made some tarts,

All on a summers day:

The Knave of Hearts.

He stole those tarts,

And took them quite away

2

The King of Hearts.

Call'd for those tarts

And beat the Knave full sore

The Knave of Hearts

Brought back those tarts

And vow'd he d steal no more

THE KING
and
QUEEN of HEARTS

Showing how notably
the Queen made her Tarts.
And how scurvily
the Knave stole them away:
with other particulars belonging thereunto

Printed for Thos. Hodgkins, Hanway Street. Nov.r 18. 1805

THE KING

AND

QUEEN OF HEARTS

A BIRTHDAY THOUGHT.

Can I, all-gracious Providence,
 Can I deserve Thy care ?
Ah no ! I've not the least pretence
 To bounties which I share.

Have I not been defended still
 From dangers and from death ;
Been safe preserved from every ill
 E'er since Thou gavest me breath ?

I live once more to see the day
 That brought me first to light ;
Oh, teach my willing heart the way
 To take Thy mercies right.

Tho' dazzling splendour, pomp, and show
 My fortune has denied ;
Yet more than grandeur can bestow
 Content hath well supplied.

I envy no one's birth or fame,
 Their titles, train, or dress :
Nor has my pride e'er stretch'd its aim
 Beyond what I possess.

I ask and wish not to appear
 More beauteous, rich, or gay :
Lord, make me wiser every year,
 And better every day.

180

For David, their belovëd king,
At his own sweet native spring.
Back through their enemies they haste,
With the hard-earn'd treasure grac'd.
What with such danger they had sought,
With joy unto their king they brought.
But when the good king David found
What they had done, he on the ground
The water pour'd, "Because," said he,
"That it was at the jeopardy
Of your three lives this thing ye did,
That I should drink it God forbid."

W G

David in the Cave of Adullam.

The stone though small had piercëd deep
Into his forehead, endless sleep
Giving Goliath—and thus died
Of Philistines the strength and pride.

DAVID IN THE CAVE OF ADULLAM.

DAVID and his three captains bold
Kept ambush once within a hold.
It was in Adullam's cave,
Nigh which no water they could have.
Nor spring, nor running brook was near
To quench the thirst that parch'd them there.
Then David king of Israel
Straight bethought him of a well
Which stood beside the city gate
At Bethlem: where, before his state
Of kingly dignity, he had
Oft drunk his fill, a shepherd lad.
But now his fierce Philistian foe
Encamp'd before it he does know.
Yet ne'er the less with heat opprest,
Those three bold captains he addrest,
And wish'd that one to him would bring
Some water from his native spring.
His valiant captains instantly
To execute his will did fly.
Those three brave men the ranks broke through
Of armëd foes, and water drew

Two young lambs by force they'd seiz'd.
The Lord was mercifully pleas'd
Me to deliver from the paw
Of the fierce bear, and cruel jaw
Of the strong lion. I shall slay
Th' unrighteous Philistine this day,
If God deliver him also
To me." He ceas'd. The king said, "Go :
Thy God, the God of Israel, be
In the battle still with thee."

 David departs, unarmed, save
A staff in hand he chanc'd to have.
Nothing to the fight he took,
Save five smooth stones from out a brook;
These in his shepherd's scrip he plac'd,
That was fasten'd round his waist.
With staff and sling alone he meets
The armëd giant, who him greets
With nought but scorn. Looking askance
On the fair ruddy countenance
Of his young enemy—" Am I
A dog, that thou com'st here to try
Thy strength upon me with a staff ?"
Goliath said with scornful laugh.
"Thou com'st with sword, with spear, with
 shield,
Yet thou to me this day must yield.
The Lord of Hosts is on my side,
Whose armies boastful thou'st defied.
All nations of the earth shall hear,
He saveth not with shield and spear."

 Thus David spake, and nigher went,
Then choosing from his scrip, he sent
Out of his slender sling a stone.—
The giant utter'd fearful moan.

His eldest brother, who had heard
His question, was to anger stirr'd
Against the youth : for (as he thought)
Things out of his young reach he sought.
Said he, "What mov'd thee to come here,
To question warlike men ? say, where
And in whose care are those few sheep
That in the wilderness you keep ?
I know thy thoughts, how proud thou art :
In the naughtiness of thy heart,
Hoping a battle thou mayst see,
Thou comest hither down to me."

Then answer'd Jesse's youngest son
In these words : "What have I done ?
Is there not cause ? " Some there which heard,
And at the manner of his word
Admir'd, report this to the king.
By his command they David bring
Into his presence. Fearless then,
Before the king and his chief men,
He shows his confident design
To combat with the Philistine.
Saul with wonder heard the youth,
And thus address'd him : "Of a truth,
No pow'r thy untried sinew hath
To cope with this great man of Gath."

Lowly David bow'd his head,
And with firm voice the stripling said :
"Thy servant kept his father's sheep.—
Rushing from a mountain steep
There came a lion, and a bear,
The firstlings of my flock to tear.
Thy servant hath that lion kill'd,
And kill'd that bear, when from the field

DAVID

Him we will leave awhile, and speak
Of one, the soft down on whose cheek
Of tender youth the tokens bare.
Ruddy he was and very fair.
David, the son of Jesse he,
Small siz'd, yet beautiful to see.
Three brothers had he in the band
Of warriors under Saul's command ;
Himself at home did private keep
In Bethlem's plains his father's sheep.

Jesse said to this his son:
" David, to thy brothers run,
Where in the camp they now abide,
And learn what of them may betide.
These presents for their captains take,
And of their fare inquiries make."
With joy the youth his sire obey'd.—
David was no whit dismay'd
When he arrivëd at the place
Where he beheld the strength and face
Of dread Goliath, and could hear
The challenge. Of the people near
Unmov'd he ask'd, what should be done
To him who slew that boasting one,
Whose words such mischiefs did forebode
To th' armies of the living God ?

" The king," they unto David say,
" Most amply will that man repay.
He and his father's house shall be
Evermore in Israel free.
With mighty wealth Saul will endow
That man : and he has made a vow ;
Whoever takes Goliath's life,
Shall have Saul's daughter for his wife."

DAVID.

IT is not always to the strong
Victorious battle shall belong.
This found Goliath huge and tall :
Mightiest giant of them all,
Who in the proud Philistian host
Defiëd Israel with boast.

 With loud voice Goliath said :
" Hear, armed Israel, gatherëd,
And in array against us set :
Ye shall alone by me be met.
For am not I a Philistine ?
What strength may be compar'd to mine ?

 " Choose ye a man of greatest might :
And if he conquer me in fight,
Then we will all servants be,
King of Israel, unto thee.
But if I prove the victor, then
Shall Saul and all his armëd men
Bend low beneath Philistian yoke."
Day by day these words he spoke,
Singly traversing the ground.
But not an Israelite was found
To combat man to man with him,
Who such prodigious force of limb
Display'd. Like to a weaver's beam
The pond'rous spear he held did seem.
In height six cubits he did pass,
And he was arm'd all o'er in brass.

ON THE FINDING OF MOSES

When to our palace he is brought,
Wise masters shall for him be sought
To train him up, befitting one
I would protect as my own son.
And Moses be a name unto him,
Because I from the waters drew him."

To see that no Egyptian eye
Her ark-hid treasure should espy.
Among the river-flags she lays
The child. Near him his sister stays.
We may imagine her affright,
When the king's daughter is in sight.
Soon the princess will perceive
The ark among the flags, and give
Command to her attendant maid
That its contents shall be display'd.
Within the ark the child is found,
And now he utters mournful sound.
Behold he weeps, as if he were
Afraid of cruel Egypt's heir !
She speaks, she says, "This little one
I will protect, though he the son
Be of an Hebrew." Every word
She speaks is by the sister heard.—
And now observe, this is the part
The painter chose to show his art.
Look at the sister's eager eye,
As here she seems advancing nigh.
Lowly she bends, says, "Shall I go
And call a nurse to thee ? I know
A Hebrew woman liveth near,
Great lady, shall I bring her here ? "
See ! Pharaoh's daughter answers, " Go."—
No more the painter's art can show.
He cannot make his figures move.—
On the light wings of swiftest love
The girl will fly to bring the mother
To be the nurse, she'll bring no other.
To her will Pharaoh's daughter say,
"Take this child from me away :
For wages nurse him. To my home
At proper age this child may come.

ON A PICTURE
OF THE FINDING OF
MOSES BY PHARAOH'S DAUGHTER.

THIS picture does the story express
Of Moses in the bulrushes.
How livelily the painter's hand
By colours makes us understand!

Moses that little infant is.
This figure is his sister. This
Fine stately lady is no less
A personage than a princess,
Daughter of Pharaoh, Egypt's king ;
Whom Providence did hither bring
This little Hebrew child to save.
See how near the perilous wave
He lies exposëd in the ark,
His rushy cradle, his frail bark !
Pharaoh, king of Egypt land,
In his greatness gave command
To his slaves, they should destroy
Every new-born Hebrew boy.
This Moses was an Hebrew's son.
When he was born, his birth to none
His mother told, to none reveal'd,
But kept her goodly child conceal'd.
Three months she hid him ; then she wrought
With bulrushes this ark, and brought
Him in it to this river's side,
Carefully looking far and wide

169

But his over-young invention
Kept not pace with brave intention,
Twenty suns did rise and set,
And he could no further get.
But unable to proceed,
Made a virtue out of need,
And (his labours wiselier deem'd of)
Did omit *what the queen dream'd of.*

QUEEN ORIANA'S DREAM.

On a bank with roses shaded,
Whose sweet scent the violets aided,
Violets whose breath alone
Yields but feeble smell or none
(Sweeter bed Jove ne'er repos'd on
When his eyes, Olympus clos'd on),
While o'erhead six slaves did hold
Canopy of cloth o' gold,
And two more did music keep
Which might Juno lull to sleep,
Oriana, who was queen
To the mighty Tamerlane,
That was lord of all the land
Between Thrace and Samarcand,
While the noontide fervour beam'd,
Mus'd herself to sleep, and *dream'd*——

 Thus far in magnific strain
A young poet sooth'd his vein,
But he had nor prose nor numbers
To express a princess' slumbers.——
Youthful Richard had strange fancies,
Was deep vers'd in old romances,
And could talk whole hours upon
The great Cham and Prester John,
Tell the field in which the Sophi
From the Tartar won a trophy——
What he read with such delight of,
Thought he could as eas'ly write of

Young student, who this story readest,
And with the same thy thoughts now feedest,
Thy weaker nerves might thee forbid
To do the thing the Spartan did ;
Thy feebler heart could not sustain
Such dire extremity of pain.
But in this story thou mayst see,
What may useful prove to thee.
By his example thou wilt find,
That to the ingenuous mind
Shame can greater anguish bring
Than the body's suffering ;
That pain is not the worst of ills,
Not when it the body kills ;
That in fair religion's cause,
For thy country, or the laws,
When occasion due shall offer,
'Tis reproachful *not to suffer*.
If thou shouldst a soldier be,
And a wound should trouble thee,
If without the soldier's fame
Thou to chance should owe a maim,
Do not for a little pain
On thy manhood bring a stain ;
But to keep thy spirit's whole,
Think on the Spartan and the *coal*.

THE SPARTAN BOY.

WHEN I the memory repeat
Of the heroic actions great,
Which, in contempt of pain and death,
Were done, by men who drew their breath
In ages past, I find no deed
That can in fortitude exceed
The noble boy, in Sparta bred,
Who in the temple minist'red.

By the sacrifice he stands,
The lighted incense in his hands.
Through the smoking censer's lid
Dropp'd a burning coal, which slid
Into his sleeve, and passëd in
Between the folds ev'n to the skin.
Dire was the pain which then he prov'd ;
But not for this his sleeve he mov'd,
Or would the scorching ember shake
Out from the folds, lest it should make
Any confusion, or excite
Disturbance at the sacred rite.
But close he kept the burning coal,
Till it eat itself a hole
In his flesh. The standers by
Saw no sign, and heard no cry,
Of his pangs had no discerning,
Till they smell'd the flesh a-burning.
All this he did in noble scorn,
And for he was a Spartan born.

The deeds of this eventful age,
 Which princes from their thrones have hurl'd,
Can no more interest wake in him
 Than stories of another world.

When I his length of days revolve,
 How like a strong tree he hath stood,
It brings into my mind almost
 Those patriarchs old before the flood.

The Great Grandfather.

THE GREAT GRANDFATHER.

My father's grandfather lives still,
 His age is fourscore years and ten ;
He looks a monument of time,
 The agedest of aged men.

Though years lie on him like a load,
 A happier man you will not see
Than he, whenever he can get
 His great grandchildren on his knee.

When we our parents have displeas'd,
 He stands between us as a screen ;
By him our good deeds in the sun,
 Our bad ones in the shade are seen.

His love's a line that's long drawn out,
 Yet lasteth firm unto the end ;
His heart is oak, yet unto us
 It like the gentlest reed can bend.

A fighting soldier he has been—
 Yet by his manners you would guess,
That he his whole long life had spent
 In scenes of country quietness.

His talk is all of things long past,
 For modern facts no pleasure yield—
Of the fam'd year of forty-five,
 Of William, and Culloden's field.

CONQUEST OF PREJUDICE

And when their master set them free,
 They thought a week was sure remitted,
And thank'd him that their liberty
 Had been before the time permitted.

Now Orme and Juba are good friends;
 The school, by Orme's example won,
Contend who most shall make amends
 For former slights to Afric's son.

Young Orme and Juba then he led
 Into a room, in which there were
For each of the two boys a bed,
 A table, and a wicker chair.

He lock'd them in, secur'd the key,
 That all access to them was stopt ;
They from without can nothing see ;
 Their food is through a skylight dropt.

A month in this lone chamber Orme
 Is sentenc'd during all that time
To view no other face or form
 Than Juba's parch'd by Afric clime.

One word they neither of them spoke
 The first three days of the first week ;
On the fourth day the ice was broke;
 Orme was the first that deign'd to speak.

The dreary silence o'er, both glad
 To hear of human voice the sound,
The Negro and the English lad
 Comfort in mutual converse found.

Of ships and seas, and foreign coast,
 Juba can speak, for he has been
A voyager : and Orme can boast
 He London's famous town has seen.

In eager talk they pass the day,
 And borrow hours ev'n from the night ;
So pleasantly time pass'd away,
 That they have lost their reckoning quite.

CONQUEST OF PREJUDICE.

Unto a Yorkshire school was sent
　　A negro youth to learn to write,
And the first day young Juba went
　　All gaz'd on him as a rare sight.

But soon with alter'd looks askance
　　They view his sable face and form,
When they perceive the scornful glance
　　Of the head boy, young Henry Orme.

He in the school was first in fame :
　　Said he, "It does to me appear
To be a great disgrace and shame
　　A black should be admitted here."

His words were quickly whisper'd round,
　　And every boy now looks offended ;
The master saw the change, and found
　　That Orme a mutiny intended.

Said he to Orme, "This African
　　It seems is not by you approv'd ;
I'll find a way, young Englishman,
　　To have this prejudice remov'd.

"Nearer acquaintance possibly
　　May make you tolerate his hue ;
At least 'tis my intent to try
　　What a short month may chance to do."

THE·FAIRY

SAID Ann to Matilda, "I wish that we knew
If what we've been reading of fairies be true.
Do you think that the poet himself had a sight of
The fairies he here does so prettily write of?
O what a sweet sight if he really had seen
The graceful Titania, the Fairy-land Queen!
If I had such dreams, I would sleep a whole year;
I would not wish to wake while a fairy was near.—
Now I'll fancy that I in my sleep have been seeing
A fine little delicate lady-like being,
Whose steps and whose motions so light were and airy,
I knew at one glance that she must be a fairy.
Her eyes they were blue, and her fine curling hair
Of the lightest of browns, her complexion more fair
Than I e'er saw a woman's; and then for her height,
I verily think that she measur'd not quite
Two feet, yet so justly proportion'd withal,
I was almost persuaded to think she was tall.
Her voice was the little thin note of a sprite—
There—d'ye think I have made out a fairy aright?
You'll confess, I believe, I've not done it amiss."
"Pardon me," said Matilda, "I find in all this
Fine description, you've only your young sister Mary
Been taking a copy of here for a fairy."

TIME SPENT IN DRESS

If faithfully you should perform
 This task, 'twould teach you to repair
Lost hours, by giving unto dress
 Not more of time than its due share.

Time Spent in Dress.

And ever when your silent thoughts
 Have on this subject been intent,
Set down as nearly as you can
 How long on dress your thoughts were bent.

Time Spent in Dress.

TIME SPENT IN DRESS.

In many a lecture, many a book,
 You all have heard, you all have read,
That time is precious. Of its use
 Much has been written, much been said.

The accomplishments which gladden life,
 As music, drawing, dancing, are
Encroachers on our precious time;
 Their praise or dispraise I forbear.

They should be practis'd or forborne,
 As parents wish, or friends desire:
What rests alone in their own will
 Is all I of the young require.

There's not a more productive source
 Of waste of time to the young mind
Than dress; as it regards our hours
 My view of it is now confin'd.

Without some calculation, youth
 May live to age and never guess,
That no one study they pursue
 Takes half the time they give **to** dress.

Write in your memorandum-book
 The time you at your toilette spend;
Then every moment which you pass,
 Talking of dress with a young friend:

ON BEING TOO FOND OF MUSIC

But we misconstrue, and defeat
 The end of any good ;
When what should be our casual treat,
 We make our constant food.

While, to th' exclusion of the rest,
 This single art you ply,
Your nobler studies are supprest,
 Your books neglected lie.

Could you in what you so affect
 The utmost summit reach ;
Beyond what fondest friends expect,
 Or skilful'st masters teach :

The skill you learn'd would not repay
 The time and pains it cost,
Youth's precious season thrown away,
 And reading-leisure lost.

A benefit to books we owe
 Music can ne'er dispense ;
The one does only *sound* bestow,
 The other gives us *sense*.

TO A YOUNG LADY,

ON BEING

TOO FOND OF MUSIC.

Why is your mind thus all day long
 Upon your music set;
Till reason's swallow'd in a song,
 Or idle canzonet?

I grant you, Melesinda, when
 Your instrument was new,
I was well pleas'd to see you then
 Its charms assiduous woo.

The rudiments of any art
 Or mast'ry that we try,
Are only on the learner's part
 Got by hard industry.

But you are past your first essays;
 Whene'er you play, your touch,
Skilful and light, ensures you praise:
 All beyond that's too much.

Music's sweet uses are, to smooth
 Each rough and angry passion;
To elevate at once, and soothe:
 A heavenly recreation.

THE DESSERT.

WITH the apples and the plums
Little Carolina comes,
At the time of the dessert she
Comes and drops her last new curt'sy;
Graceful curt'sy, practis'd o'er
In the nursery before.
What shall we compare her to?
The dessert itself will do.
Like preserves she's kept with care,
Like blanch'd almonds she is fair,
Soft as down on peach her hair,
And so soft, so smooth is each
Pretty cheek as that same peach,
Yet more like in hue to cherries;
Then her lips, the sweet strawberries,
Caroline herself shall try them
If they are not like when nigh them;
Her bright eyes are black as sloes,
But I think we've none of those
Common fruit here—and her chin
From a round point does begin,
Like the small end of a pear;
Whiter drapery she does wear
Than the frost on cake; and sweeter
Than the cake itself, and neater,
Though bedeck'd with emblems fine,
Is our little Caroline.

He sees them droop for want of more ;—
Yet when they reach the destin'd shore,
With pride th' heroic gardener sees
A living sap still in his trees.
The islanders his praise resound ;
Coffee plantations rise around ;
And Martinico loads her ships
With produce from those dear-sav'd slips.[1]

[1] The name of this man was Desclieux, and the story is to be found in the Abbé Raynal's *History of the Settlements and Trade of the Europeans in the East ana West Indies*, book xiii.

The Coffee Slips.

THE COFFEE SLIPS.

WHENE'ER I fragrant coffee drink,
I on the generous Frenchman think,
Whose noble perseverance bore
The tree to Martinico's shore.
While yet her colony was new,
Her island products but a few,
Two shoots from off a coffee-tree
He carried with him o'er the sea.
Each little tender coffee slip
He waters daily in the ship,
And as he tends his embryo trees,
Feels he is raising midst the seas
Coffee groves, whose ample shade
Shall screen the dark Creolian maid.
But soon, alas ! his darling pleasure
In watching this his precious treasure
Is like to fade,—for water fails
On board the ship in which he sails.
Now all the reservoirs are shut,
The crew on short allowance put ;
So small a drop is each man's share,
Few leavings you may think there are
To water these poor coffee plants ;—
But he supplies their gasping wants,
Ev'n from his own dry parchëd lips
He spares it for his coffee slips.
Water he gives his nurslings first,
Ere he allays his own deep thirst,
Lest, if he first the water sip,
He bear too far his eager lip.

HOME DELIGHTS.

To operas and balls my cousins take me,
And fond of plays my new-made friend would make
 me.
In summer season, when the days are fair,
In my godmother's coach I take the air.
My uncle has a stately pleasure barge,
Gilded and gay, adorn'd with wondrous charge ;
The mast is polish'd, and the sails are fine,
The awnings of white silk like silver shine ;
The seats of crimson satin, where the rowers
Keep time to music with their painted oars ;
In this on holidays we oft resort
To Richmond, Twickenham, or to Hampton Court.
By turns we play, we sing—one baits the hook,
Another angles—some more idle look
At the small fry that sport beneath the tides,
Or at the swan that on the surface glides.
My married sister says there is no feast
Equal to sight of foreign bird or beast.
With her in search of these I often roam :
My kinder parents make me blest at home.
Tir'd of excursions, visitings, and sights,
No joys are pleasing to these home delights.

WHY NOT DO IT, SIR, TO-DAY?

"Why so I will, you noisy bird,
 This very day I'll advertise you,
 Perhaps some busy ones may prize you.
A fine-tongu'd parrot as was ever heard,
I'll word it thus—set forth all charms about you,
And say no family should be without you."

 Thus far a gentleman address'd a bird,
Then to his friend: "An old procrastinator,
Sir, I am: do you wonder that I hate her?
 Though she but seven words can say,
 Twenty and twenty times a day
 She interferes with all my dreams,
 My projects, plans, and airy schemes,
 Mocking my foible to my sorrow:
 I'll advertise this bird to-morrow."

 To this the bird seven words did say:
 "Why not do it, sir, to-day?"

CLOCK STRIKING.

DID I hear the church-clock a few minutes ago,
I was ask'd, and I answer'd, I hardly did know,
 But I thought that I heard it strike three.
Said my friend then, "The blessings we always
 possess
We know not the want of, and prize them the less;
 The church-clock was no new sound to thee.

"A young woman, afflicted with deafness a year,
By that sound you scarce heard, first perceiv'd she
 could *hear*;
 I was near her, and saw the girl start
With such exquisite wonder, such feelings of pride,
A happiness almost to terror allied,
 She shew'd the sound went to her heart."

Of hostile fleets, disturb'd no more
By all that vast conflicting roar,
That sky and sea did seem to tear,
When vessels whole blew up in air,
Than at the smallest breath that heaves,
When Zephyr hardly stirs the leaves.

THE
FORCE OF
HABIT

A LITTLE child, who had desired
To go and see the Park guns fired,
Was taken by his maid that way
Upon the next rejoicing day.
Soon as the unexpected stroke
Upon his tender organs broke,
Confus'd and stunn'd at the report,
He to her arms fled for support,
And begg'd to be convey'd at once
Out of the noise of those great guns,
Those naughty guns, whose only sound
Would kill (he said) without a wound :
So much of horror and offence
The shock had given his infant sense.

Yet this was He in after days
Who filled the world with martial praise,
When from the English quarter-deck
His steady courage sway'd the wreck

143

All the wondrous variations
Of the tulip, pinks, carnations,
This woodbine here both flower and leaf;
'Tis a truth that's past belief,
That every flower and every tree,
And every living thing we see,
Every face which we espy,
Every cheek and every eye,
In all their tints, in every shade,
Are from the rainbow's colours made.

"Safely shelter'd from the shower."

THE RAINBOW.

AFTER the tempest in the sky
How sweet yon rainbow to the eye !
Come, my Matilda, now while some
Few drops of rain are yet to come,
In this honeysuckle bower
Safely shelter'd from the shower,
We may count the colours o'er.—
Seven there are, there are no more ;
Each in each so finely blended,
Where they begin, or where are ended,
The finest eye can scarcely see.
A fixed thing it seems to be ;
But, while we speak, see, how it glides
Away, and now observe it hides
Half of its perfect arch—now we
Scarce any part of it can see.
What is colour ? If I were
A natural philosopher,
I would tell you what does make
This meteor every colour take :
But an unlearned eye may view
Nature's rare sights, and love them too.
Whenever I a rainbow see,
Each precious tint is dear to me ;
For every colour find I there,
Which flowers, which fields, which ladies wear:
My favourite green, the grass's hue,
And the fine deep violet-blue,
And the pretty pale blue-bell,
And the rose I love so well,

PENNY PIECES.

"I KEEP it, dear papa, within my glove."
"You do—what sum then usually, my love,
Is there deposited ? I make no doubt,
Some penny pieces you are not without."
 "O no, papa, they'd soil my glove, and be
Quite odious things to carry. O no—see,
This little bit of gold is surely all
That I shall want ; for I shall only call
For a small purchase I shall make, papa,
And a mere trifle I'm to buy mamma,
Just to make out the change : so there's no need
To carry penny pieces, sir, indeed."
 "O now I know then why a blind man said
Unto a dog which this blind beggar led,—
'Where'er you see some fine young ladies, Tray,
Be sure you lead me quite another way.
The poor man's friend fair ladies us'd to be ;
But now I find no tale of misery
Will ever from their pockets draw a penny '—
The blind man did not see *they wear not any*."

EYES.

LUCY, what do you espy
In the cast in Jenny's eye
That should you to laughter move?
I far other feelings prove.
When on me she does advance
Her good-natur'd countenance,
And those eyes which in their way
Saying much, so much would say,
They to me no blemish seem,
Or as none I them esteem;
I their imperfection prize
Above other clearer eyes.

Eyes do not as jewels go
By the brightness and the show,
But the meanings which surround them,
And the sweetness shines around them.

Isabel's are black as jet,
But she cannot that forget,
And the pains she takes to show them
Robs them of the praise we owe them.
Ann's, though blue, affected fall;
Kate's are bright, and fierce withal;
And the sparklers of her sister
From ill-humour lose their lustre.
Only Jenny's eyes we see,
By their very plainness, free
From the vices which do smother
All the beauties of the other.

138

THOUGHTLESS CRUELTY

A fly a little thing you rate,
But, Robert, do not estimate
A creature's pain by small or great ;
 The greatest being

Can have but fibres, nerves, and flesh,
And these the smallest ones possess,
Although their frame and structure less
 Escape our seeing.

THOUGHTLESS CRUELTY.

There, Robert, you have kill'd that fly,
And should you thousand ages try
The life you've taken to supply,
 You could not do it.

You surely must have been devoid
Of thought and sense, to have destroy'd
A thing which no way you annoy'd—
 You'll one day rue it.

'Twas but a fly perhaps you'll say,
That's born in April, dies in May;
That does but just learn to display
 His wings one minute,

And in the next is vanish'd quite:
A bird devours it in his flight,
Or come a cold blast in the night,
 There's no breath in it.

The bird but seeks his proper food;
And Providence, whose power endu'd
That fly with life, when it thinks good,
 May justly take it.

But you have no excuses for't;
A life by Nature made so short,
Less reason is that you for sport
 Should shorter make it.

THE CONFIDANT.

Anna was always full of thought
 As if she'd many sorrows known,
Yet mostly her full heart was fraught
 With troubles that were not her own ;
For the whole school to Anna us'd to tell
Whatever small misfortunes unto them befell.

And being so by all belov'd,
 That all into her bosom pour'd
Their dearest secrets, she was mov'd
 To pity all—her heart a hoard,
Or storehouse, by this means became for all
The sorrows can to girls of tender age befall.

Though individually not much
 Distress throughout the school prevail'd,
Yet as she shar'd it all, 'twas such
 A weight of woe that her assail'd,
She lost her colour, loath'd her food, and grew
So dull, that all their confidence from her withdrew.

Releasëd from her daily care,
 No longer listening to complaint,
She seems to breathe a different air,
 And health once more her cheek does paint.
Still Anna loves her friends, but will not hear
Again their list of grievances which cost so dear.

On satin ever match'd the pride
Of that which marks his furry hide.
How strong his muscles ! he with ease
Upon the tallest man could seize,
In his large mouth away could bear him,
And into thousand pieces tear him :
Yet cabined so securely here,
The smallest infant need not fear.

That lordly creature next to him
A lion is. Survey each limb.
Observe the texture of his claws,
The massy thickness of those jaws ;
His mane that sweeps the ground in length,
Like Samson's locks, betok'ning strength.
In force and swiftness he excels
Each beast that in the forest dwells ;
The savage tribes him king confess
Throughout the howling wilderness.
Woe to the hapless neighbourhood,
When he is press'd by want of food !
Of man, or child, of bull, or horse,
He makes his prey ; such is his force.
A waste behind him he creates,
Whole villages depopulates.
Yet here within appointed lines
How small a grate his rage confines !

This place methinks resembleth well
The world itself in which we dwell.
Perils and snares on every ground
Like these wild beasts beset us round.
But Providence their rage restrains,
Our heavenly Keeper sets them chains ;
His goodness saveth every hour
His darlings from the lion's power.

"Within the narrow precincts of this yard."

THE BEASTS IN THE TOWER.

WITHIN the precincts of this yard,
Each in his narrow confines barr'd,
Dwells every beast that can be found
On Afric or on Indian ground.
How different was the life they led
In those wild haunts where they were bred,
To this tame servitude and fear,
Enslav'd by man, they suffer here !

In that uneasy close recess
Couches a sleeping lioness ;
That next den holds a bear; the next
A wolf, by hunger ever vext ;
There, fiercer from the keeper's lashes
His teeth the fell hyæna gnashes ;
That creature on whose back abound
Black spots upon a yellow ground,
A panther is, the fairest beast
That haunteth in the spacious East.
He underneath a fair outside
Does cruelty and treach'ry hide.

That cat-like beast that to and fro
Restless as fire does ever go,
As if his courage did resent
His limbs in such confinement pent,
That should their prey in forests take,
And make the Indian jungles quake,
A tiger is. Observe how sleek
And glossy smooth his coat : no streak

MY BIRTHDAY

By her care I'm alive now—but what retribution
　　Can I for a life twice bestow'd thus confer?
Were I to be silent, each year's revolution
　　Proclaims—each new birthday is owing to her.

The chance-rooted tree that by waysides is planted,
　　Where no friendly hand will watch o'er its young
　　　　shoots,
Has less blame if in autumn, when produce is wanted,
　　Enrich'd by small culture it put forth small fruits.

But that which with labour in hot-beds is reared,
　　Secur'd by nice art from the dews and the rains,
Unsound at the root may with justice be feared,
　　If it pay not with interest the tiller's hard pains.

MY BIRTHDAY.

A DOZEN years since in this house what commotion,
 What bustle, what stir, and what joyful ado ;
Ev'ry soul in the family at my devotion,
 When into the world I came twelve years ago.

I've been told by my friends (if they do not belie me)
 My promise was such as no parent would scorn ;
The wise and the aged who prophesied by me
 Augur'd nothing but good of me when I was born.

But vain are the hopes which are form'd by a parent,
 Fallacious the marks which in infancy shine ;
My frail constitution soon made it apparent,
 I nourish'd within me the seeds of decline.

On a sick bed I lay, through the flesh my bones
 started,
 My grief-wasted frame to a skeleton fell ;
My physicians foreboding took leave and departed,
 And they wish'd me dead now, who wishëd me
 well.

Life and soul were kept in by a mother's assistance,
 Who struggled with faith, and prevail'd 'gainst
 despair ;
Like an angel she watch'd o'er the lamp of existence,
 And never would leave while a glimmer was there.

CHARITY

Having two cloaks, give one (said our Lord) to the
 poor ;
 In such bounty as that lies the trial :
But a child that gives half of its infantile store
 Has small praise, because small self-denial.

You eat, and you drink ; when you rise in the morn,
 You are cloth'd ; you have health and content ;
And you never have known, from the day you were
 born,
 What hunger or nakedness meant.

The most which your bounty from you can subtract
 Is an apple, a sweetmeat, a toy ;
For so easy a virtue, so trifling an act,
 You are paid with an innocent joy.

Give thy bread to the hungry, the thirsty thy cup ;
 Divide with th' afflicted thy lot :
This can only be practis'd by persons grown up,
 Who've possessions which children have not.

CHARITY.

O why your good deeds with such pride do you scan,
 And why that self-satisfied smile
At the shilling you gave to the poor working man,
 That lifted you over the stile ?

'Tis not much ; all the bread that can with it be
 bought,
 Will scarce give a morsel to each
Of his eight hungry children ;—reflection and thought
 Should you more humility teach.

Vainglory's a worm which the very best action
 Will taint, and its soundness eat thro' ;
But to give one's self airs for a small benefaction,
 Is folly and vanity too.

The money perhaps by your father or mother
 Was furnish'd you but with that view ;
If so, you were only the steward of another,
 And the praise you usurp is their due.

Perhaps every shilling you give in this way
 Is paid back with two by your friends ;
Then the bounty you so ostentatious display,
 Has little and low selfish ends.

But if every penny you gave were your own,
 And giving diminish'd your purse ;
By a child's slender means think how little is done,
 And how little for it you're the worse.

INCORRECT SPEAKING.

INCORRECTNESS in your speech
 Carefully avoid, my Anna ;
Study well the sense of each
 Sentence, lest in any manner
It misrepresent the truth ;
Veracity's the charm of youth.

You will not, I know, tell lies,
 If you know what you are speaking.
Truth is shy, and from us flies ;
 Unless diligently seeking
Into every word we pry,
Falsehood will her place supply.

Falsehood is not shy, not she,—
 Ever ready to take place of
Truth, too oft we Falsehood see,
 Or at least some latent trace of
Falsehood, in the incorrect
Words of those who Truth respect.

MODERATION IN DIET

Go see some show ; pictures or prints ;
 Or beasts far brought from Indian land ;
Those foreign sights oft furnish hints,
 That may the youthful mind expand.

And something of your store impart,
 To feed the poor and hungry soul ;
What buys for you the needless tart,
 May purchase him a needful roll.

If parent, aunt, or liberal friend,
　With splendid shilling line your purse,
Do not the same on sweetmeats spend,
　Nor appetite with pampering nurse.

Moderation in Diet.

Go buy a book ; a dainty eaten
　Is vanish'd, and no sweets remain ;
They who their minds with knowledge sweeten,
　The savour long as life retain.

Purchase some toy ; a horse of wood,
　A pasteboard ship ; their structure scan ;
Their mimic uses understood
　The school-boy make a kind of man.

MODERATION IN DIET.

The drunkard's sin, excess in wine,
 Which reason drowns, and health destroys,
As yet no failing is of thine,
 Dear Jim; strong drink's not given to boys.

You from the cool fresh stream allay
 Those thirsts which sultry suns excite;
When chok'd with dust, or hot with play,
 A cup of water yields delight.

And reverence still that temperate cup,
 And cherish long the blameless taste;
To learn the faults of men grown up,
 Dear Jim, be wise and do not haste.

They'll come too soon.—But there's a vice,
 That shares the world's contempt no less;
To be in eating over-nice,
 Or to court surfeits by excess.

The first, as finical, avoid;
 The last is proper to a swine:
By temperance meat is best enjoy'd;
 Think of this maxim when you dine.

Prefer with plain food to be fed,
 Rather than what are dainties styl'd;
A sweet tooth in an infant's head
 Is pardon'd, not in a grown child.

GOOD TEMPER.

In whatsoever place resides
Good Temper, she o'er all presides;
The most obdurate heart she guides.

Even Anger yields unto her power,
And sullen Spite forgets to lour,
Or reconcilèd weeps a shower;

Reserve she softens into Ease,
Makes Fretfulness leave off to tease,
She Waywardness itself can please.

Her handmaids they are not a few:
Sincerity that's ever true,
And prompt Obedience always new,

Urbanity that ever smiles,
And Frankness that ne'er useth wiles,
And Friendliness that ne'er beguiles,

And Firmness that is always ready
To make young good-resolves more steady,
The only safeguard of the giddy;

And blushing Modesty, and sweet
Humility in fashion neat;
Yet still her train is incomplete,

Unless meek Piety attend
Good Temper as her surest friend,
Abiding with her to the end.

NURSE GREEN

"And should they do so and the coffin uncover,
 The corpse underneath it would be no ill sight ;
This frame, when its animal functions are over,
 Has nothing of horror the living to fright.

"To start at the dead is preposterous error,
 To shrink from a foe that can never contest ;
Shall that which is motionless move thee to terror ;
 Or thou become restless, 'cause they are at rest ?

"To think harm of her our good feelings forbid us
 By whom when a babe you were dandled and fed ;
Who living so many good offices did us,
 I ne'er can persuade me. would hurt us when dead.

"But if no endeavour your terrors can smother,
 If vainly against apprehension you strive,
Come, bury your fears in the arms of your mother ;
 My darling, cling close to me, I am alive."

NURSE GREEN

" Your prayers you have said, and you've wished good
 night :
 What cause is there yet keeps my darling awake ?
This throb in your bosom proclaims some affright
 Disturbs your composure. Can innocence quake ?

" Why thus do you cling to my neck, and enfold me,
 What fear unimparted your quiet devours ? "
" O mother, there's reason—for Susan has told me,
 A dead body lies in the room next to ours."

"I know it ; and, but for forgetfulness, dear,
 I meant you the coffin this day should have seen,
And read the inscription, and told me the year
 And day of the death of your poor old Nurse Green."

" O not for the wealth of the world would I enter
 A chamber wherein a dead body lay hid,
Lest somebody bolder than I am should venture
 To go near the coffin and lift up the lid."

THE BROTHER'S REPLY

Who the lives and actions show
Of men famous long ago ;
Ev'n their very sayings giving
In the tongue they us'd when living.

Think not I shall do that wrong
Either to my native tongue,
English authors to despise,
Or those books which you so prize ;
Though from them awhile I stray,
By new studies called away,
Them when next I take in hand,
I shall better understand.
For I've heard wise men declare
Many words in English are
From the Latin tongue deriv'd,
Of whose sense girls are depriv'd
'Cause they do not Latin know.—
But if all this anger grow
From this cause, that you suspect
By proceedings indirect,
I would keep (as misers pelf)
All this learning to myself ;
Sister, to remove this doubt,
Rather than we will fall out,
(If our parents will agree)
You shall Latin learn with me.

THE BROTHER'S REPLY.

SISTER, fie, for shame, no more,
Give this ignorant babble o'er,
Nor with little female pride
Things above your sense deride.
Why this foolish under-rating
Of my first attempts at Latin?
Know you not each thing we prize
Does from small beginnings rise?
'Twas the same thing with your writing,
Which you now take such delight in.
First you learnt the down-stroke line,
Then the hair-stroke thin and fine,
Then a curve, and then a better,
Till you came to form a letter;
Then a new task was begun,
How to join them two in one;
Till you got (these first steps past)
To your fine text-hand at last.
So though I at first commence
With the humble accidence,
And my study's course affords
Little else as yet but words,
I shall venture in a while
At construction, grammar, style,
Learn my syntax, and proceed
Classic authors next to read,
Such as wiser, better, make us,
Sallust, Phædrus, Ovid, Flaccus:
All the poets (with their wit),
All the grave historians writ,

The Sister's Expostulation.

Or in what they do excel
Our word, *song*. It sounds as well
To my fancy as the other.
Now believe me, dearest brother,
I would give my finest frock,
And my cabinet, and stock
Of new playthings, every toy,
I would give them all with joy,
Could I you returning see
Back to English and to me.

THE SISTER'S EXPOSTULATION

ON THE

BROTHER'S LEARNING LATIN.

SHUT these odious books up, brother;
They have made you quite another
Thing from what you us'd to be—
Once you lik'd to play with me—
Now you leave me all alone,
And are so conceited grown
With your Latin, you'll scarce look
Upon any English book.
We had used on winter eves
To con over Shakespeare's leaves,
Or on Milton's harder sense
Exercise our diligence—
And you would explain with ease
The obscurer passages,
Find me out the prettiest places,
The poetic turns, and graces,
Which, alas! now you are gone,
I must puzzle out alone,
And oft miss the meaning quite,
Wanting you to set me right.
All this comes since you've been under
Your new master. I much wonder
What great charm it is you see
In those words, *musa, musæ*;

THE OFFER.

"TELL me, would you rather be
Chang'd by a fairy to the fine
Young orphan heiress Geraldine,
 Or still be Emily?

"Consider, ere you answer me,
How many blessings are procur'd
By riches, and how much endur'd
 By chilling poverty."

After a pause, said Emily:
"In the words orphan heiress I
Find many a solid reason why
 I would not changëd be.

"What though I live in poverty,
And have of sisters eight—so many,
That few indulgencies, if any,
 Fall to the share of me:

"Think you that for wealth I'd be
Of ev'n the least of them bereft,
Or lose my parent, and be left
 An orphaned Emily?

"Still should I be Emily,
Although I look'd like Geraldine;
I feel within this heart of mine
 No change could workëd be."

The Two Boys.

THE TWO BOYS.

I saw a boy with eager eye
Open a book upon a stall,
And read as he'd devour it all:
Which when the stall-man did espy,
Soon to the boy I heard him call,
"You, sir, you never buy a book,
Therefore in one you shall not look."
The boy pass'd slowly on, and with a sigh
He wished he never had been taught to read,
Then of the old churl's books he should have had no
 need.

Of sufferings the poor have many,
Which never can the rich annoy.
I soon perceiv'd another boy
Who looked as if he'd not had any
Food for that day at least, enjoy
The sight of cold meat in a tavern-larder.
This boy's case, thought I, is surely harder,
Thus hungry longing, thus without a penny,
Beholding choice of dainty dressed meat:
No wonder if he wish he ne'er had learn'd to eat.

Parental Recollections.

PARENTAL RECOLLECTIONS.

A CHILD's a plaything for an hour ;
 Its pretty tricks we try
For that or for a longer space ;
 Then tire, and lay it by.

But I knew one, that to itself
 All seasons could control ;
That would have mock'd the sense of pain
 Out of a grievëd soul.

Thou, straggler into loving arms,
 Young climber up of knees,
When I forget thy thousand ways,
 Then life and all shall cease.

WEEDING

" The world, my Aurelia, this garden of ours
 Resembles : too apt we're to deem
In the world's larger garden ourselves as the flowers,
 And the poor but as weeds to esteem.

" But them if we rate, or with rudeness repel,
 Though some will be passive enough,
From others who 're more independent 'tis well
 If we meet not a *stinging rebuff*."

WEEDING.

As busy Aurelia, 'twixt work and 'twixt play,
 Was lab'ring industriously hard
To cull the vile weeds from the flow'rets away,
 Which grew in her father's court-yard ;

In her juvenile anger, wherever she found,
 She pluck'd, and she pull'd, and she tore ;
The poor passive suff'rers bestrew'd all the ground ;
 Not a weed of them all she forbore.

At length 'twas her chance on some nettles to light
 (Things, till then, she had scarcely heard nam'd) ;
The vulgar intruders call'd forth all her spite ;
 In a transport of rage she exclaim'd,

"Shall briars so unsightly and worthless as those
 Their great sprawling leaves thus presume
To mix with the pink, the jonquil, and the rose,
 And take up a flower's sweet room ?"

On the odious offenders enragëd she flew ;
 But she presently found to her cost
A tingling unlook'd for, a pain that was new,
 And rage was in agony lost.

To her father she hastily fled for relief,
 And told him her pain and her smart ;
With kindly caresses he soothëd her grief,
 Then smiling he took the weed's part.

Breakfast.

BREAKFAST.

A DINNER party, coffee, tea,
Sandwich, or supper, all may be
In their way pleasant. But to me
Not one of these deserves the praise
That welcomer of new-born days,
A breakfast, merits; ever giving
Cheerful notice we are living
Another day refresh'd by sleep,
When its festival we keep.
Now although I would not slight
Those kindly words we use, "Good night,"
Yet parting words are words of sorrow,
And may not vie with sweet "Good morrow,"
With which again our friends we greet,
When in the breakfast-room we meet,
At the social table round,
Listening to the lively sound
Of those notes which never tire,
Of urn, or kettle on the fire.
Sleepy Robert never hears
Or urn or kettle; he appears
When all have finish'd, one by one
Dropping off, and breakfast done.
Yet has he too his own pleasure,
His breakfast hour's his hour of leisure;
And, left alone, he reads or muses,
Or else in idle mood he uses
To sit and watch the vent'rous fly,
Where the sugar's pilëd high,
Clambering o'er the lumps so white,
Rocky cliffs of sweet delight.

CHOOSING A PROFESSION.

A CREOLE boy from the West Indies brought,
To be in European learning taught,
Some years before to Westminster he went,
To a preparatory school was sent.
When from his artless tale the mistress found,
The child had not one friend on English ground,
She, ev'n as if she his own mother were,
Made the dark Indian her peculiar care.
Oft on her fav'rite's future lot she thought;
To know the bent of his young mind she sought,
For much the kind preceptress wish'd to find
To what profession he was most inclin'd,
That where his genius led they might him train;
For nature's kindly bent she held not vain.
But vain her efforts to explore his will;
The frequent question he evaded still:
Till on a day at length he to her came,
Joy sparkling in his eyes; and said, the same
Trade he would be those boys of colour were,
Who danc'd so happy in the open air.
It was a troop of chimney-sweeping boys,
With wooden music and obstrep'rous noise,
In tarnish'd finery and grotesque array,
Were dancing in the street the first of May.

A heedless wilful dunce, and wild,
The parents' fondness spoil'd the child;
The youth in vagrant courses ran;
Now abject, stooping, old, and wan,
Their fondling is the beggar-man.

The Beggar-man.

THE BEGGAR-MAN.

ABJECT, stooping, old, and wan,
See yon wretched beggar-man ;
Once a father's hopeful heir,
Once a mother's tender care.
When too young to understand
He but scorch'd his little hand,
By the candle's flaming light
Attracted, dancing, spiral, bright,
Clasping fond her darling round,
A thousand kisses heal'd the wound.
Now abject, stooping, old, and wan,
No mother tends the beggar-man.

Then nought too good for him to wear,
With cherub face and flaxen hair,
In fancy's choicest gauds array'd,
Cap of lace with rose to aid,
Milk-white hat and feather blue,
Shoes of red, and coral too
With silver bells to please his ear,
And charm the frequent ready tear.
Now abject, stooping, old, and wan,
Neglected is the beggar-man.

See the boy advance in age,
And learning spreads her useful page ;
In vain ! for giddy pleasure calls,
And shows the marbles, tops, and balls.
What's learning to the charms of play ?
The indulgent tutor must give way.

WHICH IS THE FAVOURITE?

While they are half the year at school ;
And yet that neither is no rule.
I've nam'd them all, there's only seven ;
I find my love to all so even,
To every sister, every brother,
I love not one more than another.

WHICH IS THE FAVOURITE?

BROTHERS and sisters I have many :
Though I know there is not any
Of them but I love, yet I
Will just name them all ; and try
As one by one I count them o'er,
If there be one a little more
Lov'd by me than all the rest.
Yes ; I do think, that I love best
My brother Henry, because he
Has always been most fond of me.
Yet, to be sure, there's Isabel ;
I think I love her quite as well.
And, I assure you, little Ann,
No brother nor no sister can
Be more dear to me than she.
Only I must say, Emily,
Being the eldest, it's right her
To all the rest I should prefer
Yet after all I've said, suppose
My greatest favourite should be Rose.
No, John and Paul are both more dear
To me than Rose, that's always here.

THE SPARROW AND THE HEN

" Have you e'er learn'd to read?" said the hen to the
 sparrow.
 "No, madam," he answered, "I can't say I have."
" Then that is the reason your sight is so narrow,"
 The old hen replied, with a look very grave.

" Mrs. Glasse in a Treatise—I wish you could read—
 Our importance has shown, and has prov'd to us
 why
Man shields us and feeds us : of us he has need
 Even before we are born, even after we die."

THE SPARROW AND THE HEN.

A SPARROW, when sparrows like parrots could speak,
 Addressed an old hen who could talk like a jay :
Said he, " It's unjust that we sparrows must seek
 Our food, when your family's fed every day.

" Were you like the peacock, that elegant bird,
 The sight of whose plumage his master may please,
I then should not wonder that you are preferr'd
 To the yard, where in affluence you live at your
 ease.

" I affect no great style, am not costly in feathers,
 A good honest brown I find most to my liking,
It always looks neat, and is fit for all weathers,
 But I think your grey mixture is not very striking.

" We know that the bird from the isles of Canary
 Is fed, foreign airs to sing in a fine cage ;
But your note from a cackle so seldom does vary,
 The fancy of man it cannot much engage.

" My chirp to a song sure approaches much nearer,
 Nay the nightingale tells me I sing not amiss ;
If voice were in question I ought to be dearer ;
 But the owl he assures me there's nothing in this.

" Nor is it your proneness to domestication,
 For he dwells in man's barn, and I build in man's
 thatch
As we say to each other—but, to our vexation,
 O'er your safety alone man keeps diligent watch."

LOVE, DEATH, AND REPUTATION.

A FABLE.

Once on a time, Love, Death, and Reputation,
Three travellers, a tour together went;
And, after many a long perambulation,
Agreed to part by mutual consent.

Death said: "My fellow tourists, I am going
To seek for harvests in th' embattled plain;
Where drums are beating, and loud trumpets blowing,
There you'll be sure to meet with me again."

Love said: "My friends, I mean to spend my leisure
With some young couple, fresh in Hymen's bands;
Or 'mongst relations, who in equal measure
Have had bequeathëd to them house or lands."

But Reputation said: "If once we sever,
Our chance of future meeting is but vain:
Who parts from me, must look to part for ever,
For *Reputation lost comes not again.*"

THE MEN AND WOMEN,

AND

THE MONKEYS.

A FABLE.

When beasts by words their meanings could declare,
Some well-drest men and women did repair
To gaze upon two monkeys at a fair :

And one who was the spokesman in the place
Said, in their count'nance you might plainly trace
The likeness of a wither'd old man's face.

His observation none impeached or blam'd,
But every man and woman when 'twas nam'd
Drew in the head, or slunk away asham'd.

One monkey, who had more pride than the other,
His infinite chagrin could scarcely smother ;
But Pug the wiser said unto his brother :

"The slights and coolness of this human nation
Should give a sensible ape no mort'fication ;
'Tis thus they always serve a poor relation."

THE BOY AND THE SKYLARK

" Dull fool ! to think we sons of air
On man's low actions waste a care,
 His virtues or his vices ;
Or soaring on the summer gales,
That we should stoop to carry tales
 Of him or his devices !

" Our songs are all of the delights
We find in our wild airy flights,
 And heavenly exaltation ;
The earth you mortals have at heart,
Is all too gross to have a part
 In skylarks' conversation.

" Unless it be in what green field
Or meadow we our nest may build,
 Midst flowering broom, or heather ,
From whence our new-fledg'd offspring may
With least obstruction wing their way
 Up to the walks of ether.

" Mistaken fool ! man needs not us
His secret merits to discuss,
 Or spy out his transgression ;
When once he feels his conscience stirr'd,
That voice within him is the *bird*
 That moves him to confession."

His conscience slept a day or two,
As it is very apt to do
 When we with pains suppress it :
And though at times a slight remorse
Would raise a pang, it had not force
 To make him yet confess it.

When on a day, as he abroad
Walk'd by his mother, in their road
 He heard a skylark singing ;
Smit with the sound, a flood of tears
Proclaim'd the superstitious fears
 His inmost bosom wringing.

His mother, wondering, saw him cry,
And fondly asked the reason why ;
 Then Richard made confession,
And said, he fear'd the little bird
He singing in the air had heard
 Was telling his transgression.

The words which Richard spoke below,
As sounds by nature upwards go,
 Were to the skylark carried ;
The airy traveller with surprise
To hear his sayings, in the skies
 On his mid journey tarried.

His anger then the bird exprest :
" Sure, since the day I left the nest,
 I ne'er heard folly utter'd
So fit to move a skylark's mirth,
As what this little son of earth
 Hath in his grossness mutter'd.

WG

"He . . . walk'd by his mother."

THE BOY AND THE SKYLARK.

A FABLE.

" A WICKED action fear to do,
When you are by yourself; for though
 You think you can conceal it,
A little bird that's in the air
The hidden trespass shall declare,
 And openly reveal it."

Richard this saying oft had heard,
Until the sight of any bird
 Would set his heart a-quaking;
He saw a host of wingëd spies
For ever o'er him in the skies,
 Note of his actions taking.

This pious precept, while it stood
In his remembrance, kept him good
 When nobody was by him;
For though no human eye was near,
Yet Richard still did wisely fear
 The little bird should spy him.

But best resolves will sometimes sleep;
Poor frailty will not always keep
 From that which is forbidden;
And Richard, one day, left alone,
Laid hands on something not his own,
 And hop'd the theft was hidden.

THE MAGPIE'S NEST

Still the pie went on showing her art,
 Till a nest she had built up half way ;
She no more of her skill would impart,
 But in anger went flutt'ring away.

And this speech in their hearing she made,
 As she perch'd o'er their heads on a tree,
"If ye all were well skill'd in my trade,
 Pray, why came ye to learn it of me ?"—

When a scholar is willing to learn,
 He with silent submission should hear.
Too late they their folly discern ;
 The effect to this day does appear :

For whenever a pie's nest you see,
 Her charming warm canopy view,
All birds' nests but hers seem to be
 A magpie's nest just cut in two.

To the magpie soon every bird went,
 And in modest terms made their request,
That she would be pleas'd to consent
 To teach them to build up a nest.

She replied, " I will show you the way,
 So observe every thing that I do.
First two sticks cross each other I lay "—
 " To be sure," said the crow ; "why, I knew

" It must be begun with two sticks,
 And I thought that they crossëd should be."
Said the pie, " Then some straw and moss mix
 In the way you now see done by me."

" O yes, certainly," said the Jack Daw,
 " That must follow of course, I have thought ;
Though I never before building saw,
 I guess'd that without being taught."

" More moss, straw, and feathers, I place,
 In this manner," continued the pie.
" Yes, no doubt, madam, that is the case ;
 Though no builder myself, even I,"

Said the starling, " conjectur'd 'twas so ;
 It must of necessity follow :
For more moss, straw, and feathers, I know,
 It requires, to be soft, round, and hollow."

Whatever she taught them beside,
 In his turn every bird of them said,
Though the nest-making art he ne'er tried,
 He had just such a thought in his head.

The Magpie's Nest.

THE MAGPIE'S NEST,

OR A

LESSON OF DOCILITY.

A FABLE.

When the arts in their infancy were,
 In a fable of old 'tis exprest,
A wise magpie constructed that rare
 Little house for young birds, call'd a nest.

This was talk'd of the whole country round,
 You might hear it on every bough sung,
"Now no longer upon the rough ground
 Will fond mothers brood over their young.

"For the magpie with exquisite skill
 Has invented a moss-cover'd cell,
Within which a whole family will
 In the utmost security dwell."

To her mate did each female bird say,
 "Let us fly to the magpie, my dear;
If she will but teach us the way,
 A nest we will build us up here.

"It's a thing that's close arch'd over head,
 With a hole made to creep out and in;
We, my bird, might make just such a bed,
 If we only knew how to begin."

"SUFFER LITTLE CHILDREN, AND FORBID THEM NOT, TO COME UNTO ME."

To Jesus our Saviour some parents presented
　　Their children—what fears and what hopes they
　　　　must feel !
When this the disciples would fain have prevented,
　　Our Saviour reprov'd their unseasonable zeal.

Not only free leave to come to him was given,
　　But " of such " were the blessed words Christ our
　　　　Lord spake,
" Of such is compos'd the kingdom of heaven : "
　　The disciples, abashed, perceiv'd their mistake.

With joy then the parents their children brought nigher
　　And earnestly begg'd that his hands he would lay
On their heads ; and they made a petition still higher,
　　That he for a blessing upon them would pray.

O happy young children, thus brought to adore him,
　　To kneel at his feet, and look up in his face ;
No doubt now in heaven they still are before him,
　　Children still of his love, and enjoying his grace.

For being so blest as to come to our Saviour,
　　How deep in their innocent hearts it must sink !
'Twas a visit divine ; a most holy behaviour
　　Must flow from that spring of which then they did
　　　　drink.

You pray that your "trespasses may be forgiven,
 As you forgive those that are done unto you."
Before this you say to the God that's in heaven,
 Consider the words which you speak—Are they
 true?

If any one has in the past time offended
 Us angry creatures who soon take offence,
These words in the prayer are surely intended
 To soften our minds, and expel wrath from thence.

We pray that "temptations may never assail us,"
 And "deliverance beg from all evil" we find:
But we never can hope that our prayer will avail us,
 If we strive not to banish ill thoughts from our mind.

"For thine is the kingdom, the power and the glory,
 For ever and ever:" these titles are meant
To express God's dominion and majesty o'er ye:
 And "Amen" to the sense of the whole gives
 assent.

The Lord's Prayer.

ON THE LORD'S PRAYER.

I HAVE taught your young lips the good words to say
 over,
 Which form the petition we call the Lord's Prayer,
And now let me help my dear child to discover
 The meaning of all the good words that are there.

" Our Father,"—the same appellation is given
 To a parent on earth, and the Parent of all—
O gracious permission ! the God that's in heaven
 Allows his poor creatures him Father to call.

To " hallow his name," is to think with devotion
 Of it, and with reverence mention the same ;
Though you are so young, you should strive for
 some notion
 Of the awe we should feel at the Holy One's name.

His " will done on earth, as it is done in heaven,"
 Is a wish and a hope we are suffer'd to breathe
That such grace and favour to us may be given,
 Like good angels on high we may live here beneath.

" Our daily bread give us," your young apprehension
 May well understand is to pray for our food ;
Although we ask bread, and no other thing mention,
 God's bounty gives all things sufficient and good.

84

THE THREE FRIENDS

Which, without a word of strife,
Lasted thenceforth long as life.
Martha now and Margaret
Strove who most should pay the debt
Which they ow'd her, nor did vary
Ever after from their Mary.

Margaret, at nearer sight,
Own'd her observation right;
But they did not far proceed
Ere they knew 'twas she indeed.
She—but, ah! how chang'd they view her
From that person which they knew her!
Her fine face disease had scarr'd,
And its matchless beauty marr'd:
But enough was left to trace
Mary's sweetness—Mary's grace.
When her eye did first behold them
How they blush'd!—but when she told them
How on a sick bed she lay
Months, while they had kept away,
And had no inquiries made
If she were alive or dead;—
How, for want of a true friend,
She was brought near to her end,
And was like so to have died,
With no friend at her bedside;—
How the constant irritation,
Caused by fruitless expectation
Of their coming, had extended
The illness, when she might have mended;
Then, O then, how did reflection
Come on them with recollection!
All that she had done for them,
How it did their fault condemn!

But sweet Mary, still the same,
Kindly eas'd them of their shame;
Spoke to them with accents bland,
Took them friendly by the hand;
Bound them both with promise fast
Not to speak of troubles past;
Made them on the spot declare
A new league of friendship there;

" She was brought near to her end."

Quite destroy'd that comfort glad,
Which in Mary late she had ;
Made her, in experience' spite,
Think her friend a hypocrite,
And resolve, with cruel scoff,
To renounce and cast her off.

See how good turns are rewarded !
She of both is now discarded,
Who to both had been so late
Their support in low estate,
All their comfort and their stay—
Now of both is cast away.
But the league her presence cherish'd,
Losing its best prop, soon perish'd ;
She, that was a link to either,
To keep them and it together,
Being gone, the two (no wonder)
That were left, soon fell asunder ;
Some civilities were kept,
But the heart of friendship slept ;
Love with hollow forms was fed,
But the life of love lay dead :
A cold intercourse they held
After Mary was expell'd.

Two long years did intervene
Since they'd either of them seen,
Or, by letter, any word
Of their old companion heard,
When, upon a day, once walking,
Of indifferent matters talking,
They a female figure met.—
Martha said to Margaret,
" That young maid in face does carry
A resemblance strong of Mary."

THE THREE FRIENDS

All that Mary did confer
On her friend, thought due to her.
In her girlish bosom rise
Little foolish jealousies,
Which into such rancour wrought,
She one day for Margaret sought ;
Finding her by chance alone,
She began, with reasons shown,
To insinuate a fear
Whether Mary was sincere ;
Wish'd that Margaret would take heed
Whence her actions did proceed ;
For herself, she'd long been minded
Not with outsides to be blinded ;
All that pity and compassion,
She believ'd was affectation ;
In her heart she doubted whether
Mary car'd a pin for either ;
She could keep whole weeks at distance,
And not know of their existence,
While all things remain'd the same ;
But, when some misfortune came,
Then she made a great parade
Of her sympathy and aid,—
Not that she did really grieve,
It was only *make-believe* ;
And she car'd for nothing, so
She might her fine feelings show,
And get credit, on her part,
For a soft and tender heart.

With such speeches, smoothly made,
She found methods to persuade
Margaret (who, being sore
From the doubts she felt before,
Was prepared for mistrust)
To believe her reasons just ;

From this cause with grief she pin'd,
Till at length her health declin'd.
All her cheerful spirits flew,
Fast as Martha gather'd new ;
And her sickness waxëd sore,
Just when Martha felt no more.

Mary, who had quick suspicion
Of her alter'd friend's condition,
Seeing Martha's convalescence
Less demanded now her presence,
With a goodness built on reason,
Chang'd her measures with the season ;
Turn'd her steps from Martha's door,
Went where she was wanted more ;
All her care and thoughts were set
Now to tend on Margaret.
Mary living 'twixt the two,
From her home could oftener go,
Either of her friends to see,
Than they could together be.

Truth explain'd is to suspicion
Evermore the best physician.
Soon her visits had the effect ;
All that Margaret did suspect,
From her fancy vanish'd clean ;
She was soon what she had been,
And the colour she did lack
To her faded cheek came back.
Wounds which love had made her feel,
Love alone had power to heal.

Martha, who the frequent visit
Now had lost, and sore did miss it,
With impatience waxëd cross,
Counted Margaret's gain her loss :

" Her visits day by day."

Under which o'erwhelming blow
Martha's mother was laid low ;
She a hapless orphan left,
Of maternal care bereft,
Trouble following trouble fast,
Lay in a sick bed at last.

In the depth of her affliction
Martha now receiv'd conviction,
That a true and faithful friend
Can the surest comfort lend.
Night and day, with friendship tried,
Ever constant by her side
Was her gentle Mary found,
With a love that knew no bound ;
And the solace she imparted
Saved her dying broken-hearted.

In this scene of earthly things
There's no good unmixëd springs.
That which had to Martha prov'd
A sweet consolation, mov'd
Different feelings of regret
In the mind of Margaret.
She, whose love was not less dear,
Nor affection less sincere
To her friend, was, by occasion
Of more distant habitation,
Fewer visits forc'd to pay her,
When no other cause did stay her ;
And her Mary living nearer,
Margaret began to fear her,
Lest her visits day by day
Martha's heart should steal away.
That whole heart she ill could spare her
Where till now she'd been a sharer.

THE THREE FRIENDS.

THREE young girls in friendship met ;
Mary, Martha, Margaret.
Margaret was tall and fair,
Martha shorter by a hair ;
If the first excell'd in feature,
The other's grace and ease were greater ;
Mary, though to rival loth,
In their best gifts equall'd both.
They a due proportion kept ;
Martha mourn'd if Margaret wept ;
Margaret joy'd when any good
She of Martha understood ;
And in sympathy for either
Mary was outdone by neither.
Thus far, for a happy space,
All three ran an even race,
A most constant friendship proving,
Equally belov'd and loving ;
All their wishes, joys, the same ;
Sisters only not in name.

Fortune upon each one smil'd,
As upon a favourite child ;
Well to do and well to see
Were the parents of all three ;
Till on Martha's father crosses
Brought a flood of worldly losses,
And his fortunes rich and great
Chang'd at once to low estate ;

Courage, young friend ; the time may be
 When you attain maturer age,
Some young as you are now may see
 You with like ease glide down a page.

Even then when you, to years a debtor,
 In varied phrase your meanings wrap,
The welcomest words in all your letter
 May be those two kind words at top.

Dear Sir, Dear Madam, or *Dear Friend*,
 With ease are written at the top ;
When those two happy words are penn'd,
 A youthful writer oft will stop,

And bite his pen, and lift his eyes
 As if he thinks to find in air
The wish'd-for following words, or tries
 To fix his thoughts by fixëd stare.

But haply all in vain—the next
 Two words may be so long before
They'll come, the writer, sore perplext,
 Gives in despair the matter o'er ;

And when maturer age he sees
 With ready pen so swift inditing,
With envy he beholds the ease
 Of long-accustom'd letter-writing.

73

When Philip saw the infant crave,
He straightway to the mother gave
His quartered orange ; nor would stay
To hear her thanks, but tripp'd away.
Then to the next clear spring he ran
To quench his drought, a happy man !

THE ORANGE

"—— *To the mother gave*
His quartered orange ;——"

Who in her toil-worn arms did hold
A sickly infant ten months old ;
That from a fever, caught in spring,
Was slowly then recovering.
The child, attracted by the view
Of that fair orange, feebly threw
A languid look—perhaps the smell
Convinc'd it that there sure must dwell
A corresponding sweetness there,
Where lodg'd a scent so good and rare—
Perhaps the smell the fruit did give
Felt healing and restorative—
For never had the child been grac'd
To know such dainties by their taste.

THE ORANGE.

THE month was June, the day was hot,
And Philip had an orange got,
The fruit was fragrant, tempting, bright,
Refreshing to the smell and sight ;
Not of that puny size which calls
Poor customers to common stalls,
But large and massy, full of juice,
As any Lima can produce.
The liquor would, if squeezëd out,
Have filled a tumbler—thereabout.

The happy boy, with greedy eyes,
Surveys and re-surveys his prize.
He turns it round, and longs to drain,
And with the juice his lips to stain.
His throat and lips were parch'd with heat ;
The orange seemed to cry, *Come eat.*
He from his pocket draws a knife—
When in his thoughts there rose a strife,
Which folks experience when they wish
Yet scruple to begin a dish,
And by their hesitation own
It is too good to eat alone.
But appetite o'er indecision
Prevails, and Philip makes incision.

The melting fruit in quarters came,—
Just then there passëd by a dame,
One of the poorer sort she seem'd,
As by her garb you would have deem'd,—

The Journey from School and to School.

POETRY FOR CHILDREN

Soon we exclaim, O shame, O shame,
 This hot and sultry weather,
Who but our master is to blame
 Who pack'd us thus together !

Now dust and sun does every one
 Most terribly annoy ;
Complaints begun, soon every one
 Elbows his neighbour boy.

Not now the joyous laugh goes round,
 We shout not now huzzah ;
A sadder group may not be found
 Than we returning are.

THE JOURNEY FROM SCHOOL
AND TO SCHOOL.

O WHAT a joyous joyous day
　　Is that on which we come
At the recess from school away,
　　Each lad to his own home !

What though the coach is crammëd full,
　　The weather very warm ;
Think you a boy of us is dull,
　　Or feels the slightest harm ?

The dust and sun is life and fun ;
　　The hot and sultry weather
A higher zest gives every breast,
　　Thus jumbled all together.

Sometimes we laugh aloud, aloud,
　　Sometimes huzzah, huzzah.
Who is so buoyant, free, and proud
　　As we home travellers are ?

But sad, but sad is every lad
　　That day on which we come,
That last last day on which away
　　We all come from our home.

The coach too full is found to be ;
　　Why is it crammëd thus ?
Now every one can plainly see
　　There's not half room for us.

William his little basket fill'd
 With his berries ripe and red;
Then, naughty boy, two bees he kill'd,
 Under foot he stamp'd them dead.

William had cours'd them o'er the heath,
 After them his steps did wander;
When he was nearly out of breath,
 The last bee his foot was under.

A cruel triumph which did not
 Last but for a moment's space,
For now he finds that he has got
 Out of sight of every face.

What are the berries now to him?
 What the bees which he has slain?
Fear now possesses every limb,
 He cannot trace his steps again.

The poor bees William had affrighted
 In more terror did not haste
Than he from bush to bush, benighted
 And alone amid the waste.

Late in the night the child was found:
 He who these two bees had crush'd
Was lying on the cold damp ground,
 Sleep had then his sorrows hush'd.

A fever follow'd from the fright,
 And from sleeping in the dew;
He many a day and many a night
 Suffer'd ere he better grew.

His aching limbs while sick he lay
 Made him learn the crush'd bees' pain;
Oft would he to his mother say,
 " I ne'er will kill a bee again."

" Be careful of your little charge."

THE TWO BEES.

But a few words could William say,
 And those few could not speak plain,
Yet thought he was a man one day ;
 Never saw I boy so vain.

From what could vanity proceed
 In such a little lisping lad ?
Or was it vanity indeed ?
 Or was he only very glad ?

For he without his maid may go
 To the heath with elder boys,
And pluck ripe berries where they grow :
 Well may William then rejoice.

Be careful of your little charge ;
 Elder boys, let him not rove ;
The heath is wide, the heath is large,
 From your sight he must not move.

But rove he did : they had not been
 One short hour the heath upon,
When he was nowhere to be seen ;
 "Where," said they, "is William gone ? "

Mind not the elder boys' distress ;
 Let them run, and let them fly.
Their own neglect and giddiness
 They are justly suffering by.

64

"*Mamma heard me with scorn and pride
A wretched beggar-boy deride.*"

THE REPROOF.

MAMMA heard me with scorn and pride
A wretched beggar-boy deride.
" Do you not know," said I, " how mean
It is to be thus begging seen ?
If for a week I were not fed,
I'm sure I would not beg my bread."
And then away she saw me stalk
With a most self-important walk.
But meeting her upon the stairs,
All these my consequential airs
Were chang'd to an entreating look.
" Give me," said I, " the pocket-book,
Mamma, you promis'd I should have."
The pocket-book to me she gave ;
After reproof and counsel sage
She bade me write in the first page
This naughty action all in rhyme ;
No food to have until the time,
In writing fair and neatly worded,
The unfeeling fact I had recorded.
Slow I compose, and slow I write ;
And now I feel keen hunger bite.
My mother's pardon I entreat,
And beg she'll give me food to eat.
Dry bread would be receiv'd with joy
By her repentant beggar-boy.

"*The only substitute for me*
 Was ever found, is call'd a pen."

MEMORY.

"For gold could Memory be bought,
 What treasures would she not be worth !
If from afar she could be brought,
 I'd travel for her through the earth."

This exclamation once was made
 By one who had obtain'd the name
Of young forgetful Adelaide :
 And while she spoke, lo ! Memory came.—

If Memory indeed it were,
 Or such it only feign'd to be—
A female figure came to her,
 Who said, "My name is Memory :

"Gold purchases in me no share,
 Nor do I dwell in distant land ;
Study, and thought, and watchful care,
 In every place may me command.

"I am not lightly to be won ;
 A visit only now I make :
And much must by yourself be done,
 Ere me you for an inmate take.

"The only substitute for me
 Was ever found, is call'd a pen :
The frequent use of that will be
 The way to make me come again."

WRITTEN IN THE FIRST LEAF

OF A

CHILD'S MEMORANDUM-BOOK.

My neat and pretty book, when I thy small lines see
They seem for any use to be unfit for me.
My writing, all misshaped, uneven as my mind,
Within this narrow space can hardly be confin'd.
Yet I will strive to make my hand less awkward look;
I would not willingly disgrace thee, my neat book.
The finest pens I'll use, and wond'rous pains I'll take,
And I these perfect lines my monitors will make.
And every day I will set down in order due
How that day wasted is; and should there be a few
At the year's end that show more goodly to the sight,
If haply here I find some days not wasted quite,
If a small portion of them I have pass'd aright,
Then shall I think the year not wholly was misspent,
And that my Diary has been by some good angel sent.

THE MIMIC HARLEQUIN.

"I'll *make believe*, and fancy something strange:
I will suppose I have the power to change
And make all things unlike to what they were,
To jump through windows and fly through the air,
And quite confound all places and all times,
Like harlequins we see in pantomimes.
These thread-papers my wooden sword must be,
Nothing more like one I at present see.
And now all round this drawing-room I'll range,
And every thing I look at I will change.
Here's Mopsa, our old cat, shall be a bird;
To a Poll parrot she is now transferr'd.
Here's mamma's work-bag, now I will engage
To whisk this little bag into a cage;
And now, my pretty parrot, get you in it,
Another change I'll show you in a minute."

"O fie, you naughty child, what have you done?
There never was so mischievous a son.
You've put the cat among my work, and torn
A fine laced cap that I but once have worn."

"*I saw she look'd at nothing by the way,
Her mind seemed busy on some childish thought.*"

BLINDNESS.

In a stage-coach, where late I chanc'd to be,
 A little quiet girl my notice caught ;
I saw she look'd at nothing by the way,
 Her mind seem'd busy on some childish thought.

I with an old man's courtesy address'd
 The child, and called her pretty dark-eyed maid,
And bid her turn those pretty eyes and see
 The wide extended prospect. "Sir," she said,

"I cannot see the prospect, I am blind."
 Never did tongue of child utter a sound
So mournful, as her words fell on my ear.
 Her mother then related how she found

Her child was sightless. On a fine bright day
 She saw her lay her needlework aside,
And, as on such occasions mothers will,
 For leaving off her work began to chide.

"I'll do it when 'tis daylight, if you please,
 I cannot work, mamma, now it is night."
The sun shone bright upon her when she spoke,
 And yet her eyes receiv'd no ray of light.

ANGER.

ANGER in its time and place
May assume a kind of grace.
It must have some reason in it,
And not last beyond a minute.
If to further lengths it go,
It does into malice grow.
'Tis the difference that we see
'Twixt the serpent and the bee.
If the latter you provoke,
It inflicts a hasty stroke,
Puts you to some little pain,
But it *never stings again.*
Close in tufted bush or brake
Lurks the poison-swellëd snake
Nursing up his cherish'd wrath ;
In the purlieux of his path,
In the cold, or in the warm,
Mean him good, or mean him harm,
Whensoever fate may bring you,
The vile snake will *always sting you.*

POETRY FOR CHILDREN

BROTHER.

Sister, I think 'twere quite as well
That you should find it out ;
So think the matter o'er.

SISTER.

It's what comes in our heads when we
Play at " Let's-make-believe,"
And when we play at " Guessing."

BROTHER.

And I have heard it said to be
A talent often makes us grieve,
And sometimes proves a blessing.

WHAT IS FANCY?

I AM to write three lines, and you
Three others that will rhyme.
There—now I've done my task.

BROTHER.

Three stupid lines as e'er I knew.
When you've the pen next time,
Some question of me ask.

SISTER.

Then tell me, brother, and pray mind,
Brother, you tell me true :
What sort of thing is *fancy?*

BROTHER.

By all that I can ever find,
'Tis something that is very new,
And what no dunces *can see.*

SISTER.

That is not half the way to tell
What *fancy* is about ;
So pray now tell me more.

53

"He in safety industriously plies
 His sweet honest work all the day,
Then home with his earnings he flies;
 Nor in thieving his time wastes away."—

"O hush, nor with *fables* deceive,"
 I replied, "which, though pretty, can ne'er
Make me cease for that insect to grieve,
 Who in agony still does appear.

"If a *simile* ever you need,
 You are welcome to make a wasp do;
But you ne'er should mix fiction indeed
 With things that are serious and true."

WASPS IN A GARDEN.

The wall-trees are laden with fruit;
 The grape, and the plum, and the pear,
The peach and the nectarine, to suit
 Every taste, in abundance are there.

Yet all are not welcome to taste
 These kind bounties of Nature; for one
From her open-spread table must haste
 To make room for a more favour'd son:

As that wasp will soon sadly perceive,
 Who has feasted awhile on a plum;
And, his thirst thinking now to relieve,
 For a sweet liquid draught he is come.

He peeps in the narrow-mouth'd glass,
 Which depends from a branch of the tree;
He ventures to creep down,—alas!
 To be drown'd in that delicate sea.

" Ah say," my dear friend, " is it right
 These glass bottles are hung upon trees?
Midst a scene of inviting delight
 Should we find such mementos as these?"

"From such sights," said my friend, "we may draw
 A lesson, for look at that bee;
Compared with the wasp which you saw,
 He will teach us what we ought to be.

And not to join the illiberal crew
 In their contempt of female merit ;
What's bad enough in them, from you
 Is want of goodness, want of spirit.

What if your rougher out-door sports
 Her less robustious spirits daunt ;
And if she join not the resorts
 Where you and your wild playmates haunt :

Her milder province is at home ;
 When your diversions have an end,
When over-toil'd from play you come,
 You'll find in her an in-doors friend.

Leave not your sister to another ;
 As long as both of you reside
In the same house, who but her brother
 Should point her books, her studies guide ?

If Nature, who allots our cup,
 Than her has made you stronger, wiser ;
It is that you, as you grow up,
 Should be her champion, her adviser.

It is the law that hand intends
 Which fram'd diversity of sex ;
The man the woman still defends,
 The manly boy the girl protects.

THE
DUTY OF
A
BROTHER

Why on your sister do you look,
 Octavius, with an eye of scorn,
As scarce her presence you could brook ?—
 Under one roof you both were born.

Why, when she gently proffers speech,
 Do you ungently turn your head ?
Since the same sire gave life to each ;
 With the same milk ye both were fed.

Such treatment to a female, though
 A perfect stranger she might be,
From you would most unmanly show ;
 In you to her 'tis worse to see.

When any ill-bred boys offend her,
 Showing their manhood by their sneers,
It is your business to defend her
 'Gainst their united taunts and jeers,

49

Of " Never mind it," " We forgive,"—
If these in his short memory live
Only, perchance, for half a day—
Who minds a doll—if that should lay
The first impression in his mind
That sisters are to brothers kind ?
For thus the broken doll may prove
Foundation to fraternal love.

THE BROKEN DOLL.

An infant is a selfish sprite ;
But what of that ? the sweet delight
Which from participation springs,
Is quite unknown to these young things.
We elder children then will smile
At our dear little John awhile,
And bear with him, until he see
There is a sweet felicity
In pleasing more than only one
Dear little craving selfish John.

He laughs, and thinks it a fine joke,
That he our new wax doll has broke.
Anger will never teach him better ;
We will the spirit and the letter
Of courtesy to him display
By taking in a friendly way
These baby frolics ; till he learn
True sport from mischief to discern.

Reproof a parent's province is :
A sister's discipline is this ;
By studied kindness to effect
A little brother's young respect.
What is a doll ? a fragile toy.
What is its loss ? if the dear boy,
Who half perceives he's done amiss,
Retain impression of the kiss
That follow'd instant on his cheek ;
If the kind, loving words we speak

Feigned Courage.

FEIGNED COURAGE.

HORATIO, of ideal courage vain,
Was flourishing in air his father's cane,
And, as the fumes of valour swell'd his pate,
Now thought himself *this* hero, and now *that :*
" And now," he cried, " I will Achilles be ;
My sword I brandish ; see, the Trojans flee !
Now I'll be Hector, when his angry blade
A lane through heaps of slaughter'd Grecians made !
And now by deeds, still braver, I'll evince,
I am no less than Edward the Black Prince.—
Give way, ye coward French !—" As thus he spoke,
And aim'd in fancy a sufficient stroke
To fix the fate of Cressy or Poictiers,
(The Muse relates the hero's fate with tears)
He struck his milk-white hand against a nail,
Sees his own blood, and feels his courage fail.
Ah ! where is now that boasted valour flown,
That in the tented field so late was shown !
Achilles weeps, great Hector hangs his head,
And the Black Prince goes whimpering to bed.

" 'That you have won, my dear young son,
 A prize at school, we'll tell,
Because you can, my little man,
 In writing all excel :

" 'And you have made a poem, nearly
 All of your own invention :
Will not your father love you dearly
 When this to him I mention ?

" 'Your sister Mary, she can say
 Your poetry by heart ;
And to repeat your verses may
 Be little Mary's part.

" 'Susan, for you, I'll say you do
 Your needlework with care,
And stitch so true the wristbands new
 Dear father's soon to wear !'

" 'O hark !' said James ; 'I hear one speak ;
 'Tis like a seaman's voice.'—
Our mother gave a joyful shriek ;
 How did we all rejoice !

" 'My husband's come !' 'My father's here !'
 But O, alas, it was not so ;
 It was not as we said :
A stranger seaman did appear,
On his rough cheek there stood a tear,
 For he brought to us a tale of woe,—
 Our father dear was dead."

THE END OF MAY

The End of May.

"The end of May was yesterday,
　　We all expected him ;
And in our best clothes we were dressed,
　　Susan, and I, and Jim.

"O how my poor dear mother smil'd,
　　And clapp'd her hands for joy ;
She said to me, 'Come here, my child,
　　And Susan, and my boy.

"'Come all, and let us think,' said she,
　　'What we can do to please
Your father, for to-day will he
　　Come home from off the seas.

43

THE END OF MAY.

"Our governess is not in school,
　　So we may talk a bit ;
Sit down upon this little stool,
　　Come, little Mary, sit :

" And, my dear playmate, tell me why
　　In dismal black you're drest ?
Why does the tear stand in your eye ?
　　With sobs why heaves your breast ?

" When we're in grief, it gives relief
　　Our sorrows to impart ;
When you've told why, my dear, you cry,
　　'Twill ease your little heart."

" O, it is trouble very bad
　　Which causes me to weep ;
All last night long we were so sad,
　　Not one of us could sleep.

" Beyond the seas my father went,
　　'Twas very long ago ;
And he last week a letter sent
　　(I told you so, you know)

" That he was safe in Portsmouth bay,
　　And we should see him soon,
Either the latter end of May,
　　Or by the first of June.

THE TEXT

Who had brought home the words, and who had
 A little on the meaning thought ;
Eliza now the old man knew had
 Learn'd that which William never caught.

Without impeaching William's merit,
 His head but serv'd him for the letter ;
Hers miss'd the words, but kept the spirit ;
 Her memory to her heart was debtor.

"I said, 'Be friends with me, dear Will;'
 We quarrell'd, sir, at the church door,—
Though he cried, 'Hush, don't speak, be still,'
 Yet I repeated these words o'er

"Seven or eight times, I have no doubt.
 But here comes William, and if he
The good things he has heard about
 Forgets too, sir, the fault's in me."

"No, sir," said William, "though perplext
 And much disturbed by my sister,
I in this matter of the text,
 I thank my memory, can assist her.

"I have, and pride myself on having,
 A more retentive head than she."—
Then gracefully his right hand waving,
 He with no little vanity

Recited gospel, chapter, verse—
 I should be loth to spoil in metre
All the good words he did rehearse,
 As spoken by our Lord to Peter.

But surely never words from heaven
 Of peace and love more full descended;
That we should seventy times seven
 Forgive our brother that offended.

In every point of view he plac'd it,
 As he the Doctor's self had been,
With emphasis and action grac'd it:
 But from his self-conceit 'twas seen

THE TEXT.

ONE Sunday eve a grave old man,
 Who had not been at church, did say,
"Eliza, tell me, if you can,
 What text our Doctor took to-day?"

She hung her head, she blush'd for shame,
 One single word she did not know,
Nor verse nor chapter she could name,
 Her silent blushes told him so.

Again said he, "My little maid,
 What in the sermon did you hear?
Come tell me that, for that may aid
 Me to find out the text, my dear."

A tear stole down each blushing cheek,
 She wish'd she better had attended;
She sobbing said, when she could speak,
 She heard not till 'twas almost ended.

"Ah! little heedless one, why what
 Could you be thinking on? 'tis clear
Some foolish fancies must have got
 Possession of your head, my dear.

"What thoughts were they, Eliza, tell,
 Nor seek from me the truth to smother."—
"O I remember very well,
 I whisper'd something to my brother.

Nursing.

NURSING.

O hush, my little baby brother !
 Sleep, my love, upon my knee.
What though, dear child, we've lost our mother ?
 That can never trouble thee.

You are but ten weeks old to-morrow;
 What can you know of our loss ?
The house is full enough of sorrow.
 Little baby, don't be cross.

Peace, cry not so, my dearest love !
 Hush, my baby-bird, lie still.—
He's quiet now, he does not move,
 Fast asleep is little Will.

My only solace, only joy,
 Since the sad day I lost my mother,
Is nursing her own Willy boy,
 My little orphan brother.

If he get a hurt or bruise,
To complain he must refuse,
Though the anguish and the smart
Go unto his little heart,
He must have his courage ready,
Keep his voice and visage steady,
Brace his eye-balls stiff as drum,
That a tear may never come,
And his grief must only speak
From the colour in his cheek.
This and more he must endure,
Hero he in miniature !
This and more must now be done
Now the breeches are put on.

GOING INTO BREECHES

Baste-the-bear he now may play at,
Leap-frog, foot-ball, sport away at,
Show his strength and skill at cricket,
Mark his distance, pitch his wicket,

Run about in winter's snow
Till his cheeks and fingers glow,
Climb a tree, or scale a wall,
Without any fear to fall.

GOING INTO BREECHES.

Joy to Philip, he this day
Has his long coats cast away,
And (the childish season gone)
Puts the manly breeches on.
Officer on gay parade,
Red-coat in his first cockade,
Bridegroom in his wedding trim,
Birthday beau surpassing him,
Never did with conscious gait
Strut about in half the state,
Or the pride (yet free from sin)
Of my little MANIKIN:
Never was there pride, or bliss,
Half so rational as his.
Sashes, frocks, to those that need 'em—
Philip's limbs have got their freedom—
He can run, or he can ride,
And do twenty things beside,
Which his petticoats forbad:
Is he not a happy lad?
Now he's under other banners,
He must leave his former manners;
Bid adieu to female games,
And forget their very names,
Puss-in-corners, hide-and-seek,
Sports for girls and punies weak!

THE LAME BROTHER

The Lame Brother.

" Led by your little elder hand,
 I learn'd to walk alone ;
Careful you used to be of me,
 My little brother John.

" How often, when my young feet tired,
 You've carried me a mile !—
And still together we can sit,
 And rest a little while.

" For our kind master never minds,
 If we're the very last ;
He bids us never tire ourselves
 With walking on too fast."

THE LAME BROTHER.

My parents sleep both in one grave ;
　My only friend's a brother.
The dearest things upon the earth
　We are to one another.

A fine stout boy I knew him once,
　With active form and limb ;
Whene'er he leap'd, or jump'd, or ran,
　O I was proud of him !

He leap'd too far, he got a hurt,
　He now does limping go.—
When I think on his active days,
　My heart is full of woe.

He leans on me, when we to school
　Do every morning walk ;
I cheer him on his weary way,
　He loves to hear my talk :

The theme of which is mostly this,
　What things he once could do.
He listens pleas'd—then sadly says,
　"Sister, I lean on you."

Then I reply, "Indeed you're not
　Scarce any weight at all.—
And let us now still younger years
　To memory recall.

32

CLEANLINESS

Wanting in that self-respect
Which does virtue best protect.

 All-endearing Cleanliness,
Virtue next to Godliness,
Easiest, cheapest, needfull'st duty,
To the body health and beauty ;
Who that's human would refuse it,
When a little water does it ?

CLEANLINESS.

Come, my little Robert, near—
Fie ! what filthy hands are here !
Who that e'er could understand
The rare structure of a hand,
With its branching fingers fine,
Work itself of hands divine,
Strong, yet delicately knit,
For ten thousand uses fit,
Overlaid with so clear skin
You may see the blood within,
And the curious palm, dispos'd
In such lines, some have suppos'd
You may read the fortunes there
By the figures that appear,—
Who this hand would choose to cover
With a crust of dirt all over,
Till it look'd in hue and shape
Like the fore-foot of an ape ?
Man or boy that works or plays
In the fields or the highways,
May, without offence or hurt,
From the soil contract a dirt,
Which the next clear spring or river
Washes out and out for ever—
But to cherish stains impure,
Soil deliberate to endure,
On the skin to fix a stain
Till it works into the grain,
Argues a degenerate mind,
Sordid, slothful, ill inclin'd,

The First of April

"No doubt she concluded some sweetmeats were there,
 For the paper was white and quite clean,
And folded up neatly, as if with great care.
 O what a rude boy I have been !

" Ever since I've been thinking how vex'd she will be,
 Ever since I've done nothing but grieve.
If a thousand young ladies a-walking I see,
 I will never another deceive."

THE FIRST OF APRIL.

" TELL me what is the reason you hang down your
 head ?
 From your blushes I plainly discern
You have done something wrong. Ere you go up to
 bed,
 I desire that the truth I may learn."

" O mamma, I have long'd to confess all the day
 What an ill-natured thing I have done ;
I persuaded myself it was only in play,
 But such play I in future will shun.

" The least of the ladies that live at the school,
 Her whose eyes are so pretty and blue,
Ah ! would you believe it ? an April fool
 I have made her, and call'd her so too.

" Yet the words almost chok'd me ; and, as I spoke
 low,
 I have hopes that she might them not hear.
I had wrapp'd up some rubbish in paper, and so,
 The instant the school-girls drew near,

" I presented it with a fine bow to the child,
 And much her acceptance I press'd ;
When she took it, and thank'd me, and gratefully
 smil'd,
 I never felt half so distress'd.

27

TO A RIVER
IN WHICH A CHILD WAS DROWNED.

Smiling river, smiling river,
 On thy bosom sunbeams play :
Though they're fleeting and retreating,
 Thou hast more deceit than they.

In thy channel, in thy channel,
 Chok'd with ooze and gravelly stones,
Deep immersëd, and unhearsëd,
 Lies young Edward's corse : his bones

Ever whitening, ever whitening,
 As thy waves against them dash ;
What thy torrent in the current
 Swallow'd, now it helps to wash.

As if senseless, as if senseless
 Things had feelings in this case ;
What so blindly, and unkindly,
 It destroy'd, it now does grace.

THE FIRST TOOTH

As if it a Phœnix were,
Or some other wonder rare.
So when you began to walk—
So when you began to talk—
As now, the same encomiums pass'd.
'Tis not fitting this should last
Longer than our infant days ;
A child is fed with milk and praise.

THE FIRST TOOTH.

SISTER.

THROUGH the house what busy joy,
Just because the infant boy
Has a tiny tooth to show !
I have got a double row,
All as white, and all as small ;
Yet no one cares for mine at all.
He can say but half a word,
Yet that single sound's preferr'd
To all the words that I can say
In the longest summer day.
He cannot walk, yet if he put
With mimic motion out his foot,
As if he thought he were advancing,
It's prized more than my best dancing.

BROTHER.

Sister, I know you jesting are,
Yet O ! of jealousy beware.
If the smallest seed should be
In your mind of jealousy,
It will spring, and it will shoot,
Till it bear the baneful fruit.
I remember you, my dear,
Young as is this infant here.
There was not a tooth of those
Your pretty even ivory rows,
But as anxiously was watch'd,
Till it burst its shell new hatch'd,

24

THE BOY AND SNAKE

Fond mother ! shriek not, O beware
The least small noise, O have a care—
The least small noise that may be made,
The wily snake will be afraid—
If he hear the lightest sound,
He will inflict th' envenom'd wound.
—She speaks not, moves not, scarce does
 breathe,
As she stands the trees beneath ;
No sound she utters ; and she soon
Sees the child lift up its spoon,
And tap the snake upon the head,
Fearless of harm ; and then he said,
As speaking to familiar mate,
" Keep on your own side, do, Grey Pate : "
The snake then to the other side,
As one rebukëd, seems to glide ;
And now again advancing nigh,
Again she hears the infant cry,
Tapping the snake, " Keep further, do ;
Mind, Grey Pate, what I say to you."
The danger's o'er !—she sees the boy
(O what a change from fear to joy !)
Rise and bid the snake " good-bye ; "
Says he, " Our breakfast's done, and I
Will come again to-morrow day : "
Then lightly tripping, ran away.

"Takes his food in th' open air."

THE BOY AND SNAKE.

HENRY was every morning fed
With a full mess of milk and bread.
One day the boy his breakfast took,
And ate it by a purling brook
Which through his mother's orchard ran.
From that time ever when he can
Escape his mother's eye, he there
Takes his food in th' open air.
Finding the child delight to eat
Abroad, and make the grass his seat,
His mother lets him have his way.
With free leave Henry every day
Thither repairs, until she heard
Him talking of a fine *grey bird*.
This pretty bird, he said, indeed,
Came every day with him to feed,
And it lov'd him, and lov'd his milk,
And it was smooth and soft like silk.
His mother thought she'd go and see
What sort of bird this same might be.
On the next morn she follows Harry,
And carefully she sees him carry
Through the long grass his heap'd-up mess.
What was her terror and distress,
When she saw the infant take
His bread and milk close to a snake!
Upon the grass he spreads his feast,
And sits down by his frightful guest,
Who had waited for the treat ;
And now they both begin to eat.

MOTES
IN THE SUNBEAMS.

The motes up and down in the sun
 Ever restlessly moving we see ;
Whereas the great mountains stand still,
 Unless terrible earthquakes there be.

If these atoms that move up and down
 Were as useful as restless they are,
Than a mountain I rather would be
 A mote in the sunbeam so fair.

20

THE NEW-BORN INFANT.

WHETHER beneath sweet beds of roses,
As foolish little Ann supposes,
The spirit of a babe reposes
 Before it to the body come ;
Or, as philosophy more wise
Thinks, it descendeth from the skies,—
 We know the babe's now in the room,

And that is all which is quite clear
Even to philosophy, my dear.
 The God that made us can alone
Reveal from whence a spirit's brought
Into young life, to light, and thought ;
 And this the wisest man must own.

We'll now talk of the babe's surprise,
When first he opens his new eyes,
 And first receives delicious food.
Before the age of six or seven,
To mortal children is not given
 Much reason ; or I think he would

(And very naturally) wonder
What happy star he was born under,
 That he should be the only care
Of the dear sweet-food-giving lady,
Who fondly calls him her own baby,
 Her darling hope, her infant heir.

NEATNESS IN APPAREL.

In your garb and outward clothing
 A reservëd plainness use ;
By their neatness more distinguished
 Than the brightness of their hues.

All the colours in the rainbow
 Serve to spread the peacock's train ;
Half the lustre of his feathers
 Would turn twenty coxcombs vain.

Yet the swan that swims in rivers,
 Pleases the judicious sight ;
Who, of brighter colours heedless,
 Trusts alone to simple white.

Yet all other hues, comparëd
 With his whiteness, show amiss ;
And the peacock's coat of colours
 Like a fool's coat looks by his.

REPENTANCE AND RECONCILIATION

When I grumbled because Liddy Bellenger had
 Dolls and dresses expensive and fine.
For then 'twas of her, her own self, I complain'd ;
 Since mamma does provide all I have.

MOTHER.

Your repentance, my children, I see is unfeign'd,
 You are now my good Robert, and now my
 good Jane ;
And if you will never be naughty again,
 Your fond mother will never look grave.

JANE.

Mamma is displeas'd and looks very grave,
 And I own, brother, I was to blame
Just now when I told her I wanted to have,
 Like Miss Lydia, a very fine *name*.
'Twas foolish, for, Robert, Jane sounds very well,
 When mamma says, "I love my good Jane."
I've been lately so naughty, I hardly can tell
 If she ever will say so again.

ROBERT.

We are each of us foolish, and each of us young,
 And often in fault and to blame.
Jane, yesterday I was too free with my tongue,
 I acknowledge it now to my shame.
For a speech in my good mother's hearing I made,
 Which reflected upon her whole sex ;
And now like you, Jenny, I am much afraid
 That this might my dear mother vex.

JANE.

But yet, brother Robert, 'twas not quite so bad
 As that naughty reflection of mine,

DISCONTENT AND QUARRELLING

ROBERT.

Let's see, what were the words I spoke ?
Why, may be I was half in joke—
 May be I just might say—
Besides that was not half so bad ;
For, Jane, I only said he had
 More time than I to play.

JANE.

O *may be*, *may be*, very well :
And may be, brother, I don't tell
 Tales to mamma like you.

MOTHER.

O cease your wrangling, cease, my dears ;
You would not wake a mother's fears
 Thus, if you better knew.

15

Discontent and Quarrelling.

DISCONTENT AND QUARRELLING.

JANE.

Miss Lydia every day is drest
Better than I am in my best
 White cambric-muslin frock.
I wish I had one made of clear
Work'd lawn, or leno very dear.—
 And then my heart is broke

Almost to think how cheap my doll
Was bought, when hers cost—yes, cost full
 A pound, it did, my brother ;
Nor has she had it weeks quite five,
Yet, 'tis as true as I'm alive,
 She's soon to have another.

ROBERT.

O mother, hear my sister Jane,
How foolishly she does complain,
 And tease herself for nought.
But 'tis the way of all her sex,
Thus foolishly themselves to vex.
 Envy's a female fault.

JANE.

O brother Robert, say not so ;
It is not very long ago,
 Ah ! brother, you've forgot,
When speaking of a boy you knew,
Remember how you said that you
 Envied his happy lot.

13

THE ROOK AND THE SPARROWS.

A LITTLE boy with crumbs of bread
Many a hungry sparrow fed.
It was a child of little sense,
Who this kind bounty did dispense ;
For suddenly it was withdrawn,
And all the birds were left forlorn,
In a hard time of frost and snow,
Not knowing where for food to go.
He would no longer give them bread,
Because he had observ'd (he said)
That sometimes to the window came
A great black bird, a rook by name,
And took away a small bird's share.
So foolish Henry did not care
What became of the great rook,
That from the little sparrows took,
Now and then, as 'twere by stealth,
A part of their abundant wealth ;
Nor ever more would feed his sparrows.
Thus ignorance a kind heart narrows.
I wish I had been there, I would
Have told the child, rooks live by food
In the same way the sparrows do.
I also would have told him too,
Birds act by instinct, and ne'er can
Attain the rectitude of man.
Nay that even, when distress
Does on poor human nature press,
We need not be too strict in seeing
The failings of a fellow being.

CRUMBS TO THE BIRDS

A BIRD appears a thoughtless thing,
He's ever living on the wing,
And keeps up such a carolling,
That little else to do but sing
 A man would guess had he.

No doubt he has his little cares,
And very hard he often fares,
The which so patiently he bears,
That, list'ning to those cheerful airs,
 Who knows but he may be

In want of his next meal of seeds?
I think for *that* his sweet song pleads.
If so, his pretty art succeeds.
I'll scatter there among the weeds
 All the small crumbs I see.

None that I have named as yet
Are so good as Margaret.
Emily is neat and fine.
What do you think of Caroline?
How I'm puzzled and perplext
What to choose or think of next!
I am in a little fever.
Lest the name that I shall give her
Should disgrace her or defame her,
I will leave papa to name her.

CHOOSING A NAME

I HAVE got a new-born sister;
I was nigh the first that kiss'd her.
When the nursing woman brought her
To papa, his infant daughter,
How papa's dear eyes did glisten!—
She will shortly be to christen:
And papa has made the offer,
I shall have the naming of her.

Now I wonder what would please her,
Charlotte, Julia, or Louisa.
Ann and Mary, they're too common;
Joan's too formal for a woman;
Jane's a prettier name beside;
But we had a Jane that died.
They would say, if 'twas Rebecca,
That she was a little Quaker.
Edith's pretty, but that looks
Better in old English books;
Ellen's left off long ago;
Blanche is out of fashion now.

9

The Peach.

THE PEACH.

MAMMA gave us a single peach,
　　She shar'd it among seven ;
Now you may think that unto each
　　But a small piece was given.

Yet though each share was very small,
　　We own'd when it was eaten,
Being so little for us all
　　Did its fine flavour heighten.

The tear was in our parent's eye ;—
　　It seem'd quite out of season ;
When we ask'd wherefore she did cry,
　　She thus explain'd the reason :

" The cause, my children, I may say,
　　Was joy, and not dejection ;
The Peach, which made you all so gay,
　　Gave rise to this reflection :—

" It's many a mother's lot to share,
　　Seven hungry children viewing,
A morsel of the coarsest fare,
　　As I this Peach was doing."

7

BROTHER.

Well, soon (I say) I'll let it loose ;
But, sister, you talk like a goose,
 There's no soul in a fly.

SISTER.

It has a form and fibres fine,
Were temper'd by the hand divine
 Who dwells beyond the sky.
Look, brother, you have hurt its wing—
And plainly by its fluttering
 You see it's in distress.
Gay painted coxcomb, spangled beau,
A butterfly is call'd, you know,
 That's always in full dress :
The finest gentleman of all
Insects he is—he gave a ball,
 You know the poet wrote.
Let's fancy this the very same,
And then you'll own you've been to blame
 To spoil his silken coat.

BROTHER.

Your dancing, spangled, powder'd beau,
Look, through the air I've let him go :
 And now we're friends again.
As sure as he is in the air,
From this time, Ann, I will take care,
 And try to be humane.

THE BUTTERFLY.

SISTER.

Do, my dearest brother John,
Let that butterfly alone.

BROTHER.

What harm now do I do?
You're always making such a noise—

SISTER.

O fie, John; none but naughty boys
Say such rude words as you.

BROTHER.

Because you're always speaking sharp:
On the same thing you always harp.
A bird one may not catch,
Nor find a nest, nor angle neither,
Nor from the peacock pluck a feather,
But you are on the watch
To moralize and lecture still.

SISTER.

And ever lecture, John, I will,
When such sad things I hear.
But talk not now of what is past;
The moments fly away too fast,
Though endlessly they seem to last
To that poor soul in fear.

5

THE RIDE.

LATELY an equipage I overtook,
And help'd to lift it o'er a narrow brook ;
No horse it had, except one boy, who drew
His sister out in it the fields to view.
O happy town-bred girl, in fine chaise going !
For the first time to see the green grass growing !
This was the end and purport of the ride
I learn'd, as walking slowly by their side
I heard their conversation. Often she—
"Brother, is this the country that I see ?"
The bricks were smoking, and the ground was broke,
There were no signs of verdure when she spoke.
He, as the well-inform'd delight in chiding
The ignorant, these questions still deriding,
To his good judgment modestly she yields ;
Till, brick-kilns past, they reach'd the open fields.
Then, as with rapt'rous wonder round she gazes
On the green grass, the buttercups and daisies,—
"This is the country, sure enough !" she cries :
"Is't not a charming place ?" The boy replies,
"We'll go no further." "No," says she, "no need :
No finer place than this can be indeed !"
I left them gath'ring flow'rs, the happiest pair
That ever London sent to breathe the fine fresh air.

4

The Reaper's Child

IF you go to the field where the reapers now bind
 The sheaves of ripe corn, there a fine little lass,
Only three months of age, by the hedge-row you'll
 find,
 Left alone by its mother upon the low grass.

While the mother is reaping, the infant is sleeping;
 Not the basket that holds the provision is less
By the hard-working reaper, than this little sleeper,
 Regarded, till hunger does on the babe press.

Then it opens its eyes, and it utters loud cries,
 Which its hard-working mother afar off will hear;
She comes at its calling, she quiets its squalling,
 And feeds it, and leaves it again without fear.

When you were as young as this field - nursëd
 daughter,
 You were fed in the house, and brought up on the
 knee;
So tenderly watched, thy fond mother thought her
 Whole time well bestow'd in nursing of thee.

Envy.

W.G.

POETRY FOR CHILDREN

ENVY.

THIS rose-tree is not made to bear
The violet blue, nor lily fair,
 Nor the sweet mignonette:
And if this tree were discontent,
Or wish'd to change its natural bent,
 It all in vain would fret.

And should it fret, you would suppose
It ne'er had seen its own red rose,
 Nor after gentle shower
Had ever smell'd its rose's scent,
Or it could ne'er be discontent
 With its own pretty flower.

Like such a blind and senseless tree
As I've imagined this to be,
 All envious persons are:
With care and culture all may find
Some pretty flower in their own mind,
 Some talent that is rare.

POETRY FOR CHILDREN

the last to be found had been the earliest written, if not the first to be lost. One may doubt, however, whether it was absolutely the first piece of work of this kind which Charles Lamb had done for Godwin. It will be noticed that he refers to it casually, as a man would who was known to be in the way of producing little things of this sort. And certainly the titles of some of the other more juvenile works in Godwin's list have a something about them that makes one guess they might be more young Lambs —Lambs seen only in the great distance, sporting upon the morning mountains, and a long day's journey, I fear, beyond our present reach. Could we but reach them, we should judge more securely, what they are, by the flavour—for the proof of the Lamb, as of the pudding, is in the eating of it. With which encouraging remark the Editor now gracefully retires, leaving his young friends of all ages under a-hundred-and-three to fall to.

W. M.

NOTE.—Mr Shepherd's edition has served as basis for our text of "Poetry for Children," but the copy has been corrected by collation with the original edition before being sent to the printer. This means that I have thought it desirable to restore these by-gone conventions of punctuation which Mr Shepherd did not consider it necessary to reproduce. The principal of these consists in the free use of the apostrophe to indicate elisions: not only in such instances of *real* elision as "Heav'n" or "trav'llers," but in such words as "wish'd." The intention was, to obviate any momentary uncertainty, which would have been a hindrance to reading aloud, as to whether the latter word, say, was or was not to be pronounced "wishèd," as it sometimes would be in poetry: For instance, in Milton, "*While wishèd morn delays.*" There is unfortunately only one volume of the original edition in the British Museum, but that has served well enough for the whole book : the pieces not contained in that volume have been conformed to the rules it prescribes.

I have put at the end of "Poetry for Children" a little stray piece (*A Birthday Thought*) that appears in the Fitzgerald Edition of Lamb's works. It was probably written by Mary Lamb, and may have been meant for the collection in which I have ventured to give it a place.

I, being the author, beg Mr Johnny Wordsworth's acceptance and opinion. *Liberal Criticism*, as G. Dyer declares, I am always ready to attend to." One hopes that no want of liberality in Mr Johnny Wordsworth's criticism was to blame for the silence which fell upon the author from this time henceforth in regard to that book. But certainly no more is heard of it from that time, though it continued to be advertised amongst the other "Elegant and approved Publications, containing each of them the Incidents of an agreeable Tale, exhibited in a Series of Engravings, Price 1s. plain, or 1s. 6d. coloured," which were on sale at the Juvenile Library, 41 Skinner Street, Snow Hill. Students of Lamb had been familiar with the name of the book for a good many years as it appeared in the lists of Godwin's publications; but the discovery that Charles Lamb was the author of it lent an entirely new interest to the subject. Mr Lucas lost no time in going in search of a copy; and, having struck upon a good scent at once, he followed it with vigour athwart various fields, obstacles, and running waters, until he fairly ran down the dear and diminutive quarry. Several other copies have been found since then, and they vary in the date upon the printed cover. That of the copy found by Mr Lucas is dated 1809, that of the copy from which the facsimile in this volume has been made was dated 1818, and yet other copies, I believe, bear other dates. These variations, however, only mean that as the large stock originally printed from the copper plates was but slowly sold off, the publisher from time to time changed the date upon the printed cover. But there were of course no changes within the book itself, and the original date of publication—November 18, 1805—appears in all copies alike. It would seem, then, that amongst the four Recovered Books which this volume contains,

INTRODUCTION

In a word, I am much inclined to think that this is a genuine Lamb *trouvaille*—as people say nowadays —but that it is the work not of Charles but of Mary Lamb. In that case Charles certainly saw to it that ample amends were made for the annoyance caused (*to him at least*) by the way in which her "Tales from Shakspeare " had been illustrated : for nothing could be prettier than the pictures—that is, the uncoloured pictures—to this little book. For the privilege of being able to reprint the story here, and to reproduce those same pretty pictures, we are indebted to Mrs Andrew Tuer ; but for whose prompt liberality and kindness in placing at our disposal an invaluable and beautiful copy of the original edition —perhaps the most treasured amongst all the late Mr Tuer's treasures of that description—the Publishers and the Editor would have had little to announce in regard to this matter save their inabilities and their regrets.

Finally, the last to re-emerge from obscurity, and the quaintest apparition of all, was the "King and Queen of Hearts." This delightful little work belongs to a remoter past than either of the preceding, and the secret of its existence had been kept for about ninety years in what one would have supposed to be no very close prisonhouse for matter of that sort : namely, in one of Lamb's own letters. But it was an unpublished letter, or rather an unpublished passage in a letter which has been a long while before the world. When examining the Wordsworth correspondence two or three years ago Mr E. V. Lucas came upon this passage in a letter to Wordsworth dated February 1, 1806. Lamb there enumerates the contents of a parcel of books and other things which he has just despatched by carrier from London : and amongst these " A Paraphrase on the King and Queen of Hearts, of which

suggested that it may have been Lamb who—not without a perception of the fun of the thing—put it into Godwin's head to propose such a humble piece of work to a genius so great, and so conscious of his greatness, as Wordsworth. That is just as it may be ; but upon the whole I do not see much reason for associating Lamb with a joke which, if *meant* for a joke, would have been rather a poor and rather an impertinent one. One may say, too, that had Lamb been Godwin's instigator in this act, Godwin would have been pretty certain to mention that he had Lamb's assurance that Wordsworth was the man to do this thing better than anybody else ; and Wordsworth would in that case almost certainly have made some allusion to Mr Lamb's flattering opinion in the course of his reply, which is very explanatory and leaves nothing unsaid. To continue, however. It has further been supposed that, Wordsworth not rising or falling to the occasion, Lamb himself was next appealed to, and consented to do the work. This again might or might not be. What we know is that the work was done by somebody not long after ; that the book was published in 1811 ; and that it resembled Prince Dorus in general plan and appearance, size, type, and, to some extent, character of illustrations. I don't think we can say exactly that it belonged to the same series. It is a much more expensive work ; for while " Prince Dorus " was sold at 1s. 6d. coloured and 1s. plain, " Beauty and the Beast " is advertised as costing 5s. 6d. coloured or 3s. 6d. plain. As a fact, the edition with the pictures not coloured is infinitely more desirable than those which suffer from that embarrassment of embellishment. But as to its authorship? Well, personally, I have strong doubts as to its being by Lamb at all : but at the same time I have a feeling—strong, but not so strong—that it comes from his neighbourhood.

of every effort to spread a knowledge of Lamb's writings and so to increase the area of his wise and kindly influence—he very courteously permitted Mr Shepherd to reprint the story in full in his complete edition of " Poetry for Children ": from which source the present Editor, in turn, has been permitted to derive his text. As to the little book itself, it was published in 1811—by Godwin, of course—and seems to have had a continuous sale, if not a very large one; for there was a second edition in 1818. Of course neither it, nor the others in the series to which it belonged—nor, for that matter, " Poetry for Children " itself—had any name save the Publisher's on the title-page. The humour of "Prince Dorus" has been much admired, and to be sure it was addressed to an audience which is a severe judge of jokes, if also the heartiest in welcoming a really good one. Of the pictures I say nothing ; to the connoisseur, especially to the audience aforesaid, they will speak for themselves with convincing effect.

The next lost treasure to come to light was "Beauty and the Beast," discovered by Mr Pearson in 1885. But here there is a difference to be noted. " Prince Dorus " we know to be by Lamb, but " Beauty and the Beast " is only inferred to be his from a number of circumstances that seem to associate him with it. These are not many, nor very convincing. What we know is, that Godwin wrote to Wordsworth early in 1811 making the unlikely proposal that Wordsworth should re-write the story of Beauty and the Beast in verse, from a prose version which he was sending him ; and that Wordsworth declined, and pointed out at the end of his letter that the tiny booklet which Godwin had addressed to him at his home in the mountains had cost him (Wordsworth) four and ninepence for carriage. So far we have facts and figures ; but the rest is guess-work. It has been

more perilous, for no one even knew that *they* had ever existed ; whereas, however scarce and unprocurable copies of the first edition of "Poetry for Children" may have become, we have all along been aware that such a book had been written and published and that Lamb sent it to his friends in 1810. His published correspondence, however, says not a word about these other little works, and therefore I shall speak of them—and that very briefly, for they are but little things—not in the order in which they were written, but in the order in which they were re-discovered.

The first re-discovery we owe to a passage in Henry Crabb Robinson's Diary, a chronicle which runs to thirty-five closely-written manuscript volumes, but from which a copious selection was made and published in three volumes, tremendously well-packed with print, in 1869. Under the date of May 15, 1811, Crabb Robinson says : "A very pleasant call on Charles and Mary Lamb. Read his version of Prince Dorus, the Long-Nosed King." And in a footnote, written many years afterwards, he adds : " This is not in his collected works, and, as well as two volumes of Poems for Children, is likely to be lost." They say that prophecies often bring about their own fulfilment, but sometimes foretelling things is the surest way to keep them from coming to pass. This prophecy of Crabb Robinson's did indeed come true ; and if it had not been *written*, so that future folk could read it, it might have remained true for ever. But this mention of " Prince Dorus," and this prophesying that it was likely to be lost, were just the things that let people know there had been such a book, and that sent them seeking to find it. And happily it could still be found. Mr B. Macgeorge of Dunoon became possessed of a copy not long after, and—being the unwavering and unwearying friend

century turned out. So Mary Lamb's verse-work is not to be stupidly disparaged merely because an occasional inverting of what we call the natural order of words came so natural to her that she probably scarcely even thought of it under the excusing denomination of a poetic licence. And as to cockney rhymes—as "torn" with "dawn"—well, Keats, who, as everybody knows, had the secret of the beautiful and the right way of saying things in him as strongly as though he had been an ancient Greek—Keats, I say, used them, and never explained or apologised to anybody for doing so. And moreover, as it is clear that the said metropolis of England is going to extend, when it has all been built, from Cornwall to Sutherlandshire, and as, consequently, the whole of this island will be ruled by the London County Council and will take its tone from the West-Central District and its pronunciation from Covent Garden, it is clear that the poets of future generations will either have to accept cockney rhymes or remain very provincial indeed. All this seems worth saying because some people in our day are possessed by a morbid horror of cockney rhymes—just as there are people who become instantly unhappy on hearing a good pun, perhaps because they could not have made it for their lives—and even the good Mr Shepherd so far succumbed to this malady that, in order to ease his pain, he actually replaced a line of Mary Lamb's by one of his own, and a very poor line his own was ! This shows that while good taste is full of allowance, fastidiousness may be the beginning of crime.

The three smaller Children's-Books which this volume contains are like "Poetry for Children" in having had their own fates and fortunes, in having been lost and then been found again, after a great length of days. Indeed their adventure was still

much that is likely to bide with them and to build them up, as no other is so honest and direct, or so well grounded in that pre-requisite of poetry which a great poet has called "fundamental brain work." A child might read many volumes of poetry that moderns would think much superior in its kind to most that is in this book : but the child would not get half so much from them, nor like them half so well. And the child would judge wisely ; for all these very clever modern books of Poetry for Children want matter, they want the hard core of sound intelligence and good sense which a child expects from those who profess to be instructive, and the writers of them think they are simple when they are only childish (if one may so use the word) and that they are serious when they are only conventional, sentimental, make-believe and mushy. But the diction is the poetic diction of their own time, and therefore they are supposed to be better poetry than some things here. Than some things of Mary Lamb's, especially, who had not always, perhaps, that ease in expressing herself in verse that she had in prose, and would sometimes put a word a little out of its right place in order to get her rhyme—and her rhyme, sometimes, was such as betrayed her to be native-born of the metropolis of England. But as to the first of these criticisms, one may reply that the tune of the time always seems a good song, and the poetic diction of an age will always seem to that age an essential of good craftsmanship if not the very constituent thing in poetry. But the next age comes along and that fashion no longer pleases, and we are not gratified by a faultless conformity to canons of excellence which do not impress us. Much of the best verse of the seventies is as obsolete to-day, and as tedious to read, and as easy to get the shallow trick of, as anything that the literary machinery of the eighteenth

give to Mary *Motes in the Sunbeams, The Lame Brother* and *The Spartan Boy,* though these might very well (especially the last one) have been written by Charles Lamb. We know for certain at any rate that he wrote *The Three Friends, Queen Oriana's Dream,* and *To a River in which a Child was Drowned,* for those were included amongst his Poems in the first volume of his " Works," published in 1818. That volume contained some poems by Mary also, but none that were taken from " Poetry for Children." On the other hand we know that Mary wrote *The Two Boys;* for at the end of the Essay entitled " Desultory Thoughts on Books and Reading " he quotes these lines in full and says that they are by " a quaint poetess of our day." The quaint poetess kept house for him, and it is to be hoped she cooked him a bad dinner on this occasion in return for his calling people names.[1] It has been inferred that *The First Tooth* is also one of Mary's contributions, but not on sufficient grounds, I think. But whether the brother or the sister be the writer of this or that page in the book is not so worth knowing as the book is worth reading and learning from. It differs from all other books of the kind, and is superior to all other books of the kind, in its true moral and intellectual substantiality, in its matterfulness, in the body of good thinking and good feeling that it contains. No other book of Poetry for Children contains so

[1] For nearly fifty years nobody knew whom he was really referring to, until an anonymous correspondent of " Notes and Queries," writing from Philadelphia, pronounced thus oracularly : " Charles Lamb's sister Mary was the ' quaint poetess' who wrote the verses called *The Two Boys* quoted in one of his Essays " (" N. and Q." July 27, 1867). The writer gave no reasons for saying this, and the accuracy of his statement remained doubtful till the discovery of original copies of " Poetry for Children " just ten years later. Probably he had seen a copy of the Boston reprint of 1812, but did not know enough to understand how important and rare a tome it was.

Next, when a copy of their book was found after all
the lapse of years, it was very kind of Mr Sandover
to let Mr. Shepherd have it free, gratis and for
nothing, instead of holding back this treasure till he
saw a chance of exchanging it for a bag of diamonds
or perhaps a crown imperial. Finally, it is by the
crowning kindness and the imperial courtesy of
Messrs Chatto and Windus that we in turn are put
in possession of this treasure, they having generously
given to us, the present Publishers and the present
Editor, permission to make use of the matter in Mr
Shepherd's complete edition, which is their property,
as though it were our own.

And now that we have got the complete book,
we may be tempted to fall into the idleness which
Charles Lamb slyly expected his friend Manning
would fall into—"You may amuse yourself by
guessing them out," he said. It is best that every-
body should guess them out for himself, perhaps, and
make his own list of what he thinks looks like
Charles Lamb's writing, and what, again, like Mary's.
Mr Shepherd made a list, which I don't agree with
at all ; and so I make a list of my own, which I
don't ask anybody to agree with who doesn't like
it or me. My own opinion is that Charles wrote
*The Ride, Choosing a Name, The New-born Infant,
The Boy and the Snake, The First Tooth, To a River
in which a Child was Drowned, Going into Breeches,
Feigned Courage, Anger, The Orange, The Three
Friends, The Men and Women and the Monkeys,
Parental Recollections, Love, Death and Reputation,
The Beasts in the Tower, The Force of Habit, Why
not Do it, Sir, To-day ? The Coffee Slips, The Dessert,
The Great-Grandfather, Queen Oriana's Dream,* and
—I think I must add—*On a Picture of the Finding of
Moses by Pharaoh's Daughter.* In regard to these
I feel a considerable certainty : but am inclined to

INTRODUCTION

It was sent him by Dr E. J. Marsh, of Paterson, New Jersey, and contained—a copy of an edition of "Poetry for Children" which had been printed at Boston as early as 1812.[1] Nobody in this country had ever suspected, until now, that Boston had shown its literary discernment in so marked a way and at so early a time in the modern history of the States. Charles Lamb *would* have been pleased ; much more pleased than many a less important author to whom Boston has from time to time paid the same compliment since then. And so with the first English edition and the first American edition before him, Mr Shepherd gave to the world a full reprint at last of the long lost book : "Poetry for Children : by Charles and Mary Lamb. To which are added Prince Dorus, and some uncollected Poems by Charles Lamb. Edited, Prefaced, and Annotated by Richard Herne Shepherd. London : Chatto and Windus. 1878." Now it will be seen that every stage in the history of this book has been marked by an act of courtesy and kindness. It was very kind of Charles and Mary Lamb to write it, for the delight and instruction of thousands and thousands of little boys and girls whom they didn't know personally, but had a great liking for, all the same. And it was both courteous and kind of them to permit so many of their poems to be included in Mr Mylius's book, though that kindness went near to killing their own book altogether, as it happened.[2]

[1] Unfortunately the Boston edition was not quite a faithful reprint, for the publisher had been ill-advised enough to leave out three of the Poems ; namely, *Clock Striking*, *Home Delights*, and *Why not Do it, Sir, To-day ?*

[2] It is worth noting that Mylius was a master at Christ's Hospital, so that Charles Lamb would feel that the inclusion of some of Mary's and his own verses in the Mylius book would convey a little influence or a kind word from them back into the old school world of his tender memories.

title-page difference of two years between. In Mr
Hazlitt's book, twenty-two out of the twenty-six
Lamb Poems were identified and given in full ; while
Mr Shepherd's book gave those twenty-two, and two
more besides.[1] The plentiful discussion of these
books by the press had the effect of getting general
interest in this subject well into the air ; and a good
wind coming along carried that interest right to the
Antipodes at the other side of the world, with the
happiest and most unlooked-for result. Early in 1877
there reached Mr Shepherd (or Mr Shepherd's pub-
lishers) a small parcel and a letter, which was dated
Adelaide, South Australia, Dec. 28, 1876. And the
parcel contained —what ? " The two precious though
tiny tomes of the original English edition—a courteous
and most welcome gift from the Hon. William Sand-
over, who had purchased them among others at a sale
of furniture and books at Plymouth, when on a visit
to England in the year 1866." Books, it has been said,
like mortals have their fates and fortunes : and it was
certainly a happy fate for those books to fall, at such
a desperate juncture of their lives, into the hands of
so well-worthy a purchaser. They might easily,
being of such diminutive size, have been swept into
a corner along with the dust and waste-paper and so
have ended in lighting the pipe of the auctioneer's
man ! But more surprises were yet to follow. Mr
Shepherd wrote for the " Gentleman's Magazine "
(July 1877) an interesting account of his recent
acquisition ; and this article, having been extensively
quoted in the newspapers and magazines in different
parts of the world, led to a further acquisition and to
a yet more unexpected discovery. For again Mr
Shepherd received a parcel, this time from America.

[1] These were *Breakfast* and *The Coffee Slips*, which had appeared
in another compilation, namely, " Mylius's Poetical Class-Book."

INTRODUCTION

A number of reasons for this mysterious disappearance have been suggested by Mr Shepherd, who at a later time made a profound inquiry into this whole matter and knew more about it than anybody else. One of the reasons he mentions is " the diminutive size of the work " in its original form : each volume being "a tiny 18mo. of 5½ by 3⅜ inches, proportionately thin, and containing little over a hundred pages, printed on paper of the thinnest imaginable texture." Certainly small things are easily lost, and paper of the thinnest imaginable texture soon worn out, as the youngest purchaser or peruser of this volume will be prepared to admit. But when Mr Shepherd goes on to adduce, as another cause of the disappearance of those two tiny volumes, what he calls " the destructiveness of children "—there, to be sure, he is letting slip a word less seasonably, as Charles Lamb would have been the first to tell him, and I take leave to affirm that I don't believe it in the least. From whatever cause, however, " Poetry for Children " had become a lost treasure of literature ; and for about fifty years the idea of even trying to find it had ceased to be anywhere entertained. But about the beginning of the last quarter of last century—say from 1872–1877 —renewed interest in the matter was awakened, and people wrote and ransacked, and found first this and then that, and by a few rapid approaches arrived finally at a complete recovery of the whole contents of the lost books. Part of the contents, recovered from Mylius's First Book of Poetry, were first given in two works which were compiled, apparently, about the same time,[1] though there is a

[1] "Poetry for Children. By Charles and Mary Lamb. Edited and Prefaced by Richard Herne Shepherd." London: B. M. Pickering. 1872.

" Mary and Charles Lamb : Poems, Letters and Remains, now first collected, with Reminiscences and Notes." By W. Carew Hazlitt. London : Chatto and Windus. 1874.

years afterwards—when, in a letter to Bernard Barton (August 1827), he writes thus : " One likes to have one copy of every thing one does. I neglected to keep one of ' Poetry for Children,' the joint production of Mary and me, and it is not to be had for love or money. . . . Know you any one who has it, and would exchange ? "

" Know you any one who has it ? " There was reason enough to ask the question, long before that time and for many a year after; and very little hope, it seemed, of a satisfactory answer ever being returned. The book was clean perished, like the lost books of antiquity—some of which, however, seem to have been a good riddance—and had perished at an early date. First published in 1809 under the title of " Poetry for Children. Entirely original. By the author of ' Mrs Leicester's School.' In two volumes, 18mo., ornamented with two beautiful frontispieces. Price 1s. 6d. each, half bound and lettered "—already in 1812 it was announced to be out of print. " But," says the Publisher, in his list of New Books, " the best pieces are inserted in Mylius's ' First Book of Poetry.' " This latter work, which was also published by Godwin, was widely and immensely popular ; and like most widely and immensely popular things, it had a great deal to answer for. For if Godwin did not trouble to reprint Charles and Mary Lamb's book, that, we may be sure, was entirely due to his erroneous notion that " the best pieces had been inserted " in the compilation of Mr Mylius. Yet it is difficult to understand how he could really think he had the *best* pieces there, when he had only twenty-six out of a total of eighty-four. At any rate, the book was not reprinted ; and copies of the original edition began to disappear from the earth at a rate that would have been alarming, if it had not been, as a fact, quite unperceived by the people then living.

two other works must already have been thought of, if they were not well in hand ; namely, " Adventures of Ulysses " and " Specimens of English Dramatic Poets who lived about the Time of Shakspeare." But as these were produced by Charles Lamb alone, we need not take further account of them here ; where we are concerned only with the history of that brief era of literary collaboration between the brother and sister, to which we are indebted for the only pages that are worth reading in this and the two preceding volumes of " Charles Lamb's Works "— as we call them for short, following Charles Lamb's own example, of which Mary approved.

The third—and, as far as we can gather, the last— stage of that collaboration is represented by " Poetry for Children"; which is like nearly all Lamb's works in being something which we have not been permitted to see in the making, and of which we only hear when it has actually been published, or is on the point of being published. " I shall have to send you, in a week or two," (thus he announces abruptly to Coleridge, in a letter dated June 7, 1809) " two volumes of Juvenile Poetry done by Mary and me within the last six months. . . . Our little poems are but humble ; but they have no name. You must read them remembering they were task-work ; and perhaps you will admire the number of subjects, all of children, picked out by an old bachelor and an old maid. Many parents would not have found so many." And on January 2, 1810, he writes to Manning : " There comes with this two volumes of minor poetry, a sequel to *Mrs Leicester ;* the best you may suppose mine, the next best are my coadjutor's. You may amuse yourself by guessing them out, but I must tell you mine are but one third in quantity of the whole." That is all we learn, at that time ; and we hear no more on the subject till about eighteen

INTRODUCTION

THE Introduction to "Tales from Shakspeare"
(vol. vi. of this Edition) gives some account
of the circumstances in which Charles and Mary
Lamb were living when, in 1805–6, they were
induced to write something for the series of books
for young people published by their friend William
Godwin, at the Juvenile Library in Hanway Street.
"Tales from Shakspeare" itself was a work entered
upon, in the first instance, by Mary alone ; but after
a time she was fain to enlist her brother in the
service, and so they finished the work between them
and have shared the glory ever since. But no sooner
was this task finished, than Mary, again bravely
setting out by herself, had taken a new one in hand,
namely, the book of stories known as "Mrs Leicester's
School" (vol. vii. of this Edition). She had chosen a
subject, this time, that seemed to exclude her brother
from all hope of participation in the labour or the
praise : for what could *he* be supposed to know of
the kind of conversation with which the more
thoughtful and observant pupils at a young ladies'
seminary entertain and instruct one another, and even
their preceptress ? However, he was, as it happened,
a genius ; and it is the privilege and mark of a genius
to know far more than people suppose and, in fact,
a great deal more than he is himself aware of. Con-
sequently, when Charles Lamb was permitted (as he
was in the end) to take part in this work also, the
three tales which he contributed did not betray any
want of knowledge of the scene and the subject, and
were not found to be the least delightful of the nine.
About the time that this was in progress (in 1807),

LIST OF ILLUSTRATIONS

LIST OF ILLUSTRATIONS

Charles Lamb from the drawing by T. Wageman, 1824-1825
(Photogravure) *Frontispiece*

xi

CONTENTS

CONTENTS

CONTENTS

CONTENTS

First Published 1903
Reprinted 1970

STANDARD BOOK NUMBER:
8369-6113-7

LIBRARY OF CONGRESS CATALOG CARD NUMBER:
78-108585

POETRY
FOR CHILDREN

BY

CHARLES & MARY LAMB

EDITED WITH INTRODUCTION

BY

WILLIAM MACDONALD

WITH ILLUSTRATIONS

BY

WINIFRED GREEN

AND REPRODUCTIONS

FROM THE

ORIGINAL ILLUSTRATIONS

Granger Index Reprint Series

BOOKS FOR LIBRARIES PRESS
FREEPORT, NEW YORK

Charles Lamb.
From the drawing by T. Wageman, 1824-1825.

POETRY FOR CHILDREN